OVERSIZE BOOK

COPY 47

759
W Wheelock, Arthur K
 Jan Vermeer / by Arthur Wheelock. New
 York : Abrams, [1981]
 167 p. : ill.
 (The Library of great painters)

 ISBN 0-8109-1730-0 : 40.00

 1.Vermeer, Johannes, 1632-1675.

 35657

 F82

 81-1754
 CIP MARC

LIBRARY OF GREAT PAINTERS

VERMEER

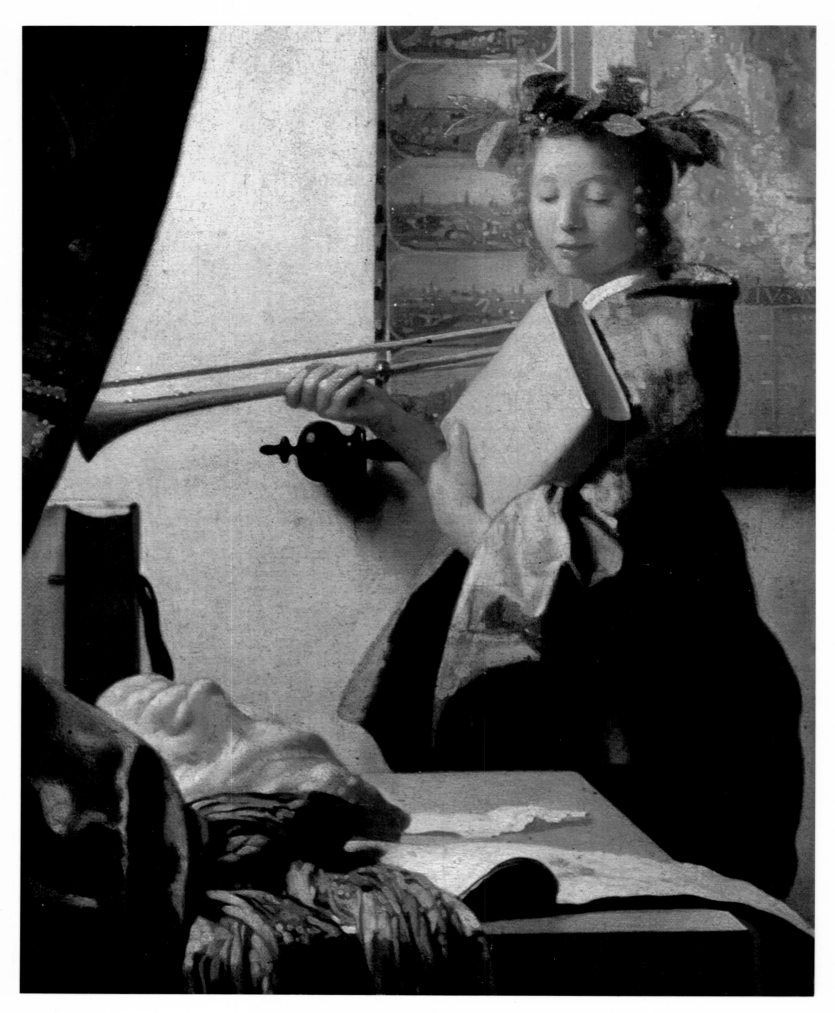

LIFT COLORPLATE FOR TITLE AND COMMENTARY

JAN
VERMEER

TEXT BY

ARTHUR K. WHEELOCK, JR.

Curator, Dutch and Flemish Paintings

National Gallery of Art, Washington, D.C.

THE LIBRARY OF GREAT PAINTERS

HARRY N. ABRAMS, INC., PUBLISHERS, NEW YORK

Editor: Margaret Donovan
Designer: Darilyn Lowe
Rights and Reproductions: James A. Murch

Library of Congress Cataloging in Publication Data
Wheelock, Arthur K., Jr.
 Jan Vermeer.
 (The Library of great painters)
 Bibliography: p. 163
 Includes index.
 1. Vermeer, Johannes, 1632-1675. I. Title.
II. Series: Library of great painters.
ND653.V5W47 759.9492 81-1754
ISBN 0-8109-1730-0 AACR2

Published in 1981 by Harry N. Abrams, Incorporated, New York
All rights reserved. No part of the contents of this book may be
reproduced without the written permission of the publishers

Printed and bound in Japan

CONTENTS

ACKNOWLEDGMENTS

A great many people have helped make this book possible, but I owe a particular debt of gratitude to A. B. DE VRIES. The many hours we have spent talking about and looking at Vermeer's paintings are ones that I will always remember and treasure, and I am pleased to dedicate this book to him.

I am also greatly indebted to two of my colleagues at the National Gallery of Art: Kay Silberfeld, for her help in understanding Vermeer's painting techniques; and Charles Parkhurst, for his support and encouragement. I have also received similar support, for which I am most grateful, from Seymour Slive.

Collectors and colleagues from other museums have been extremely generous in allowing me to study their paintings under optimum circumstances. In particular I would like to thank: Sir Alfred Beit, Henning Bock, A. Bréjon de Lavergnée, Christopher Brown, Klaus Demus, John Dick, Fritz DuPark, Everett Fahy, Jacques Foucart, Deborah Gribbon, E. Haverkamp-Begemann, Hans Hoetink, John Jacob, Jan Kelch, Rudiger Klessman, Walter Kloek, Simon Levie, Walter Liedtke, Hugh Macandrew, Kenneth Malcolm, A. Mayer-Meintschel, Sir Oliver Millar, Knut Nicolaus, Andrew O'Connor, Sir John Pope Hennessy, Pierre Rosenberg, Madame la Baronne Guy de Rothschild, John Soultaniam, Pieter van Thiel, Martin Wyld, Hans Ziemke.

I have also greatly benefited from my discussions with J. R. J. van Asperen de Boer (who has also helped me make infra-red reflectographs of a number of Vermeer's paintings), J. M. Montias, Hubert von Sonnenburg, Kirby Talley, Albert Blankert, and with my students at the University of Maryland. I would also like to thank Deborah A. Gómez for her assistance in preparing the manuscript, and Jim Murch, Margaret Donovan, and Darilyn Lowe from the staff of Harry N. Abrams, Inc., for their untiring help in gathering photographs, editing the text, and designing the book.

Much of the research for this book was funded by a generous grant from the National Endowment for the Arts.

Finally, to my parents, my children, Tobey, Laura, and Matthew, and my wife, Susan, who patiently read and astutely commented upon the ideas that went into this book, go my warmest thanks for sharing in and making possible this study.

Meer

THE IMAGES JAN VERMEER has left us are few and of limited scope: a woman pouring milk in a sunlit corner of a room, a girl reading a letter or adorning herself with pearls. Occasionally he introduces a second or a third figure and depicts a concert, a gentleman offering a woman a drink, a maid delivering a letter. Two cityscapes, a Biblical painting, a mythological scene, a few allegories, nothing more. Yet we esteem him as one of the greatest artists who ever lived.

The fascination of Vermeer's paintings, however, is not in his choice of subject but in the poetic ways his images are portrayed. It is in the way he uses light and color, proportion and scale, to enhance the moods of his figures. He imparts nuances of thought and meaning to his scenes which are at once understandable but not totally explicit. Ultimately, however beautiful or sensitive his paintings may be, they continue to appeal because they can never be completely explained.

Vermeer's life and art are closely associated with the city of Delft. He was born in Delft in 1632 and lived there until his death in 1675.[1] Delft, despite being a commercial center in the mid-seventeenth century, was a provincial place (figs. 1, 2). Its growth was restrained and orderly; its canals and houses small and unpretentious. Today one still finds this tranquility in its tree-lined streets. Only its two great churches, the Oude Kerk and the Nieuwe Kerk, interrupt the low profile of the city's skyline. Vermeer's paintings are similarly intimate and selectively focused. The immediacy of his images is strong, yet he encourages viewers to stay and ponder, transferring to them the quietude of his scenes and his world.

The Little Street (colorplate 9), for example, draws one into this world. Vermeer encourages us to explore its simplicity, its variety, and its measured beauty. Vermeer's particular concern with the physical and psychological relationship of figures to their environment is evident in this work. The women framed in the courtyard and in the doorway as well as the children bent over their activity on the sidewalk are not extraneous elements in the painting—they are essential to its mood. The character of *Girl Reading a Letter at an Open Window* (colorplate 7) is similarly restrained. The young woman is depicted alone and immersed in a moment of quiet contemplation. In this instance she is framed not by a doorway, but by a window, a table, and a curtain. Light floods the room and falls gently on her figure; it imbues her with the soft radiance that pervades the scene.

The moods generated by Vermeer's paintings are unique, and it is virtually impossible to explain their derivation. We have little information about his temperament, his ambitions, or his intentions which would help explain his artistic vision. Although recent archival research has taught us more about Vermeer's family, many questions

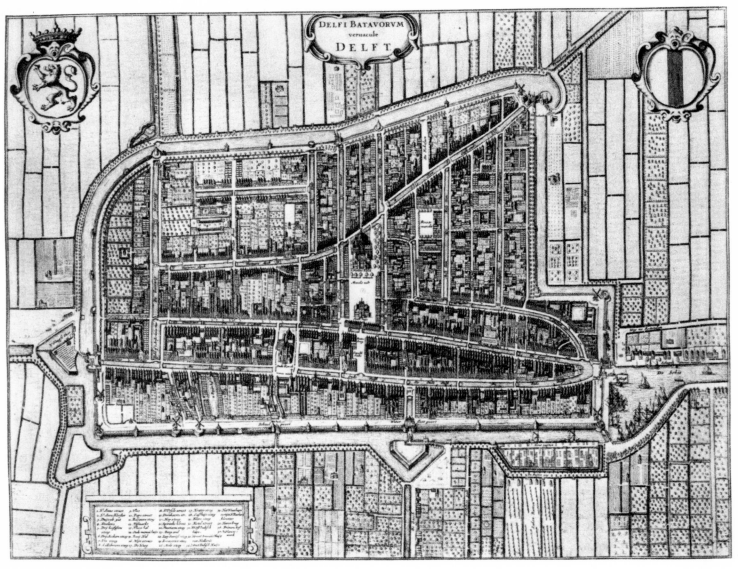

1. Groundplan of Delft, 1649. From Willem Blaeu, *City Atlas of The Netherlands*, Amsterdam, 1649

about his life remain unanswered.[2] What, for example, was his relationship to the other artists working in and around Delft? What other influences contributed to his own stylistic evolution? What effect did his painting techniques have on his style of painting? Did he experiment with the camera obscura or other optical devices? These questions are further complicated by our incomplete knowledge of the chronology of his work. Of the thirty-four paintings accepted here as authentic,[3] only two are dated: *The Procuress* (1656), and *The Astronomer* (1668).[4] Although art historians now generally agree on the broad chronology of Vermeer's work, speculation on the specific sequence of his paintings is hazardous.[5]

Some of the difficulties of appraising Vermeer's achievement are inherent in any attempt to interpret the works of a previous era. Paintings are essentially a means of communication. Through them artists strive to relate stories, ideas, moods, and credos. But because paintings are physically durable and generally outlive the generation and the century in which they were created, they take on added historical interest. They become visual statements of the attitudes, moods, and ideas of a different age. Often paintings succeed in transcending their historical interest: they have a capacity to live and to remain aesthetically viable for different generations, races, and cultures. The moods and meanings they transmit communicate directly to men with different needs and expectations.

Jan Vermeer's tranquil images of Dutch interiors are historical documents, but they also suggest aspects of the human experience that remain meaningful in the twentieth century. Perhaps more than most seventeenth-century artists,

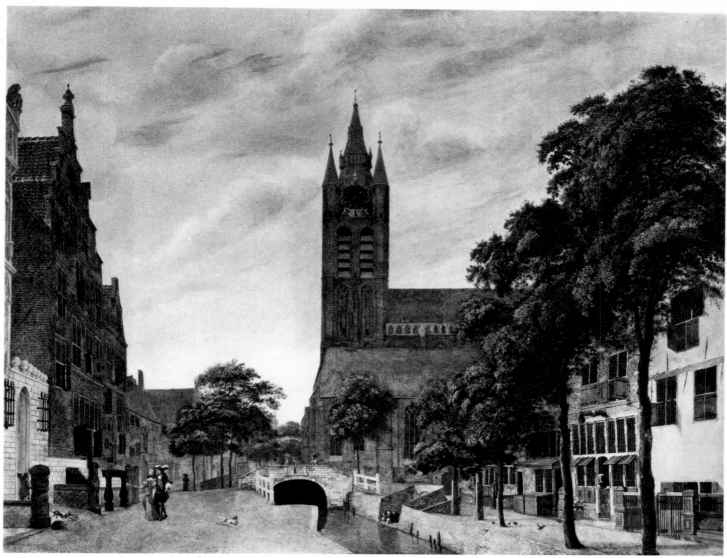

2. Jan van der Heyden. *Oude Kerk in Delft*. n.d. Oil on wood, 21 3/4 × 27 7/8″ (55.3 × 70.8 cm). The Detroit Institute of Arts. Gift of Mr. and Mrs. Edgar B. Whitcomb

Vermeer communicates through mood rather than through narrative or anecdote. Basic moralizing themes are frequently implied without being explicitly stated. Although it is difficult to say how his paintings were "read" in the seventeenth century, the viewer today, without a thorough knowledge of Dutch thematic and emblematic traditions, is only distantly aware of their moralizing implications. Thus a difficulty in current appraisals of Vermeer is to balance one's intuitive emotional response to his paintings with an understanding of the artistic and thematic traditions of his time and place.

This study is divided into two parts: an introductory essay on the artistic environment within which Vermeer worked, and commentaries on all of his accepted paintings (and one often attributed to him). Besides outlining Vermeer's life and

subsequent reputation, the essay examines problems that are basic to an understanding of Vermeer's approaches to his work: for example, the nature of painting in Delft before and after 1650, attitudes toward realism, the impact of perspective and optics, and the question of symbolism. The commentaries focus on Vermeer's painting techniques and the manner in which his style evolved during his career.

Life

Little is known about Vermeer's early life. By 1641, his father was sufficiently prosperous to purchase a large house, the "Mechelen," which contained an inn in the market square in Delft. Various documents also indicate that Reynier Vermeer was a silk weaver who produced "caffa,"

a fine satin fabric used chiefly in clothing, as well as an art dealer and member of the Saint Luke's Guild (the trade association to which artists, dealers, and artisans belonged).[6] One document, written a few years after his death in 1652, even refers to him as a painter.[7] Although no evidence exists to indicate that Jan Vermeer actually succeeded his father as innkeeper of the Mechelen, he apparently inherited his father's business in 1652. We do know from a statement by Vermeer's wife, Catharina Bolnes, that Vermeer continued buying and trading paintings until his death in December, 1675.[8]

Vermeer was married to Catharina Bolnes in April, 1653, somewhat against the wishes of Catharina's mother, Maria Thins. Maria Thins, who had been divorced from her husband about 1640, resisted the marriage proposal, possibly because Vermeer had been raised a Protestant and Catharina was a Catholic. She may also have been concerned about Vermeer's financial future; he was probably only an apprentice at the time, since he did not become a master in the Saint Luke's Guild until December 29 of that year. As subsequent events would reveal, Vermeer's financial prospects were limited, and Maria Thins, who was a person of some means, would have to help support her daughter and son-in-law.

Maria Thins and her family remained close to Vermeer throughout his life. Although Vermeer and Catharina Bolnes probably lived in the Mechelen after their marriage, they moved to Maria Thins's household on the Oude Langendijk about 1660. Recent archival material discovered by J. M. Montias has shown the extent to which Vermeer assisted Maria Thins with running the household and with caring for her mentally disturbed son, Willem Bolnes.[9] The bonds between mother and daughter were also strong, and Maria Thins, until her death in 1680, greatly assisted the financially troubled Catharina Bolnes after Vermeer's death.

The causes of the debts that plagued Catharina Bolnes are not precisely known. A revealing document of April 30, 1676, in which Catharina requested that she not be required to pay all of her debts, blames the depression brought on by the war with France for the losses Vermeer sustained while selling paintings "he had bought and with which he was trading."[10] Catharina's explanation for her precarious financial condition raises the question of whether or not painting was Vermeer's main vocation, at least at the end of

his life. Vermeer, however, always designated himself a painter in legal documents. He was also recognized as an important master in Delft and was chosen a member of the Board of the St. Luke's Guild in 1662–63 and again in 1670–71.

Vermeer's oeuvre is not large: only thirty-four paintings can be firmly attributed to him. No drawings or prints by him are known.[11] Although a few other works are mentioned in old inventories, it seems that the small size of his oeuvre is not the result of attrition. One wonders how Vermeer, painting at a rate of less than two works a year, could have supported himself, his wife, and his eight children who survived infancy without supplementing his income by other means.

Some scholars have speculated that Vermeer was partially supported by a rich patron who received first option to buy his works.[12] Such arrangements existed for other artists, among them Gerard Dou and Emanuel de Witte. The man identified as the patron is Jacob Dissius, one of Vermeer's neighbors on the marketplace of Delft. When he died, in 1682, Dissius owned nineteen of Vermeer's paintings.[13] No extant document, however, indicates that an arrangement between Vermeer and Dissius existed, and Dissius could well have acquired these paintings after Vermeer's death. An inventory of Vermeer's estate dated February 29, 1676, indicates that Catharina Bolnes and Maria Thins had been bequeathed, among other goods, nineteen unidentified paintings.[14] Although the inventory is not very precise, works owned by Vermeer but painted by other masters were cursively described. Surprisingly, no paintings by Vermeer are identified in the inventory even though at least one, *The Allegory of Painting* (colorplate 33), is mentioned in a later document as belonging to Maria Thins.[15] Since Catharina Bolnes never regained financial solvency, she may well have sold these paintings to Dissius after her mother's death in 1680.

Varied information exists about the values attached to Vermeer's paintings by his contemporaries. A recently discovered inventory from 1657 values at 20 guilders a painting now lost, *The Visit of the Holy Women to the Tomb of Christ*.[16] Vermeer's later genre paintings may have been more highly valued by his contemporaries than his early Biblical and mythological scenes. One French traveler, Balthasar de Monconys, who visited Delft, and Vermeer, in 1663, thought such works overvalued. Vermeer had no paintings to show him, but De Monconys did visit a baker who

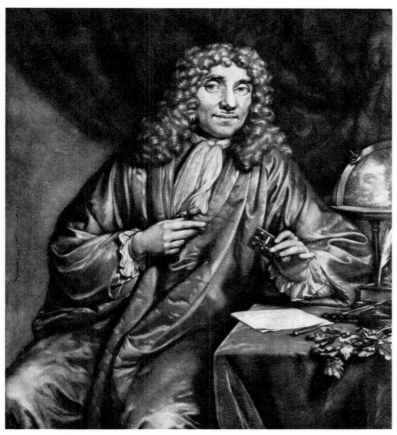

3. Jan Verkolje. *Portrait of Antoni van Leeuwenhoek.* 1686.
Mezzotint, 11 3/4 × 8 1/2" (30 × 21.7 cm).
Rijksmuseum, Amsterdam

and Van Leeuwenhoek, aside from his interest in natural science, worked as a cloth merchant. A connection could have existed as a result of the silk weaving business owned by Vermeer's father, a business which Vermeer apparently inherited upon his father's death.[20]

A shared fascination with science and optics might also have brought them together. Van Leeuwenhoek's interests in navigation, astronomy, mathematics, and philosophy, which began as early as 1655, parallel Vermeer's accurate depictions of maps and globes in his paintings.[21] One even wonders if Van Leeuwenhoek could have commissioned and perhaps served as the model for Vermeer's depictions of *The Astronomer* (colorplate 37) and *The Geographer* (colorplate 38). Van Leeuwenhoek's microscopic discoveries and Vermeer's distinctive painting techniques also share certain similarities. Van Leeuwenhoek, for example, eventually believed that matter was composed of small "globules," a term that could be used to describe the diffused dots of color that

offered him a painting by Vermeer for 480 guilders. De Monconys thought the price for a painting with a single figure outrageous and valued the picture at one tenth the amount.[17] In another instance, in 1676 Catharina Bolnes satisfied a debt of 617 guilders and 6 stuivers to the baker, Hendrick van Buyten (perhaps the same one visited by De Monconys), by transferring to him two paintings, a letter writer and a woman playing a guitar.[18] Prices of 300 to 400 guilders for a painting were good for genre paintings at that time, but, considering the small size of Vermeer's oeuvre, they were hardly sufficient to support a family.

If few documents link Vermeer with known individuals during his lifetime, one intriguing relationship is suggested by documents dating from after his death. In 1676 Antony van Leeuwenhoek (1632–1723), the famed microscopist, was named trustee for Vermeer's estate. Van Leeuwenhoek (fig. 3) appears to have dealt sympathetically with Vermeer's bankrupt estate and to have spent much effort in satisfying the demands of creditors.[19] One can only wonder whether or not Vermeer and Van Leeuwenhoek had been friends previously. Circumstantial evidence is persuasive. Both men were born in Delft in 1632,

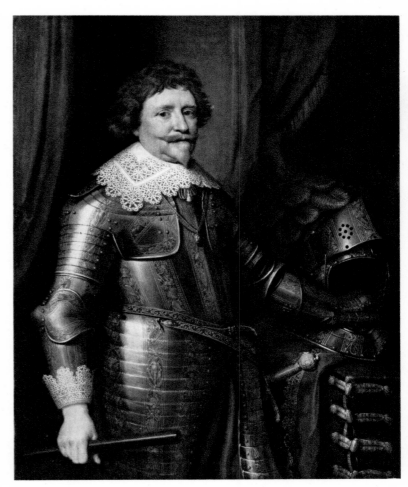

4. Michiel Jansz. van Miereveld. *Frederik Hendrik, Prince of Orange.* n.d. Oil on canvas, 44 1/2 × 34 7/8" (113 × 88.5 cm). Rijksmuseum, Amsterdam

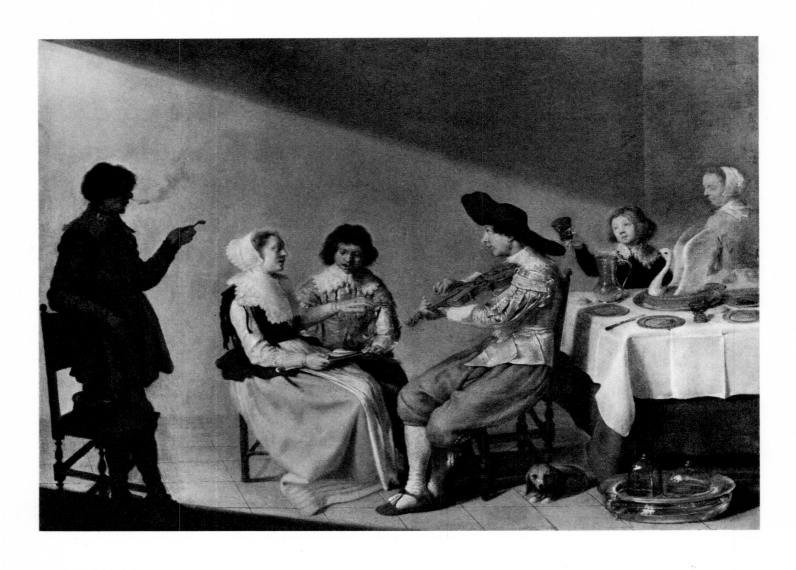

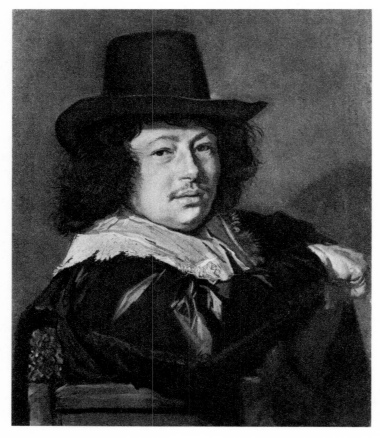

5. *Above*: Jacob van Velsen. *A Musical Party*. 1631. Oil on wood, 15 3/4 × 21 3/4″ (40 × 55 cm). National Gallery, London

6. *Left*: Frans Hals. *Portrait of a Young Man*. c. 1645. Oil on canvas, 26 7/8 × 21 7/8″ (68.3 × 55.6 cm). National Gallery of Art, Washington, D.C. Andrew Mellon Collection, 1937

7. *Right*: Esaias van de Velde. *View of Zierikzee*. 1618. Oil on canvas, 10 5/8 × 15 3/4″ (27 × 40 cm). Staatliche Museen Preussischer Kulturbesitz, Gemäldegalerie, Berlin-Dahlem

Vermeer often used to enliven the surfaces of objects in his paintings. Although one must be cautious about overstating such connections, the distinct possibility exists that Vermeer's art was enriched through contacts with this remarkable scientist.

Bramer and the Artistic Traditions in Delft

We have no documents relating to Vermeer prior to those concerning his marriage; information about his artistic training and apprenticeship is therefore totally lacking. Vermeer presumably trained in Delft, but his early paintings, *Christ in the House of Martha and Mary* (colorplate 1) and *Diana and Her Companions* (colorplate 3), do not resemble works by other artists active in that city. He may have studied elsewhere, perhaps in Amsterdam, but differences in style and technique among these early paintings are sufficiently great that no clear associations with a particular artist or style can be made.[22]

Delft had not developed a particularly distinguished artistic tradition in the first half of the seventeenth century. Most of its artists, including the portrait painter Michiel van Miereveld (fig. 4), the still-life painter Balthasar van der Ast, and the genre painters Anthonie Palamedesz. and

Jacob van Velsen (fig. 5), were competent but not innovative masters. Delft lacked artists who saw the world with the fresh spontaneity of a Frans Hals (fig. 6), an Esaisas van de Velde (fig. 7), or a Rembrandt van Rijn (fig. 24). The joyous discovery of the visible world, so characteristic of other Dutch art at that time, was not shared by Delft's artists.

Delft's artistic traditions were aristocratic and conservative because of the close connections the city had to the Court of the House of Orange in The Hague. The Court had once been in Delft, and the city's ties to the House of Orange had remained strong. Although the princes of Orange had never been noted as significant patrons of the arts, they, and others connected with the Court, did commission a number of works of art, primarily portraits (fig. 4) and history paintings. Their aristocratic expectations had a significant impact on stylistic currents in Delft and The Hague.

The princes also aspired to create monuments to their fame comparable to those found in France and England. Prince Frederik Hendrik and his wife, Amalia van Solmes, constructed and decorated two palaces near Delft during the 1630s and 1640s, Honselaarsdijk and Rijswijk.[23] After Frederik Hendrik's death in 1647, Amalia van

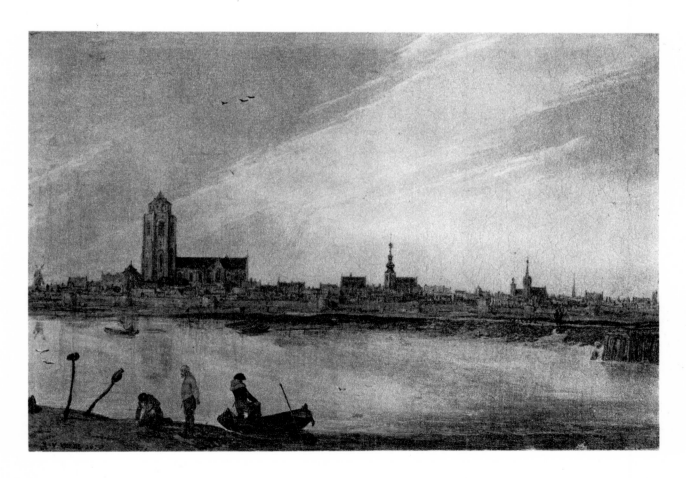

Solmes commissioned artists to decorate yet a third palace, the Huis ten Bosch, outside The Hague.[24]

The artists commissioned to decorate the interiors of these buildings were ones noted for their classicistic tendencies and their ability to paint large mural decorations. Among the artists involved in these projects were two from Delft, Christiaen van Couwenbergh and Leonaert Bramer (1596–1674).[25] As with the artists from Haarlem and Utrecht who also worked on these mural decorations, Van Couwenbergh and Bramer had been to Italy and had mastered the ability to paint broad forms and illusionistic space. A drawing by Bramer of musicians performing on a balcony may well reflect the type of illusionistic designs he produced for the palaces (fig. 8; see also fig. 58 for an illustration of this type of painting). A number of these painters had close ties with Flemish traditions; indeed, for the Huis ten Bosch, Flemish artists, including Jacob Jordaens, were invited to participate.

The impact of these princely commissions on Dutch artistic traditions has been largely forgotten because two of these palaces, Honselaarsdijk and Rijswijk, were later destroyed. The Huis ten Bosch has often been seen as an anomaly in Dutch art: its distinctly Flemish orientation stands outside Dutch traditions. Nevertheless, until the untimely death of Prince Willem II in 1650 and the passing of the government from the House of Orange to the Grand Pensionary Johan de Witt, the Court was a significant patron of the arts. The honor and remuneration of royal commissions encouraged artists to adhere to the classicistic, Italianate traditions preferred by the House of Orange.

Although the impact of the House of Orange on artistic tastes does not bear directly on Jan Vermeer, it amplifies our understanding of the artistic climate in Delft. Bramer, one artist who painted at Honselaarsdijk and Rijswijk, was a friend of Vermeer's and may have guided the young artist or have even been his teacher. Bramer's work at these palaces brought him into contact with Utrecht Caravaggisti, Haarlem Classicists, and Flemish artists. He may have broadened Vermeer's awareness of the different artistic currents in the Netherlands. Vermeer's appreciation of these other traditions of Dutch art is evident in the kinds of paintings he owned and those he represented in his interior scenes. Among the latter paintings are one by Dirck van Baburen, a Utrecht Caravaggisti (fig. 9; see colorplates 29, 46); one attributed to Caesar van Everdingen, a Haarlem Classicist (see colorplates 18, 45); and one by Jacob Jordaens (see colorplate 43).[26]

The primary connection between Bramer and Vermeer is a document indicating that Bramer came forward in 1653 as a witness on Vermeer's behalf at the time of his betrothal to Catharina

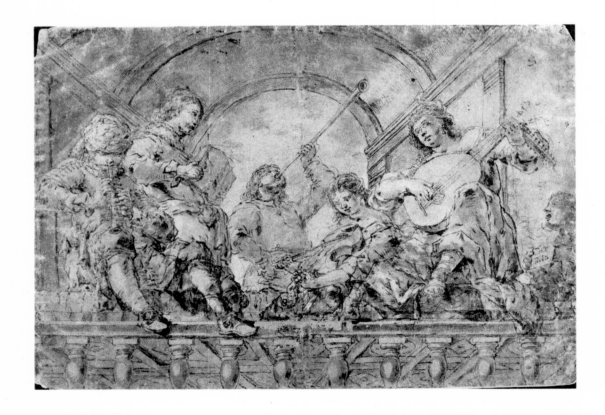

8. Leonaert Bramer. *A Musical Company*. n.d. Drawing, pen and black ink with gray washes on gray paper, 14 3/8 × 21 1/8" (36.5 × 53.7 cm). Philadelphia Museum of Art

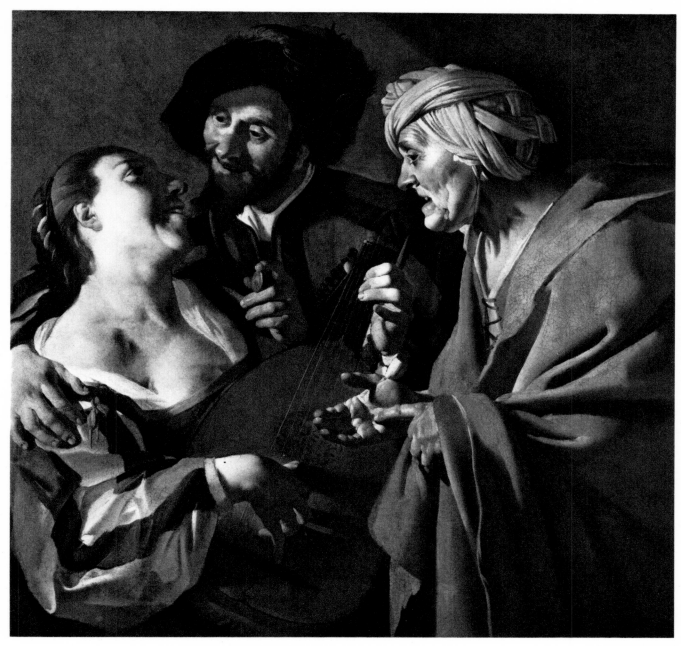

9. Dirck van Baburen. *The Procuress*. 1622. Oil on canvas, 39 3/4 × 42 1/4″
(101 × 107.3 cm). Museum of Fine Arts, Boston

Bolnes.[27] As previously mentioned, the marriage had been objected to by Maria Thins, Catharina's mother, probably in part because of religious differences. Vermeer may have requested Bramer's presence because Bramer was a Catholic, rather than because of a professional relationship. Nevertheless, Bramer was one of the most important artists in Delft at that time and one who could have encouraged Vermeer to begin his career as a painter of Biblical and mythological scenes.

With the death of Willem II, prospects for future commissions from the House of Orange, which in the 1640s must have been prestigious to receive, became rare. History painting, once of such significance to Delft artists, was no longer an appealing genre in which to work. Although Bramer continued to work in that vein, only Vermeer among the younger Delft artists experimented with history painting in the mid-1650s. Finally, with the near demise of the House of Orange, the close bonds between Delft and The Hague weakened and Delft became receptive to trends that were evolving in other artistic centers, particularly Amsterdam. This change of focus is evident in the number of artists who moved back and forth between the two cities and also in the range of stylistic sources apparent in Vermeer's early work.

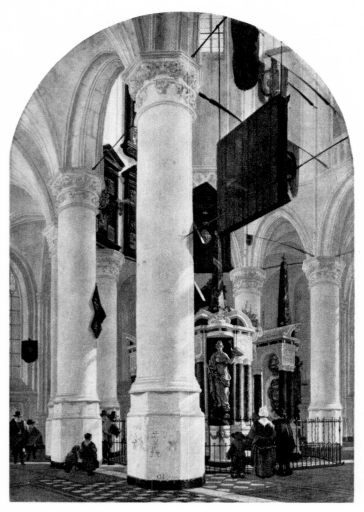

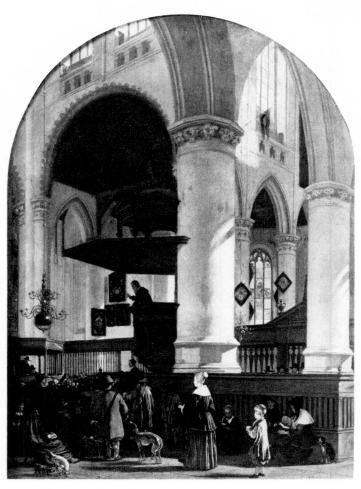

10. Gerard Houckgeest. *The Tomb of Willem the Silent in the Nieuwe Kerk in Delft.* 1651. Oil on wood, 30 1/2 × 25 3/4" (77.5 × 65.4 cm). Mauritshuis, The Hague

11. Emanuel de Witte. *Interior of the Oude Kerk, Delft.* 1651. Oil on wood, 23 7/8 × 17" (60.6 × 43 cm). Reproduced by Permission of the Trustees of the Wallace Collection, London, Crown Copyright

New Artistic Currents in Delft

Delft in the early 1650s must have been an active and exciting place for a young artist like Vermeer. The stylistic conventions that had recently dominated the city were replaced by fresh approaches to the depiction of landscape, cityscape, architectural painting, portraiture, and genre painting. Whereas Delft artists in the first half of the century had effectively removed their subjects from the context of daily life, those working after 1650 actively sought to depict man within, and reacting to, a specific environment. Identifiable buildings, streets, churches, and tombs serve as backdrops, or even points of focus, for their paintings. Locations are recognizable because objects are painted with the utmost care and precision. At the same time, these artists became increasingly aware of the effects of natural light in both interior and exterior scenes.

This sudden change in attitude occurred for a number of reasons. Primary among these was the great number of young artists who moved to Delft in the early 1650s, including Adam Pynacker, Carel Fabritius, Jan Steen, and Pieter de Hooch. Other artists, Pieter Saenredam, Gerard ter Borch, and Jan van der Heyden, visited Delft in those years. Before assessing the impact these and other artists had on Vermeer, however, one must also recognize the profound effect social and political events had on artistic attitudes in Delft. This effect can be seen most readily by examining stylistic developments about 1650 in the work of two established artists in Delft, Gerard Houckgeest (c. 1600–1661) and Emanuel de Witte (c. 1617–1692).[28]

HOUCKGEEST AND DE WITTE

About 1650 Houckgeest and De Witte devised a new range of expressive possibilities for architec-

tural painting that clearly anticipated the stylistic developments of the 1650s and 1660s. Their depictions of church interiors (figs. 10, 11, 28) pulsate with life and vitality. The compositions appear informal: views into churches are often obscured by columns and pilasters. Men, women, and children converse, observe, and play. Rays of sunlight and flashes of bright colors further enliven the scenes.

Houckgeest had been trained as an architectural painter, probably by Bartholomeus van Bassen (c. 1590–1652), an architect and painter who lived in The Hague. Van Bassen painted in a fanciful architectural style, and Houckgeest's early works are patterned in the same traditional mold. A typical example is his view of an imaginary church interior in Copenhagen, painted about 1647–48 (fig. 12). Its somber browns and reds, horizontal format, and ornate church interior bear little resemblance to his compositions of just a few years later. The contrast between these works is so great that it appears unlikely that his style shifted without some external influence.

Emanuel de Witte had a background different from Houckgeest's. He was trained by the still-life painter Evert van Aelst (1602–1657) before he entered the Delft guild in 1642. Until 1650, when he painted *The Holy Family in the Carpenter's Shop*,

now in the Prinsenhof in Delft, he concentrated on mythological scenes and portraits. Most of his few extant early subject paintings are night scenes illuminated by firelight or candles. De Witte's early works show no more relationship to his church interiors after 1650 than do Houckgeest's early architectural paintings to his.

The reasons for the profound shift in style evident in their paintings are not certain, but they may stem from the dramatic social and political developments surrounding the House of Orange in 1650 and 1651. On November 6, 1650, young Prince Willem II, who had succeeded his father in 1647, died of smallpox at the age of twenty-four. Although Prince Willem III was born eight days later, the death of Prince Willem II effectively meant the end of the power of the House of Orange for over twenty years. Shortly after the prince's death, the States-General met and decided that the Union should not have a captain-general and that the position of Stadholder, traditionally occupied by the Prince of Orange, was not necessary for the functioning of the republic. This period of government, called the Stadholder period (1651–72), put more authority in the hands of the upper middle class and shifted the center of power from The Hague to Amsterdam.

12. Gerard Houckgeest. *Interior of a Catholic Church.* c. 1647–48. Oil on wood, 19 1/4 × 25 1/2" (49 × 65 cm). Statens Museum for Kunst, Copenhagen

The death of Willem II had a tremendous emotional impact on the young republic and especially on Delft, a city with particularly strong bonds to the House of Orange. Willem II's grandfather, Willem the Silent, the father of the country, had been assassinated in Delft during the war with Spain. His tomb in the Nieuwe Kerk also was the final resting spot for other members of the royal family, including Prince Maurits (1567–1625) and Prince Frederik Hendrik (1584–1647). The tomb, designed by Hendrick de Keyser (1565–1621), was the most magnificent one in Delft and was famous throughout Europe. In March of 1651 the tomb was once again the focus of national mourning as the elaborate funeral procession of Willem II arrived at the Nieuwe Kerk from The Hague. The large number of pamphlets and broadsheets published at his death reiterate a basic theme: "O Prince Willem the First! In you did our state begin. Prince Willem the Second! Shall our state demise with you? The state, the republic that was so large, so mighty, so formidable in Europe, in all parts of the world...."[29] The opening line of one broadsheet after Willem's death was "O former golden age! Whither have you now fled?"[30]

These attitudes attest to the state of extreme uncertainty affecting those who had valued the dynasty of the House of Orange. The foundations for the type of society it symbolized no longer existed. Houckgeest reacted to Prince Willem II's death by turning away from the conservative traditions of which he had been a part. Almost immediately he began to paint realistic pictures of the Tomb of Willem the Silent, the symbol of the fame and glory of the House of Orange. In a series of paintings from 1650 to 1651 Houckgeest depicted the tomb in the apse of the Nieuwe Kerk and the people who came to look and ponder its significance. He showed the tomb from a diagonal viewpoint surrounded and partially obscured by columns, emphasizing the intimate, personal nature of the onlooker's responses (fig. 10).

The political fortunes of the House of Orange cannot have been the only factor in determining Houckgeest's and De Witte's styles of painting in the early 1650s, but it does seem that contemporary events provided an important impetus toward their reassessment of architectural painting. An established tradition of topographical painting, including depictions of specific buildings, already existed in the Netherlands. Pieter Saenredam (1597–1665), who began as a topographical artist, had pioneered the specific genre of church interior scenes. This tradition generally gained strength around 1650 because of the outburst of civic pride that followed the signing of the Treaty of Münster in 1648, symbolizing the end of hostilities with Spain. Although the greatest manifestation of this pride was the erection of the new town hall in Amsterdam, it is further reflected in the sudden interest in cityscapes and views of important buildings and monuments in the 1650s. The culmination of this tradition is Vermeer's *View of Delft* (colorplate 16), unquestionably the most compelling city view ever painted.

STEEN, DE HOOCH, AND TER BORCH

About the time that Houckgeest and De Witte began to paint realistic church interiors, there came to Delft other artists who reinforced the decisive new directions the architectural painters were taking. In one way or another they were all interested in depicting scenes in a convincingly realistic manner. Their interest in realism had many aspects: it meant close attention to effects of light and atmosphere and to varieties in textures of materials; it meant an interest in the accurate portrayal of the three-dimensional space

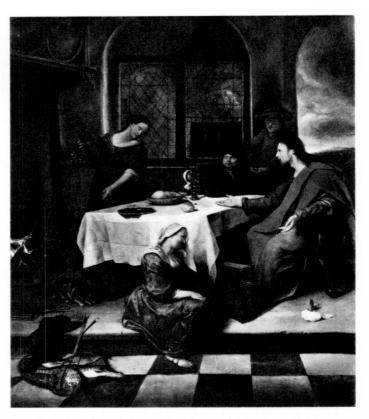

13. Jan Steen. *Christ in the House of Martha and Mary.* c. 1653. Oil on canvas, 41 3/4 × 35 1/8″ (106 × 89 cm). Private collection, The Netherlands

14. Jan Steen. *The Burgher of Delft and His Daughter.*
1655. Oil on canvas, 32 × 27″ (81.5 × 68.5 cm).
Private collection, Great Britain

15. Pieter de Hooch. *Players at Tric-Trac.*
c. 1652–55. Oil on wood, 18 1/8 × 13″ (46 ×
33 cm). National Gallery of Ireland, Dublin

that their paintings defined; and finally it meant
an interest in depicting the psychological reactions
of people to events in their lives. Although the
influence of each of these new artists on Vermeer
is not known, their general concerns coincide with
the directions his art took in the mid-1650s.

These artists came to Delft from many loca-
tions and for many reasons. Pieter Saenredam, for
example, visited Delft in 1651 to observe the
funeral of Willem II and to depict it for the city
of Haarlem. Adam Pynacker (1622–1673), born
near Delft, returned home in 1649 after a number
of years in Italy and quickly developed into one
of the outstanding Italianate landscapists. His
scenes were imbued with a silvery light and with
delicate atmospheric effects. Perhaps more sig-
nificant to Vermeer than these artists was the
arrival of Jan Steen and Pieter de Hooch about
1655.

Steen (c. 1625–1679), who had trained in
Utrecht, Haarlem, and The Hague, worked
largely in Leiden and The Hague until the early
1650s. He painted a number of religious and

mythological subjects in his early years; one,
Christ in the House of Martha and Mary (fig. 13),
is remarkably close in conception to Vermeer's
painting of the same theme (colorplate 1). Steen's
major focus, however, was genre scenes. By 1654
he had already established himself as a genre
painter in the tradition of Adriaen van Ostade,
but one with an unusually rich sense of humor.
About 1655 Steen's father purchased a brewery
in Delft as an investment for his son, and Steen
may well have lived briefly in Delft at that time.
Only one painting of his can be definitely as-
sociated with the city, the so-called *Burgher of
Delft and His Daughter* (fig. 14). Whereas portrait
traditions in Delft had been conservative, Steen
portrayed the burgher in a distinctly informal
manner, talking with an old beggar woman. The
scene is set against a backdrop of the Delft town-
scape, with the tower of the Oude Kerk rising on
the right.

Steen's painting seems to have made an im-
mediate impression on another young artist who
had recently moved to Delft, Pieter de Hooch

16. Pieter de Hooch. *A Dutch Courtyard*. c. 1657. Oil on canvas, 26 3/4 × 23 1/4" (68 × 59 cm). National Gallery of Art, Washington, D.C. Andrew W. Mellon Collection

(1629–after 1684). De Hooch, who was born and probably trained in Rotterdam, had moved to Delft by 1654. Many of his early works were interior low-life genre and guard room scenes (fig. 15). After De Hooch joined the St. Luke's Guild in Delft in 1655 he began to paint a number of intimate courtyard scenes (fig. 16). One of the earliest of these contains a family portrait in which the studied informality of the posed figures, situated at the garden entrance to their home, is reminiscent of the group in Steen's portrait of the burgher.

De Hooch's painting differs from Steen's in that he encloses the space surrounding the sitters by defining it with walls and doorways. Only in selected places does he allow glimpses into other equally defined and measured spaces. Whether in his exterior courtyard views or in his interior genre paintings (fig. 17), De Hooch carefully articulated the specific environment of his scene. In many respects he focused more on the structural foundations of his spatial constructions than on the relationship of figures to that space.

The implications of De Hooch's orientation toward a structural foundation for his paintings can be appreciated by comparing his paintings with those of another important genre painter of the period, Gerard ter Borch (1617–1681). Ter Borch had specialized as a painter of small-scale portraits during the 1640s. In the early 1650s he evolved a new mode of genre painting. In contrast to De Hooch, he placed little emphasis on physical surroundings. He was particularly interested in focusing on single figures (fig. 18) or small groups of figures to convey nuances of their psychological reactions to unexpected events. He was fond of depicting individual reactions to letters or to visitors. One of his favorite devices was to portray a woman from the back and to indicate her emotional state by reflecting her image in a mirror (fig. 19).

Ter Borch, who spent most of his life after 1654 in Deventer, is not generally associated with Delft, whereas De Hooch, during the latter 1650s, established himself as one of the foremost artists in the city. J. M. Montias, however, has recently discovered a document co-signed by Vermeer and Ter Borch in Delft in 1653, shortly after Vermeer's wedding. One wonders whether Vermeer's marriage was the motivation for Ter Borch's visit.[31] In any event, Ter Borch's attitudes toward genre painting seem to have been known to Vermeer. De Hooch, who worked in Delft until the early 1660s, and Vermeer certainly knew each other. The sunlit interiors of De Hooch's genre scenes from the mid-1650s have many obvious parallels with Vermeer's paintings from the same period (see fig. 17 and colorplate 14). In fact, De Hooch was probably the initiator of this particular mode of genre painting. Even the motif of viewing over a soldier's shoulder that Vermeer uses about 1658 in his *Officer and Laughing Girl* (colorplate 10) occurs in De Hooch's paintings in the mid-1650s (fig. 15).

Despite the close associations of style between Vermeer and De Hooch, their temperaments were quite different. Whereas De Hooch was interested in characteristic scenes from daily life—figures sitting around a table, a woman doing household chores or caring for children—Vermeer focused on the psychological moods of his figures. Like Ter Borch, Vermeer often chose themes that isolated figures during moments of reflection and contemplation. Vermeer also similarly used the device of reflected images to give an even greater sense of intimacy to his scenes (colorplate 7).

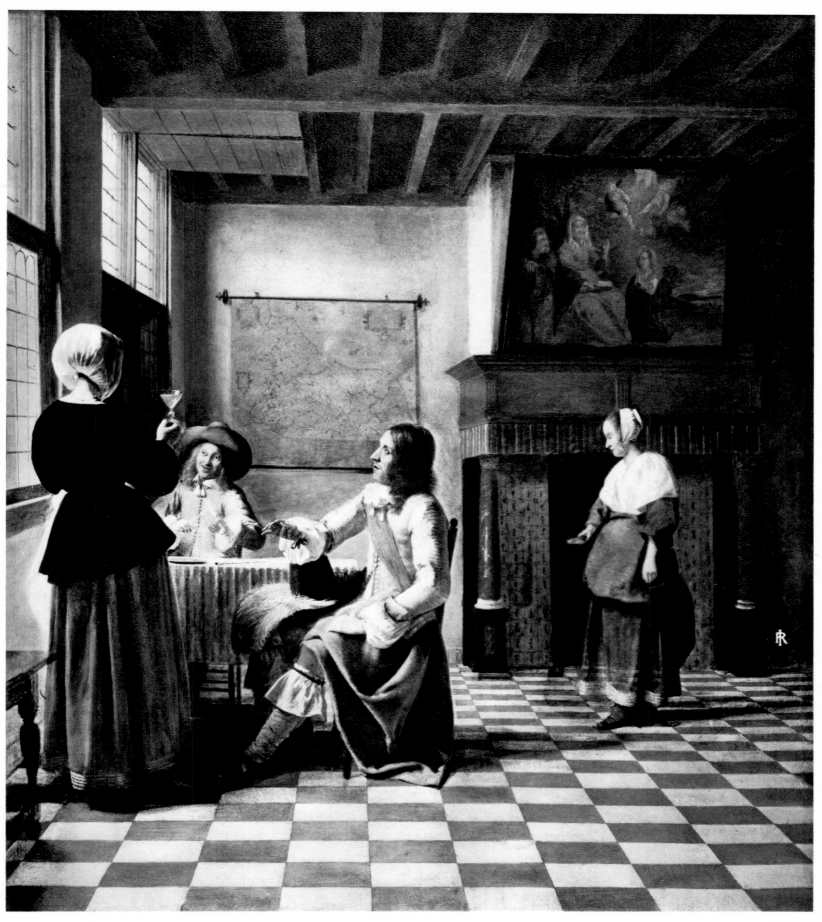

17. Pieter de Hooch. *An Interior Scene.* 1658. Oil on canvas, 29 × 25 3/8″ (73.7 × 64.6 cm).
National Gallery, London

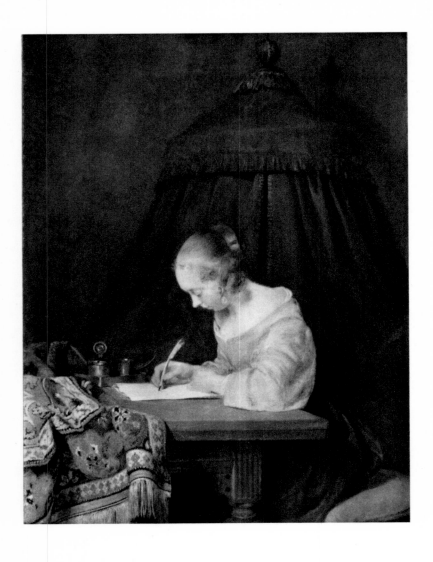

18. *Left*: Gerard ter Borch. *Woman Writing a Letter*. c. 1655. Oil on wood, 15 3/8 × 11 5/8" (39 × 29.5 cm). Mauritshuis, The Hague

19. *Below*: Gerard ter Borch. *Woman at a Mirror*. c. 1652. Oil on wood, 13 5/8 × 10 1/4" (34.5 × 26 cm). Rijksmuseum, Amsterdam

20. *Opposite, left*: Gerard Dou. *A Lady Playing a Clavichord*. c. 1665. Oil on panel, 14 7/8 × 11 3/4" (37.7 × 29.8 cm). The Dulwich Picture Gallery, London

21. *Opposite, right*: Frans van Mieris the Elder. *Young Lady Before a Mirror*. c. 1662–65. Oil on wood, 11 3/4 × 9 1/8" (30 × 23 cm). Staatliche Museen Preussischer Kulturbesitz, Gemälde-galerie, Berlin-Dahlem

Ultimately, Vermeer's uniqueness as an artist lies not in the type of scenes he depicted but in the way he conceived them; many of his subjects belonged to well-established iconographic traditions. We do not know the degree to which he was aware of developments in other artistic centers, such as Amsterdam and Leiden, but remarkable coincidences of theme and composition do exist. Aside from Ter Borch, Gabriel Metsu (1629–1667) portrayed letter writers in ways comparable to Vermeer (see fig. 51). Gerard Dou (1613–1675), the Leiden *fijnschilder* who painted his scenes with incredible detail, was another artist who depicted similar subjects. Dou's *A Lady Playing a Clavichord*, about 1665 (fig. 20), for example, anticipates Vermeer's late *A Lady Seated at the Virginals* (colorplate 46). Dou also introduced a curtain as a pictorial device in a manner comparable to that in a number of Vermeer's paintings. Dou's student, Frans van Mieris the Elder (1635–1681), also painted subjects that parallel those of Vermeer. His *Young Lady Before a Mirror*, about 1662–65 (fig. 21), reminds one of Vermeer's

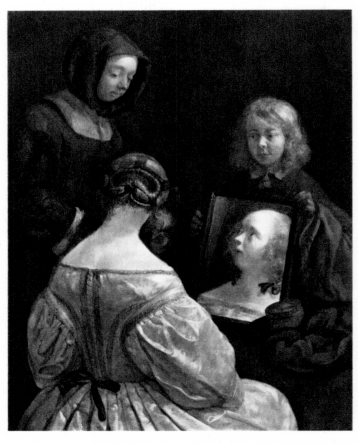

Woman with a Pearl Necklace (colorplate 24), even though Van Mieris's refined technique and dark background create a very different effect.

CAREL FABRITIUS

Of all the artists associated with Delft in the early 1650s the one who most clearly anticipates Vermeer's dual interest in the figure and in its physical environment is Carel Fabritius (1622–1654). Vermeer valued Fabritius's work and owned three of his paintings. A poem by Arnold Bon in Dirck van Bleyswijck's book on Delft published in 1667 (but probably written some years earlier) associates the two masters.[32] Bon identifies Vermeer as the successor to Fabritius's approach to painting, a reference that some have interpreted to mean that Vermeer studied with Fabritius. Aside from this reference, one can argue that Fabritius and Vermeer had many common approaches to their subject matter as well as a shared interest in the effects of perspective and optics.

Fabritius, who probably moved to Delft in 1650, had been one of Rembrandt's most gifted pupils in the mid-1640s. After his period with Rembrandt, he lived in Midden-Beemster, a small town north of Amsterdam, where he had

been born and raised. Although Fabritius initially painted in a Rembrandtesque style, by 1650 he had developed a distinctive artistic personality. One of his many talents was mural painting. Contemporary writers, including Bleyswijck and Samuel van Hoogstraten, praised the extraordinarily illusionistic effects he achieved. Fabritius's abilities as a mural painter may explain his decision to move to Delft to work for Prince Willem II. Although no visual evidence exists to demonstrate that Fabritius did work for the prince, a statement by Fabritius's widow after his tragic death in the explosion of the Delft powder magazine in 1654 described him as "painter of H. H. the Prince of Orange."[33]

Unfortunately, none of Fabritius's mural paintings have survived. His few small, cabinet-size paintings from the 1650s, however, demonstrate his exceptionally imaginative and versatile artistic personality. *The Sentry* (1654; fig. 22) and *View in Delft, with a Musical Instrument Seller's Stall* (1652; fig. 23) are unlike any other Dutch paintings of the seventeenth century. The peculiar perspective of the *View in Delft* and the unusual architectural structure in *The Sentry* create strangely irrational effects. Placed within these settings are equally unconventional figures: a brood-

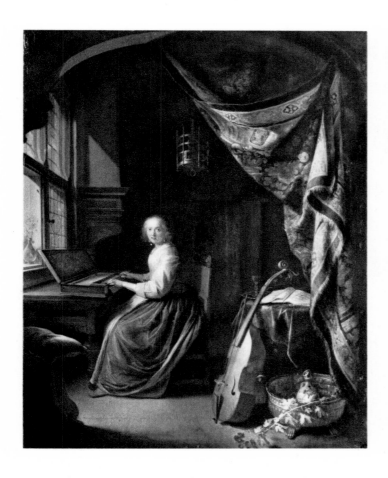

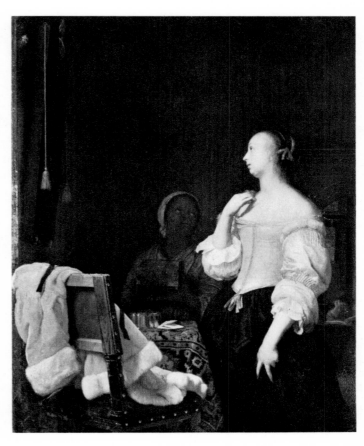

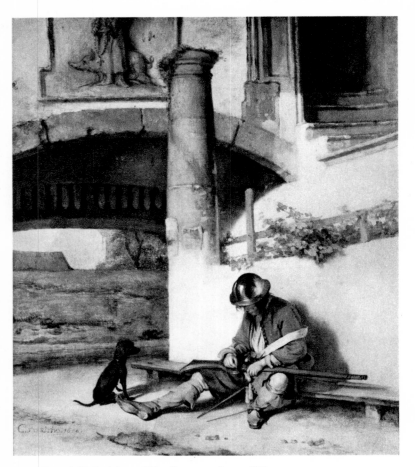

22. Carel Fabritius. *The Sentry*. 1654. Oil on canvas, 26 3/4 × 22 7/8" (68 × 58 cm). Staatliches Museum, Schwerin

ing, melancholic man who sits near two musical instruments, and a sentry who apparently dozes, gun in lap, near an open gate. While the color and light in these paintings are extremely naturalistic, the most distinctive characteristics of these works are the complex moods Fabritius has evoked.

Fabritius must have intended his works to have a meaning beyond the purely realistic. Indeed, in *The Sentry* he gave a distinct clue that he wished his painting to be read as a moral statement. The bas-relief over the archway depicts Saint Anthony and his attribute, a hog, symbol of the demon of sensuality and gluttony that the saint had overcome. Clearly, Saint Anthony's vigilance against sin was more successful than that of the sentry, and his presence in the painting serves to remind the viewer of the sentry's failure to uphold his responsibilities. Only the dog stays alert, and the sentry, like the column behind him which supports nothing, is useless and without purpose.

If the mood of *The Sentry* is enhanced by closely intertwined symbolic elements, the mood of the *View in Delft* is achieved by different means. In this instance Fabritius isolated two unattended musical instruments and a foreground figure from the distant vista of the Nieuwe Kerk and sur-

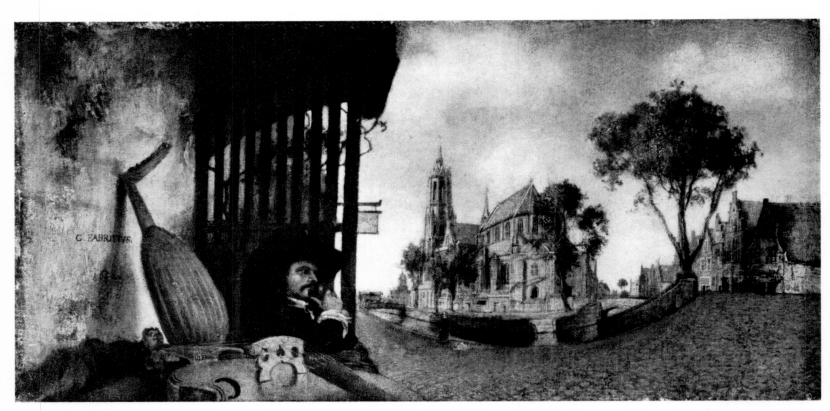

23. Carel Fabritius. *View in Delft, with a Musical Instrument Seller's Stall.* 1652.
Oil on canvas mounted on wood, 6 1/8 × 12 3/8" (15.5 × 31.6 cm). National Gallery, London

rounding houses. The separation between the two is so great that the cityscape has a dreamlike quality, as though it were an extension of the man's brooding thoughts. Although Fabritius's specific intention is not known, the juxtaposition of these elements is provocative. One senses that Fabritius was contemplating questions of time, transitory versus eternal, or questions of value, sensual versus spiritual. In any event, as in *The Sentry*, he used the architectural setting as an integral component of his composition. The figure does not merely exist within the setting; the setting reinforces and fulfills the moods evident within him. This close interaction of figure and environment is perhaps Fabritius's greatest contribution to Dutch art, and the one that Vermeer, as did no other painter, drew upon and refined in his distinctly personal idiom.

During his Delft period, Fabritius introduced certain naturalistic effects of light and shadow that anticipate Vermeer's later work. His earlier, Rembrandtesque style, however, featured bold brushwork and strong chiaroscuro contrasts. Fabritius may well have encouraged the young Vermeer to study Rembrandt's painting style, for in a number of his early works, Vermeer painted in deep reds and browns and utilized chiaroscuro effects in a manner reminiscent of Rembrandt. The clearest evidence that Vermeer studied Rembrandt's paintings and etchings is found in *The Procuress* (colorplate 4), where the figure on the left, who may be a self-portrait, is thrown into shadow. Nuances of both his dress and pose are found, in reverse, in Rembrandt's *Self-Portrait with Saskia* (fig. 24) in Dresden, a painting that was originally intended to portray the Prodigal Son. The subject has many parallels to *The Procuress*, and, indeed, one wonders whether the theme of the Prodigal Son also underlies Vermeer's painting. Another Rembrandtesque feature of this painting is the old woman who oversees the financial transaction. She is a figure type seen occasionally in paintings by pupils of Rembrandt, including *The Beheading of John the Baptist* (fig. 25), traditionally attributed to Fabritius and certainly painted by a pupil of Rembrandt.[34]

The Procuress, in its subject, use of half-length figures, and compositional arrangement, also shares characteristics with paintings from the Utrecht School, and therein lies one of the great difficulties of assessing Vermeer's early works. His style varied enormously from painting to painting as he assimilated one influence after another. If

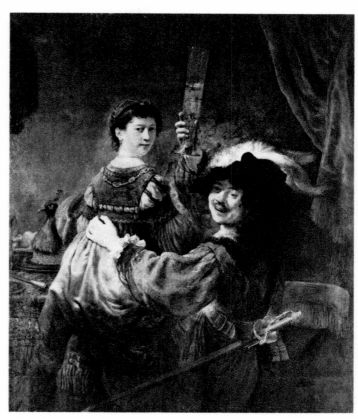

24. Rembrandt van Rijn. *Self-portrait with Saskia* (*The Prodigal Son in the Tavern*). c. 1636. Oil on canvas, 63 3/8 × 51 5/8″ (161 × 131 cm). Staatliche Kunstsammlungen, Gemäldegalerie, Dresden

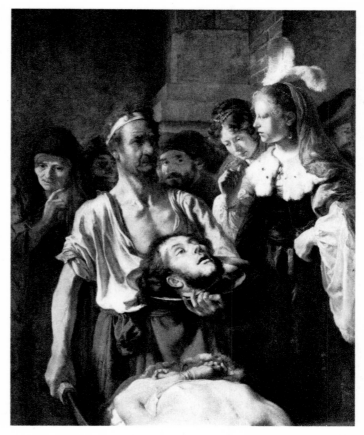

25. Carel Fabritius (?). *The Beheading of John the Baptist*. n.d. Oil on canvas, 58 5/8 × 47 5/8″ (149 × 121 cm). Rijksmuseum, Amsterdam

26. Samuel van Hoogstraten. Interior of a Perspective Box (detail). c. 1658–60. Oil on wood, 23 × 32 × 23″ (58.4 × 81.3 × 58.4 cm). National Gallery, London

more early paintings had survived, the pattern of his development might be clearer, but at present the varieties of subject, style, and technique are often difficult to reconcile.

Realism

Realism is an all-pervading concept in Dutch art, one that lies at the heart of seventeenth-century artistic practice and theory. The term realism, however, has many aspects that make it more complicated to define than is immediately apparent. Of course, Dutch artists delighted in recording aspects of their physical world. Vermeer's accurate depictions of maps, musical instruments, and paintings within paintings, and his interest in recording differences in textures of materials and the effects of sunlight and shadow, can only be understood in these terms. Nevertheless, the realism of Dutch art was not always limited to the precise depiction of objects and effects of light. Fabritius's *The Sentry* (fig. 22) and *View in Delft*

(fig. 23), for example, look realistic; yet the meaning inherent in the symbolism of *The Sentry* and the mood evoked by the perspective of the *View in Delft* suggest that this realism involves problems of human psychology as well. The way in which the viewer responds to a painting or interprets its meanings thus becomes relevant.

In this respect, one must also consider those times when the viewer is deceived into thinking that a painted image is, in fact, a real object. Samuel van Hoogstraten, one of the few Dutch artists who wrote about his expectations for painting, defined the art of painting as "a science that represents all ideas or notions that the entire visible world can give, and deceives the eye with outlines and colors."[35] He felt that a completed painting is like a mirror of nature where things that do not appear seem to appear and in which the viewer is deceived in an allowably entertaining and praiseworthy manner. Indeed, Hoogstraten was a master of that unique Dutch art form, the perspective box, where this mode of artistic representation could be

27. Samuel van Hoogstraten. Interior of a Perspective Box (detail). c. 1658–60. Oil on wood, 23 × 32 × 23″ (58.4 × 81.3 × 58.4 cm). National Gallery, London

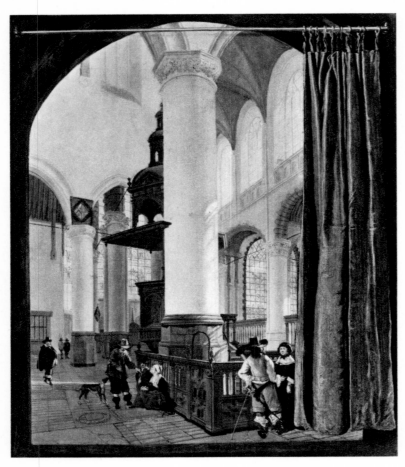

28. Gerard Houckgeest. *Interior of the Oude Kerk in Delft.* 1651(?). Oil on panel, 19 1/4 × 16 1/8″ (49 × 41 cm). Rijksmuseum, Amsterdam

fully achieved. Looking through a peephole in one of these boxes reveals a world so real in appearance that the interior limits of the box are totally negated by the illusion (figs. 26, 27).

In most Dutch paintings, however, this degree of illusionism could not be attained. Since Dutch paintings were primarily cabinet size, no restrictions could be placed on the viewer's vantage point. Perspective was an important basis for realism, but only in exceptional circumstances could it, by itself, create *trompe l'oeil* effects.

Although we must be cautious about accepting too literally Hoogstraten's dictum that painters are supposed to deceive the eye with outlines and colors, the principle of attempting to simulate reality in painting certainly existed. One type of *trompe l'oeil* device that Dutch artists did include in their paintings was a curtain that appeared to hang on a rod stretching across the painting. Both De Witte and Houckgeest (fig. 28), among the Delft artists, painted curtains and curtain rods that cast shadows over their church interiors. This type of *trompe l'oeil* was effective because it simulated the

types of curtains that often hung over paintings in Dutch households (see fig. 50). The success of its illusion, moreover, was not dependent on perspective, and hence not on the vantage point of the viewer.

Vermeer often painted curtains in the foreground of his paintings. Generally they are drawn back in one corner of the painting and clearly belong to the room in which the scene takes place. They establish a frontal plane for the scene and help limit the openness of the space, which might otherwise lessen the focus on the figures. In one painting, the *Girl Reading a Letter at an Open Window* (colorplate 7), the curtain comes very close to the *trompe l'oeil* tradition. It does not belong to the room because it reaches only to the top of the table, not to the floor. Light hits the front of the curtain even though the window is behind it and the front edge of the table is in deep shadow. Yet Vermeer did not include a "frame" or "shadows" cast from the curtain and curtain rod onto the painting. Ver-

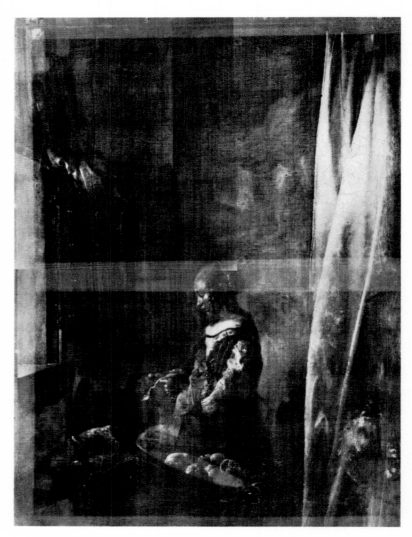

29. X-ray photograph of Vermeer's *Girl Reading a Letter at an Open Window*. Staatliche Kunstsammlungen, Gemäldegalerie, Dresden

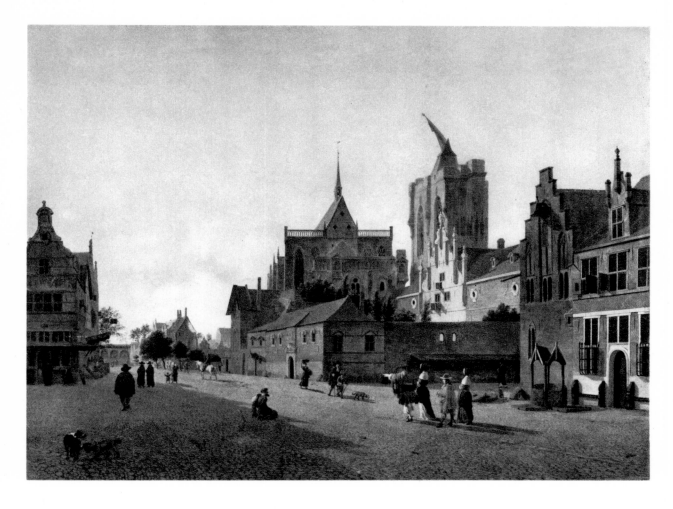

30. Jan van der Heyden. *A Street in Cologne*. 1660–65. Oil on wood, 11 × 17″ (27.9 × 43.2 cm). National Gallery, London

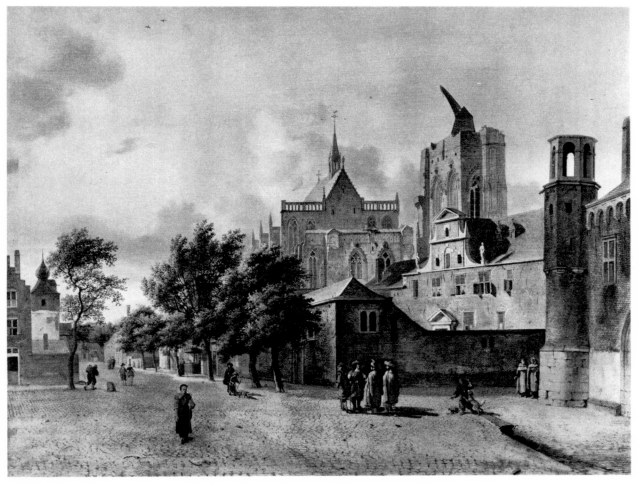

31. Jan van der Heyden. *A Street Scene in Cologne*. 1665–70. Oil on wood, 12 3/8 × 15 7/8″ (31.4 × 40.3 cm). Reproduced by Permission of the Trustees of the Wallace Collection, London, Crown Copyright

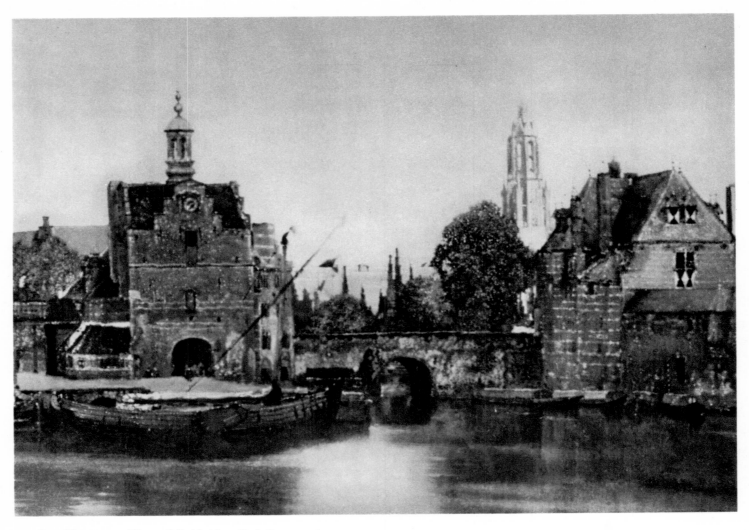

32. Jan Vermeer. *View of Delft* (detail, left center).
Mauritshuis, The Hague

meer, who was so sensitive to effects of light and
shade, probably would not have neglected these
shadows if he intended his curtain to be primarily
a *trompe l'oeil* device.

The best explanation for the curtain is that
Vermeer intended it to provide the private, inti-
mate feelings that are so evident in this painting.[36]
X-radiographs reinforce this conclusion since they
demonstrate that the curtain was not part of
Vermeer's original conception (fig. 29). At an
earlier stage he depicted a large glass, called a
roemer, in the lower right. The composition at this
stage was thus extremely different from what it is
now, and the contrast in scale between the still-life
elements and the girl would have been too dra-
matic.

Hoogstraten's concept of realism differs from
the one often associated with seventeenth-century
Dutch artists. Eugène Fromentin, a nineteenth-
century admirer of Dutch realism, wrote that
Dutch art "attempts to imitate what is, to make

what is imitated charming, to clearly express
simple, lively and true sensations. . . . It has for
law, sincerity, for obligation, truth."[37] Such an
interpretation is misleading and not at all what
Hoogstraten intended by his remarks. Fromentin
would have been very surprised, for example, to
find that two paintings of the same town square in
Cologne by Jan van der Heyden (figs. 30, 31),
both of which appear to be realistic and topograph-
ically accurate, differ extensively in the buildings
depicted.

Even Vermeer, whom many have charac-
terized as a realist in the strictest sense of the word,
continually made modifications in the shapes and
sizes of objects in his paintings to accord with his
pictorial demands. One of the most interesting
examples of the kinds of adjustments he made is the
View of Delft (colorplate 16, fig. 32). Vermeer has
approached Delft from the south across the river
Schie, where ships and barges that carried cargo
and passengers to and from Rotterdam and

32

Schiedam were anchored. On either side of a small bridge stand city gates, on the left the Schiedam Gate and on the right the Rotterdam Gate. Beyond the bridge the tower of the Nieuwe Kerk rises in the sunlight. One receives the impression that Vermeer painted the scene on the spot with total topographical accuracy.

In examining the painting in conjunction with old maps, prints, and drawings (fig. 33), however, several discrepancies occur which raise questions about the exactitude of Vermeer's scene. (His painting portrays the city as seen from the lower right in fig. 1, Blaeu's map of 1649.) Vermeer seems to have subtly adjusted the position and size of buildings to create a friezelike effect. One notices in Rademaker's drawing, for example, that the buildings are more vertical, varied in their contours, and closer together than in Vermeer's work.

These modifications are unexpected because the realistic impression the painting gives leads one to expect topographical accuracy. Evidence also suggests that in his interior scenes Vermeer frequently made similar modifications of scale, proportion, and placement of objects for compositional reasons. For example, he occasionally included a map or picture on a wall which reappears in a different scale in another of his works.

A wall map that occurs in his *Officer and Laughing Girl* (colorplate 10) appears in a different scale and with different colors in the *Woman in Blue Reading a Letter* (colorplate 21). Baburen's *The Procuress* (fig. 9), which is in the background of *The Concert* (colorplate 29), is depicted in a larger scale in *A Lady Seated at the Virginals* (colorplate 46). A more dramatic shift of scale occurs in representations of *The Finding of Moses*, a painting that appears in both *The Astronomer* (colorplate 37) and in *Lady Writing a Letter with Her Maid* (colorplate 42).

Another aspect of Dutch realism that will be subsequently discussed is the relationship of these "pictures within pictures" to Vermeer's themes. As Fabritius did in *The Sentry*, Vermeer often amplified the meaning of a scene by the use of such devices. One must also ask whether other objects depicted in his works have similarly subtle associations that might affect the meaning of the paintings.

PERSPECTIVE AND OPTICS

Dutch realism is something more than strict imitation. Hoogstraten does not recommend that paintings copy nature but that they give the appearance of having copied nature. Painting, he

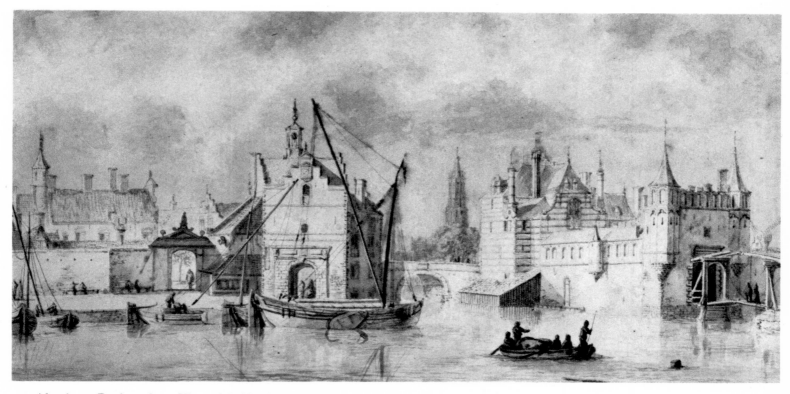

33. Abraham Rademaker. *View of Delft with Schiedam and Rotterdam Gates.* n.d. Drawing, pen, brown ink, and wash, 8 7/8 × 17 3/4″ (22.5 × 45 cm). Stedlijk Museum, "Het Prinsenhof," Delft

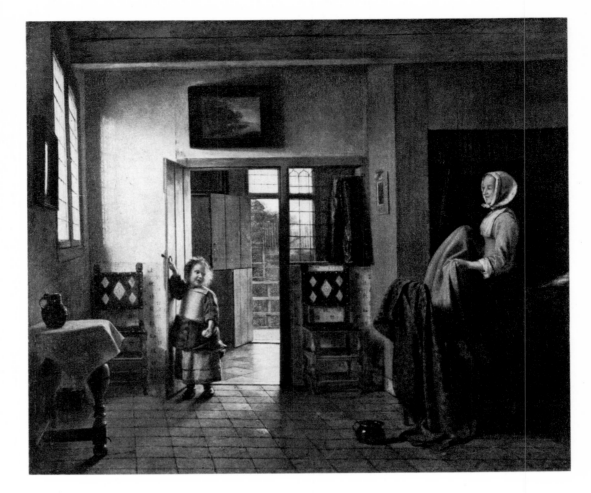

34. Pieter de Hooch. *The Bedroom*. c. 1660. Oil on canvas, 20 × 23 1/2″ (50.8 × 59.7 cm). National Gallery of Art, Washington, D.C. Widener Collection, 1942

35. Pieter de Hooch. *Maternal Duty*. c. 1660. Oil on canvas, 20 5/8 × 24″ (52.5 × 61 cm). Rijksmuseum, Amsterdam

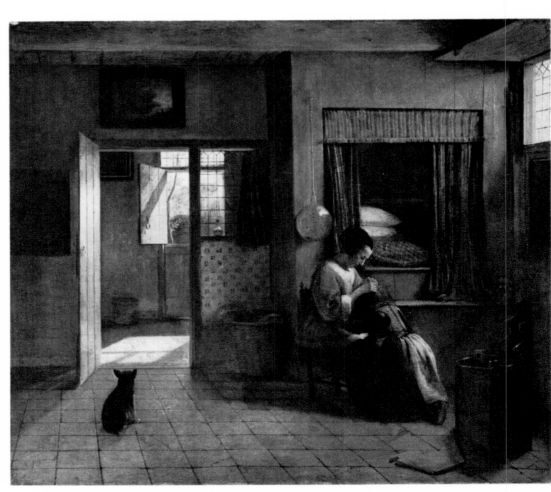

felt, was a science and was based on a theoretical level beyond that of pure imitation. This aspect of Dutch realism may be seen in a comparison of two interiors by Pieter de Hooch, *The Bedroom* (fig. 34) and *Maternal Duty* (fig. 35). Although both these scenes take place within the same interior setting, De Hooch varied the effects of light and the placement of furniture to create different moods that reinforce the respective subject matters. One does not doubt that these scenes were painted from life, but, as Van der Heyden has done in his paintings of Cologne, De Hooch has freely altered architectural components of the rooms, particularly the marble floor in the antechamber, to further reinforce the focus of his compositions.

Despite the apparently intuitive nature of these modifications, De Hooch based his representations of this interior upon a firm scientific foundation: the laws of linear perspective. He effectively integrated a single vanishing point perspective system within his naturalistic scene and, in doing so, he followed the example of the most influential early seventeenth-century perspective theorist, Jan Vredeman de Vries. In his treatise of 1604–5, Vredeman de Vries had demonstrated the many ways in which abstract concepts of linear perspective could be applied to problems of pictorial representation. For example, he had shown that the orthogonals of floor tiles, ceiling beams, open doors, and windows should recede to a single horizon (fig. 36). Vredeman de Vries insisted that the horizon line should be suitable for a person whose eye level was 5 1/2 feet high. He also demonstrated how every figure in the painting should be placed along this horizon.

De Hooch was dealing with the problem of depicting an actual scene and not an abstract design. Consequently, he was less consistent than Vredeman de Vries and varied the level of his horizon in these two paintings: raising it for the painting with standing figures and lowering it for that with seated ones. De Hooch felt free, therefore, to deviate from strict perspective rules to enhance the compositional effects of his painting.

The imaginative way in which Dutch artists adapted Vredeman de Vries's perspective conventions for their apparently realistic architectural interiors has often caused their dependency on his influence to be overlooked. Even Houckgeest's dramatically expressive depictions of the Tomb of Willem I in the Nieuwe Kerk in Delft (fig. 10) are based on a perspective design found in Vredeman de Vries (fig. 37). The contrasts in scale

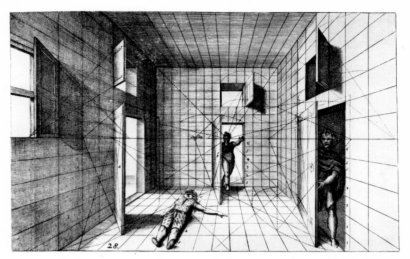

36. Jan Vredeman de Vries. Perspective Diagram. Engraving from *Perspective*, Leiden, 1604–5, plate 28

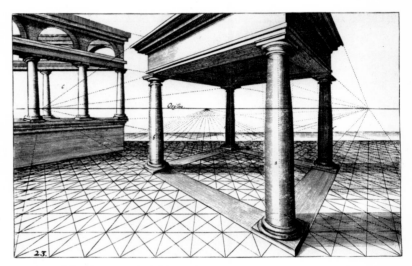

37. Jan Vredeman de Vries. Perspective Diagram. Engraving from *Perspective*, Leiden, 1604–5, plate 23

between near and far objects that give Houckgeest's paintings much of their intensity are totally consistent with perspective rules. Houckgeest merely emphasized this contrast, which occurs because of the monocular character of single point perspective theory, rather than minimizing it as most artists had previously done.

Vermeer, likewise, adapted perspective conventions for his interior genre scenes. In his paintings with sunlit interiors and regular tile patterns (colorplates 14 and 15, for instance), one senses that every object has a precise location that can be measured and defined. Nevertheless, Vermeer did not utilize perspective as a neutral framework for his compositions. He recognized that horizon heights and vanishing points had expressive possibilities. In the *Officer and Laughing Girl* (colorplate

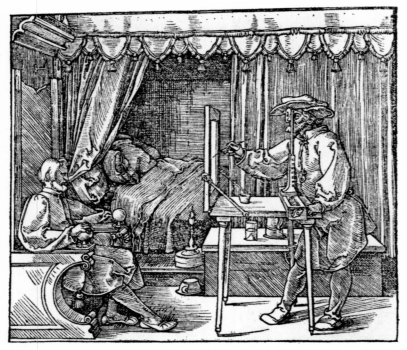

38. Albrecht Dürer. Perspective Device. Woodcut from *Underweysung der Messung ...*, Nuremberg, 1525

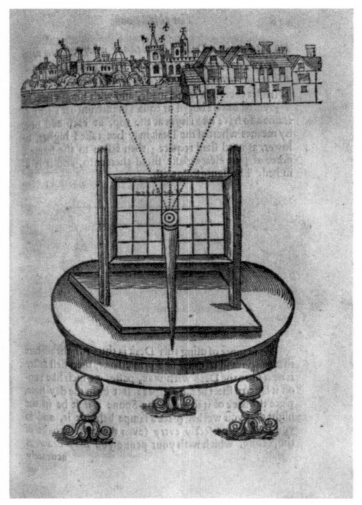

39. John Bate. Perspective Device. Woodcut from *The Mysteries of Nature and Art*, London, 1635

10), for example, the vanishing point of the perspective falls midway between the gazes of the two figures, activating and intensifying that crucial area of the painting.

Vermeer also realized that single point perspective created an apparent distortion in scale between near objects and distant objects that could be used for expressive purposes. In *The Concert* (colorplate 29), for instance, the disproportionately large scale of the table in the foreground enhances the feeling of intimacy one senses within the group of three figures in the background.

Perspective theory was only one source that artists relied upon in their attempts to give their paintings the appearance of reality. Indeed, Vermeer generally did not depend exclusively on precise perspective constructions, possibly because they gave his scenes a frozen quality. As in *The Geographer* (colorplate 38), much of this sense of space was created intuitively by juxtaposing near and far objects. The geometrical optics of Vredeman de Vries, moreover, did not address the problem of the effects of light and atmosphere, so essential to the depiction of a naturalistic scene.

A variety of artistic aids were available to Dutch artists to minimize the need for perspective construction. One of the most commonly employed perspective aids was the glass frame, which had been strongly recommended by Albrecht Dürer in his 1525 treatise, *Underweysung der Messung mit dem Zirckel und Richtscheyt* (fig. 38). Dürer's advice was seconded by a number of perspective theorists, including Hendrick Hondius, a popular Dutch theorist of the early seventeenth century. Hondius wrote that the glass frame "est pratiqué par les plus excellents maîtres ordinairement."[38]

A modification of this device appeared in the early seventeenth century in a book by the English author John Bate.[39] Bate placed before the squared frame a small glass, presumably a concave lens (fig. 39). This device, he explained, helped one depict a wide compass—as, for example, a profile view of a city—in a small space. Although it is difficult to determine which artists used such devices, glass frames and lenses would have been useful to artists portraying topographical scenes. Lenses leave no physical traces on the painting, and only when certain distortions are evident, or optical effects are present that are not seen with the naked eye, can one deduce that an optical device has been used as an artistic aid.

Sufficient distortions are evident in Fabritius's little *View in Delft* (fig. 23) to suggest that he

experimented with a wide-angle lens. In this painting the Nieuwe Kerk appears small and remote, whereas in reality it is very large and quite near to the picture plane (fig. 40). This effect and the peculiarly distorted foreground space are characteristic of scenes viewed through a wide-angle lens (fig. 41). Although some have argued that Fabritius would have devised means to correct these distortions, as for example, by curving his image and placing it in a perspective box, these distortions cannot be corrected.[40] In this instance Fabritius must have used a lens not to ensure an accurate depiction of the site but to exploit its peculiarly distorting effects for their emotional impact.

Lenses, mirrors, and glass frames operate on the principle of monocular vision. They thus reinforce the tendency found in perspective theory to exaggerate the contrast of near and far objects. The optical distortions created by wide-angle lenses and convex mirrors further exaggerate this effect. Vermeer, who emphasized such contrasts of scale in his painting, may have noted their occurrence in optical devices. The peculiar spatial effects of *A Girl Asleep* (colorplate 6), particularly the small scale of the girl in comparison to the foreground chair and the slanted angle of the table top, are comparable to those seen in a lens or convex mirror. Vermeer, under the inspiration of Fabritius, may have sought to exploit optical distortions to emphasize the remote, melancholic mood of the sitter.

In most of Vermeer's paintings, however, perspective distortions associated with lenses and mirrors are difficult to isolate from those that could be derived from an imaginative use of perspective theory. One possible clue to the use of a lens or mirror is the heightened sense of light and color that they create. Since these devices reduce the scale of objects but not the intensity of their colors, contrasts of light and dark are enhanced and colors become more vivid than in ordinary vision. In this respect, the luminosity of the *Officer and Laughing Girl* (colorplate 10) is as much an argument for a wide-angle lens or mirror as are the exaggerated contrasts in scale between the figures.

THE CAMERA OBSCURA

Artists in Delft exploited perspective conventions and optical devices, including wide-angle lenses, for their expressive characteristics. The lens, how-

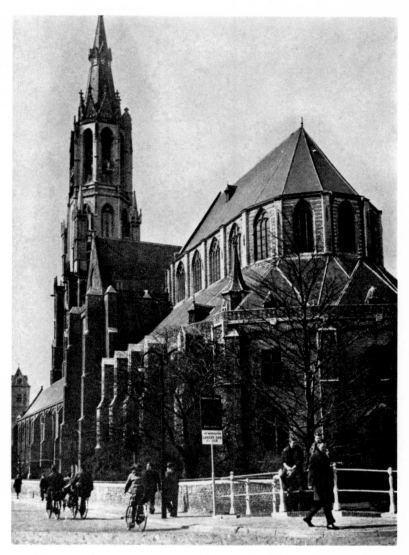

40. Nieuwe Kerk, Delft. From E. Elias, *Delft*, 1964, plate 61

41. Nieuwe Kerk, Delft, photographed through a double concave lens in a tilted position. Photo by Jac. T. Stolp

37

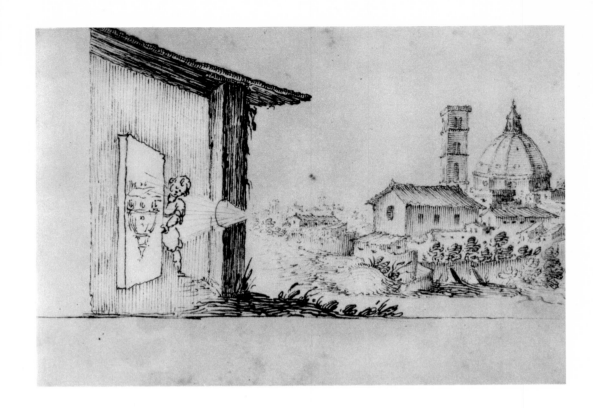

42. Stefano della Bella (?). *Camera Obscura*. From a 17th-century manuscript of military fortifications. Drawing, pen and brown ink, 4 3/4 × 6 1/4" (12 × 16 cm). Rosenwald Collection, Library of Congress, Washington, D.C.

ever, was not the only optical aid available in the seventeenth century: another was the camera obscura, a device that is frequently associated with Vermeer.[41] Like the mirror and lens, the camera obscura was fascinating to seventeenth-century Dutch artists because it opened up a new range of expressive possibilities. It also suggested relationships of perspective and color that could be utilized for pictorial effects.

The camera obscura works on the optical principle that focused rays of light, whether direct or reflected, will project an image of the source from which they derive. Many camera obscuras were literally darkened rooms into which only a point of light was admitted (fig. 42). The image would then be focused, perhaps with the aid of a convex lens, on a wall or screen placed opposite the light source. By the mid-seventeenth century, portable camera obscuras were equipped with lenses and focusing tubes which permitted the formation of sharp images from various distances (fig. 43). Nevertheless, in unfocused areas, particularly where bright lights were reflected off hard or metallic surfaces, highlights became diffused spots of light.

As with the lens, mirror, or glass frame, contemporary theorists also recommended that artists use the camera obscura for depicting landscapes. One seventeenth-century author, J. Leurechon, praised the camera obscura's lifelike image in the following terms.

Above all there is the pleasure of seeing the movement of birds, men, or other animals and the quivering of plants waving in the wind; for although all that is reversed, nevertheless, this beautiful painting, beyond being foreshortened in perspective, represents ingeniously well that which no painter has ever been able to represent in his painting, to realize movement continued from place to place.[42]

Although historical sources indicate contemporary interest in the camera obscura, they do not specifically document Vermeer's use of this device. Because a camera obscura leaves no physical traces on the painting, one must rely on an interpretation of the image to determine whether it exhibits characteristics that could only have derived from the use of a camera obscura. The difficulty then is to perceive the extent that the camera obscura played a role in determining Vermeer's particular vision and his stylistic evolution.

A number of optical effects visible in the camera obscura seem to have attracted Vermeer, particularly its accentuated perspective, heightened colors, contrasts of light and dark, and halation of highlights. The diffused highlights Vermeer painted on the boat in the distant right of the *View of Delft* are so similar to the halation of highlights seen in a camera obscura that it

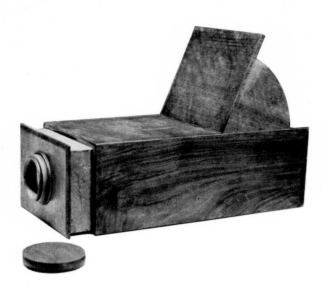

43. Portable camera obscura. 18th century, but similar in style to those made in the 17th century. Rijksmuseum voor de Geschiedenis der Natuurwetenschappen, Leiden

seems probable that he conceived this scene with its aid. Similar highlights in other paintings, specifically in *The Girl with a Red Hat* (colorplate 34) and *The Lacemaker* (colorplate 41), suggest that he used this device for interior scenes as well as for landscapes. Vermeer, however, used these phenomena creatively and not totally in accordance with their actual appearance in a camera obscura. While the halation of highlights on the lion head finial in *The Girl with a Red Hat* might be seen in a camera obscura, such is not the case with the diffuse yellow highlights on the girl's blue robe; in a camera obscura, reflections off unfocused cloth create blurred images. Similarly, in the *View of Delft*, Vermeer painted diffused highlights on the side of the boat on the right where they would not have occurred because the boat is in the shadows. In this instance he probably depicted them to suggest the flickering reflections of the water on the side of the boat.

One misconception concerning Vermeer's painting style which has affected theories about his use of the camera obscura is that he was a realist in the strictest sense, that his paintings faithfully record the models, rooms, and furnishings he saw before him.[43] As evident in his mature works, Vermeer's compositions are the product of intense control and refinement. Figures and their environment are subtly interlocked through perspective, proportion, and color. This same mentality must have dictated his artistic procedure,

whether he viewed his scene directly or through an optical device like a camera obscura. Even in the small *The Girl with a Red Hat*, which is perhaps the closest any of his images come to revealing the effects of a camera obscura, he shifted and adjusted his forms, particularly the position of the chair finials, to maintain compositional balance.[44] Thus even though he must have referred to an image from a camera obscura when painting *The Girl with a Red Hat* and must have sought to exploit some of its optical effects, he probably did not trace its image directly on the panel. The likelihood that he traced his more complex compositions is even more remote.

Vermeer's response to the camera obscura paralleled his underlying sensitivity to the optical effects of light and colors, and his use of the device must be placed in the broader context of his achievement as an artist. It was but one means through which he explored the world about him as he sought to record his distinctive impressions. The camera obscura apparently had no significant impact on his work until the late 1650s, about the time he painted *The Milkmaid* (colorplate 12). In both this painting and the *View of Delft* from the early 1660s, Vermeer devised techniques which would allow him to suggest the types of diffused highlights evident in a camera obscura. *The Girl with a Red Hat*, which shows similar effects but is painted in a more fluid and abstract technique, dates from the late 1660s.

Most of the optical effects seen in a camera obscura were modifications of painting techniques characteristic of the period in which Vermeer lived. For example, he highlighted points of reflected light as early as 1656 (in the glass held by the young woman in *The Procuress*) and consistently did so in other paintings of that period. The same technique also was used by other artists of the 1650s: Nicolaes Maes (fig. 44), Willem Kalf (fig. 45), and even Pieter de Hooch. In these works, however, the points of light do not share the peculiarly unfocused, diffused character of the highlights seen in paintings like *The Girl with a Red Hat*. Vermeer undoubtedly responded to the diffusion of highlights seen in a camera obscura because his own stylistic heritage provided him with the vocabulary to perceive and to be responsive to it.

PICTURES WITHIN PICTURES

Fabritius's *The Sentry* (fig. 22) presents another aspect of Dutch realism that was frequently over-

44. Nicolaes Maes. *The Listening Maid.* 1656. Oil on canvas, 34 × 28 3/8″ (86.4 × 72.1 cm). Reproduced by Permission of the Trustees of the Wallace Collection, London, Crown Copyright

looked in the nineteenth century: the moralistic implications of these pictures. A great many Dutch genre paintings contain symbolic allusions to meanings beyond the specific subject portrayed. Just as Fabritius included the bas-relief of Saint Anthony above the gate as a commentary on the inattentive sentry, so did other artists include secondary scenes, or pictures within pictures, to characterize the nature of the scene being depicted. By the mid-seventeenth century, specific household objects, and even poses of figures, often had associations attached to them that amplified the meaning of a painting. Thus a musical instrument was often included in paintings about love; a man smoking or a boy blowing bubbles in a painting that had Vanitas overtones;

or a statue of Fortune in a painting depicting a gambling scene.

The "apparent realism" of Dutch art, as it has been termed by one scholar, E. de Jongh, is strongly related to the moralistic climate of thought that stemmed from the Calvinistic heritage of the Netherlands.[45] Dutch artists often chose to make their works didactic, to include within them a moral or a proverb that would be understood by their contemporaries. Jan Steen's predilection for this type of painting has been noted over the years, particularly because he included relevant texts on stray bits of paper painted into his scenes. For example, in one painting (fig. 46), Steen portrayed a popular festival in the Netherlands, Twelfth Night, in-

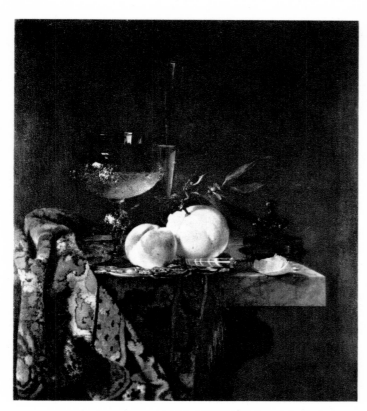

45. Willem Kalf. *Still Life with Glass Goblet and Fruit*. 1655. Oil on canvas, 25 5/8 × 22″ (65 × 56 cm). Staatliche Museen Preussischer Kulturbesitz, Gemäldegalerie, Berlin-Dahlem

cluding all the joy and festivity of the occasion. The painting, however, contains a subtheme, the foolishness of man, which is clearly indicated by a proverb depicted on a piece of paper tacked to the fireplace: "What use is a candle and eyeglasses if the owl refuses to look?"

The underlying meanings of Vermeer's paintings have been more difficult to decipher than Steen's because Vermeer minimized the anecdotal character of his scenes. Whereas Steen often reinforced the meaning of the proverb with a number of explicit gestures or actions among his figures, Vermeer's figures are generally quiet and reserved and betray no marked emotion. Vermeer is a poetic and not a narrative painter, and the nuances of meaning that one receives are often fleeting and incomplete.

In *A Woman Holding a Balance* (colorplate 22), for example, Vermeer includes a painting of the Last Judgment on the rear wall of the room. Clearly, the juxtaposition of this scene and the woman holding a balance before it is not accidental; Vermeer intended the painting to amplify the meaning of her gesture. Unlike Steen, however, Vermeer has stated his meaning subtly, and it has been interpreted in many different ways.

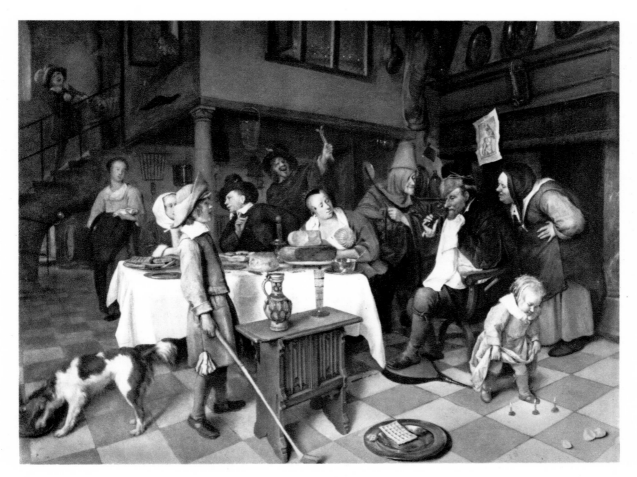

46. Jan Steen. *A Twelfth Night Feast: The King Drinks*. c. 1665. Oil on panel, 15 3/4 × 21 1/4″ (40 × 54 cm). Copyright reserved

41

Some have viewed the Last Judgment as a warning that the woman should not be distracted by weighing earthly goods and should focus on eternal values.[46] In this interpretation the woman is associated with the iconographic tradition of the goldweigher and its consequent Vanitas connotations (fig. 47). Careful examination reveals that the woman is not weighing gold; indeed, her scales are empty. Vermeer probably meant to suggest the need for moderation in one's life. One should weigh and balance one's responses to the world with a realization that one's decisions are ultimately judged by Christ.

Paintings and maps often appear on the walls of Vermeer's interiors and, as in *A Woman Holding a Balance*, they may sometimes relate directly to the scene taking place before them. In other cases, the connections are so tenuous that we wonder if they exist at all. Two paintings, *Girl Interrupted at Her Music* (colorplate 18) and *A Lady Standing at the Virginals* (colorplate 45), prominently display a painting of a cupid holding a bow in one hand and a card in the other. This painting, perhaps by Caesar van Everdingen, is based on a popular emblem by Otto van Veen that states that lovers should focus on only one love, not

48. Otto van Veen. *Perfectus Amor Est Nisi ad Unum*. Engraving from *Amorum Emblemata*, Antwerp, 1608

49. Jan Harmensz. Krul. *Cupid Delivering a Letter*. Engraving from "Toneel spel van Rozemond," *Pampiere Wereld*, Amsterdam, 1644

47. Gerard Dou. *The Money Lender*. 1664. Oil on wood, 11 3/8 × 9" (29 × 23 cm). The Louvre, Paris

50. Gabriel Metsu. *Lady Reading a Letter*.
c. 1666–67. Oil on canvas, 20 1/2 × 16″ (52.1 ×
40.6 cm). Collection Sir Alfred Beit, Bart.,
Blessington, Ireland

51. Gabriel Metsu. *Man Writing a Letter*.
c. 1666–67. Oil on canvas, 20 1/2 × 16″ (52.1 ×
40.6 cm). Collection Sir Alfred Beit, Bart.,
Blessington, Ireland

many (fig. 48). Even with this information, the precise relationship between the painting on the wall and the figures is not clear. The circumspect way Vermeer suggests meanings to his paintings closely parallels the mode of thought underlying the emblem books.

These books were extremely popular throughout Europe in the sixteenth and seventeenth centuries. The emblems they contained were moralistic, but the morals were abstrusely presented. The emblem itself consisted of three parts: a motto, an illustration, and an explanation. The meaning of the emblem was often difficult to fathom, and the conceit of being able to decipher the emblem was clearly part of the enjoyment. Emblems, moreover, were not totally consistent. As E. de Jongh has noted, Jacob Cats, probably the most frequently read author of his day, prefaced his emblematic book *Sinne en Minnebeelden* in 1618 by warning the reader not to be disturbed by finding images used for a certain meaning in one instance and for a contrary meaning in another. A man playing a lute in the company of his lover, for example, may represent the sanguine tempera-

ment, the element earth, the sense of hearing, or the age of young manhood.[47]

Many emblems beyond those found in Van Veen's book deal with the theme of love, and it appears that Vermeer and other genre painters were familiar with their content. One form of expressing love is through love letters, a theme found in emblem books like that of Jan Harmensz. Krul (fig. 49) and in many paintings by Vermeer, Ter Borch (fig. 18), Metsu (figs. 50, 51), and others. The associations between Vermeer's *Love Letter* (colorplate 39) and Krul's emblem are particularly close: in both, a letter is brought to the mistress of the house and a painting of a boat in a calm sea appears on the back wall. A similar seascape is, in fact, the subject of another emblem by Krul which emphasizes that love is as a sea, and a lover as a ship searching for a safe harbor. A calm sea is a good omen; a stormy sea is a bad one. A further reinforcement of the love theme is the lute the woman holds in Vermeer's painting, for the bonds of love and music are frequently expressed in emblem books (fig. 52).

52. Crispin de Passe. *Amor Docet Musicam*. Engraving for Gabriel Rollenhagen's *Nucleus Emblematum* ..., Cologne, 1611

FROM DAILY LIFE TO ALLEGORY

The allusions to secondary meanings or moralizing attitudes in Vermeer's paintings are subtly achieved. The types of themes found in his paintings and the ways in which they are presented indicate that Vermeer approached his work in an intellectual manner. His style probably appealed to only a small group of sophisticated collectors. Even those paintings which do not appear to have extended meanings, like the *Young Woman with a Water Jug* (colorplate 26) or *The Guitar Player* (colorplate 44), have a refinement and elegance that would have appealed to only a limited range of individuals.

One of the most difficult questions remaining about the nature of seventeenth-century Dutch art is the extent to which the market influenced the style of an artist's work. With Vermeer, who did not consistently sell his paintings, the problem is aggravated. One of the reasons he switched from Biblical and mythological paintings to genre paintings and then to paintings in a refined technique may have been the prices that he could realize for his works. Similarly, one might ask whether the large, distinctive paintings in his oeuvre, the *View of Delft* (colorplate 16), for example, or the *Allegory of the Faith* (colorplate 43), were the result of specific commissions.

In the latter instance, circumstantial evi-dence strongly suggests that a commission did exist and that it came from the Jesuits of Delft. The *Allegory of the Faith* is an unusual painting in many respects, but particularly in its strict adherence to an iconographic program. Whereas literary sources are only alluded to indirectly in most of Vermeer's works, the *Allegory of the Faith* conforms to a remarkable degree to images described in a popular iconographic handbook, Cesare Ripa's *Iconologia* (1644). Both the subject of the allegory, which glorifies Faith, specifically the Catholic faith, and the didactic nature of the imagery are consistent with Jesuit beliefs and approaches to religious art.[48] The Jesuit community was located in the neighborhood where Vermeer lived at the end of his life. It is known that Vermeer worshipped at the Jesuit chapel with his family and named his youngest son after the founder of the order, Ignatius of Loyola. Obviously, he must have had close ties with the Jesuit priests.

The Jesuits in the seventeenth century were active patrons of the arts, particularly in Italy and Flanders. In Holland, however, where the Catholic Church was not officially recognized by the state, their impact on artistic traditions was not so pronounced. Indeed, the type of didactic allegory favored by the Jesuits and evident in Vermeer's *Allegory of the Faith* is extremely uncommon in Dutch art.

Having few pictorial models as a basis for his allegory, Vermeer adapted, as best he could, the type of imagery he had evolved in his genre paintings for the specific iconographic demands of this painting. Thus, instead of depicting flying angels and clouds to fulfill his allegory, he gave tangible substance to abstract ideas with objects, among them a globe, a glass sphere, a picture on the wall, and a strand of pearls. Faith, described by Ripa as a female personage "looking tenderly pensive" and as "having the world under her feet," is shown by Vermeer with one foot on a globe. Although Ripa recommends that the scene of Abraham's sacrifice of Isaac be placed behind the figure of Faith, Vermeer depicts a painting of the Crucifixion on the back wall, a work by Jacob Jordaens that he apparently owned. Indeed, in this carefully conceived allegory, every object can be interpreted to have some symbolic meaning that enhances the underlying concept of the painting.

The actual composition of the painting parallels an earlier work by Vermeer that is essentially

allegorical, *The Allegory of Painting* (colorplate 33). A curtain on the left is drawn back in both instances as though the viewer is being shown a stage set. Once again a clue for the allegory is found in Ripa's book. The figure portrayed with laurel wreath and trumpet is Clio, a muse associated with both history and fame. Unlike the *Allegory of the Faith*, however, this painting does not convey such a precise meaning.

One possible interpretation is that Vermeer intended the painting to be an allegory of the importance of artists to the fame of their country and specifically of its cities. The presence of the map on the back wall is certainly not accidental, particularly since Clio is standing next to it. A theme expressed in *Beschryvinge der Stadt Delft*, Dirck van Bleyswijck's contemporary description of Delft, is that citizens who bring fame to their cities are often not recognized during their lifetimes.[49] Just as Bleyswijck was forbidden by convention from presenting biographies of living artists (including Vermeer) in his book, so is the artist in *The Allegory of Painting* seen from the back and anonymous to the viewer.

The poetic way in which Vermeer integrated concepts of art, fame, and history in *The Allegory of Painting* is more like his approach in other paintings than is the relatively literal transcription of symbolism in the *Allegory of the Faith*. Although the latter work is often cited as evidence of Vermeer's declining powers, perhaps his creative imagination was hampered by its strict iconographical requirements. Even if *The Allegory of Painting* was also a commissioned work (perhaps by the St. Luke's Guild in Delft), the concept does not seem to have been so explicitly detailed.[50]

Vermeer's Reputation

If we have little information about any commissions Vermeer received, or about a relationship between him and Jacob Dissius, at least we can be fairly certain that his works were not widely known. With the possible exception of Metsu, Vermeer did not have a significant impact on other artists, which is surprising since he was a respected member of the Delft artistic community. There are no documents referring to pupils of his although one would expect that, as one of the heads of the Saint Luke's Guild at two different periods, he would have had some.

Two paintings that often have been attributed

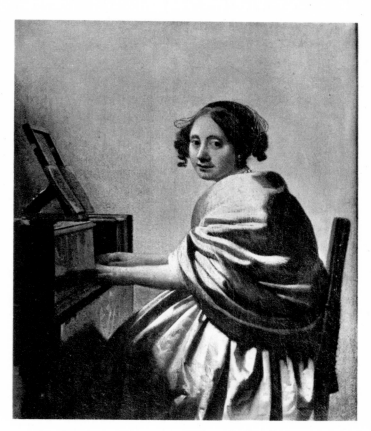

53. Circle of Jan Vermeer. *Girl at the Virginals*. n.d. Oil on canvas, 9 5/8 × 7 5/8″ (24.5 × 19.5 cm). Formerly collection Sir Alfred Beit, Bart., Blessington, Ireland

to Vermeer, however, may in fact have been executed by close followers. The better of these two examples, the *Young Girl with a Flute* (colorplate 47), certainly was painted by someone who had studied and understood Vermeer's painting techniques. The other work, *Girl at the Virginals* (fig. 53), is a reduced version of Vermeer's late painting *A Lady Seated at the Virginals* (colorplate 46). The compositional weaknesses in this little work, particularly the awkward pattern of folds in the woman's yellow cloak, have suggested to some that the painting was executed by Vermeer at the very end of his career, at a time when his artistic powers had substantially declined. The arguments are not convincing, for even in Vermeer's late works one never finds such simplified treatment of folds and textures.

Although these two little paintings suggest that Vermeer was not a totally isolated artistic figure in Delft, his fame did not reach far. Vermeer was but a name to Arnold Houbraken, who noted only his birthdate in his indispensable lexicon of Dutch artists, *De Groote Schouburgh der nederlantsche konstschilders en schilderessen*, published in Amsterdam from 1718 to 1721. Houbraken, who lived in

Dordrecht until some time between 1705 and 1710, may have missed the Dissius sale and thus may not have known Vermeer's work.

A contributing factor to Houbraken's neglect was his method of compiling information about Dutch artists. While well informed on artists from Amsterdam and from his native Dordrecht, he drew on other sources for information about artists from other cities. His primary source for Delft was Bleyswijck's *Beschryvinge der Stadt Delft*, which included only those artists born in Delft who had died by 1667 and therefore contained merely a reference to Vermeer's birthdate.

Another factor that affected Vermeer's reputation was that so few of his paintings were known beyond a select group of collectors and connoisseurs. Vermeer's oeuvre is much smaller than that of other genre painters, particularly Metsu, Ter Borch, and De Hooch, and his paintings, unlike those of his contemporaries, did not come up regularly at auction. One of the few illustrations of a Vermeer painting in the eighteenth century, for example, was the engraving of *The Astronomer* in Lebrun's important catalogue of 1784 (fig. 54). Thus, despite many instances where the individual qualities of Vermeer's paint-ings were commented upon, his work as a whole was not well studied or understood.

Thus neglected by Houbraken, the principal source for the lives of seventeenth-century Dutch artists, and unknown to a broad public, Vermeer's name rarely entered art historical literature of the eighteenth and early nineteenth centuries. One senses, however, that interest in his paintings continued to grow in the early nineteenth century despite the paucity of available information about his life. The paintings were praised in sales catalogues of the period and generally sold for respectable prices. For example, a Paris catalogue entry of 1809 reads as follows:

> ... his paintings are so rare, particularly in composed subjects, that Amateurs are reduced today to be content with some portraits of artists from the hand of this painter, whose productions have been regarded as classic and worthy of ornament of the most beautiful cabinets.[51]

Some nineteenth-century artists also seem to have responded to Vermeer's images. One of these was Wybrand Hendriks (1744–1831), who is known to have copied the *View of Delft* and who also

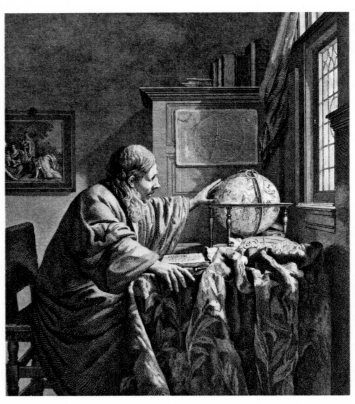

54. *The Astronomer*. Engraving after Vermeer, 9 1/4 × 7 3/4″ (23.6 × 19.8 cm). From Galerie Lebrun catalogue, Paris, 1792

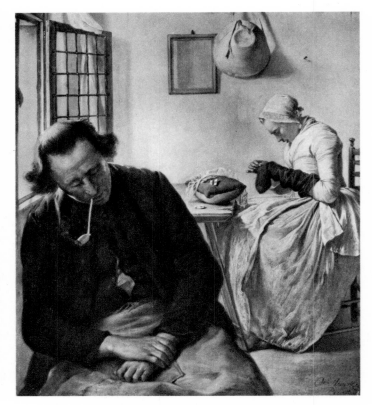

55. Wybrand Hendriks. *Interior with Sleeping Man and Woman Darning Socks*. n.d. Oil on panel, 15 × 13″ (38 × 33 cm). Frans Halsmuseum, Haarlem

painted genre scenes reflecting Vermeer's influence (fig. 55).

The first attempt to draw together some information about an artist of whom "the biographers have never spoken" was made in 1821 when Christian Josi, an engraver and publisher, discussed Vermeer in an essay entitled "Discours sur l'état ancien et moderne des arts dans les Pays-Bas."[52] After remarking on the simplicity of Vermeer's subjects and their truth of expression, Josi notes that the artist's works were little known in his own day. He then added that, "Today connoisseurs know to appreciate the works of this master." To substantiate his point, he demonstrated how prices for Vermeer's paintings had risen dramatically in the preceding decades, citing as one example *The Geographer*, bought in 1798 for "7 louis" and sold in 1803 for "36 louis."

Josi's observations were dramatically confirmed the following year when Vermeer's *View of Delft* was purchased for the Mauritshuis for the extraordinary sum of 2,900 florins. The sales catalogue described it as: "This most important and most famous painting by this master, whose works are seldom available...."[53] Josi's contribution toward an evaluation of Vermeer is interesting historically, but seems to have had little impact on contemporary literature. Although Vermeer's works continued to appear in the art market and to be well received by collectors and by most connoisseurs, his life remained a mystery and his oeuvre remained undefined.

The individual who really brought Vermeer's fame before a wide public was the French writer and critic, Thoré-Bürger. In a series of enthusiastic articles which appeared in 1866, Thoré-Bürger perceptively characterized Vermeer's art and catalogued his paintings, with immediate and dramatic effect.[54] His articles were timely, appearing at a moment when contemporary ideals were most compatible with Vermeer's specific mode of vision. The striking luminosity of his paintings, their apparent realism, and the dignity imparted to the common man and everyday situations all struck responsive chords. Also, Thoré-Bürger wrote with a verve and enthusiasm for Vermeer that is extremely compelling. One cannot read his articles without sharing the excitement he felt before a newly discovered Vermeer painting or during his search to find others. As he wrote: "Cette manie pérséverante m'a entraîné

à bien des voyages et à bien des dépenses. Pour voir tel tableau de van der Meer, j'ai fait des centaines de lieues; pour obtenir une photographie de tel van der Meer, j'ai fait des folies."[55]

With Thoré-Bürger, Vermeer finally entered art literature and his popular reputation immediately soared to new heights. The art market experienced a surge of Vermeer paintings in the 1880s and 1890s. In the first decades of the twentieth century, other paintings, including *The Girl with a Red Hat*, were discovered in private collections. Paintings whose attributions had been changed to more fashionable artists, Metsu, Eglon van der Neer, and De Hooch, were returned to Vermeer. On the other hand, in the enthusiasm of their discovery, Thoré-Bürger and others mistakenly included within Vermeer's oeuvre a number of paintings by Vermeer's contemporaries, among others, Cornelis de Man, De Hooch, Jacobus Vrel, and Jan Vermeer of Haarlem, a landscape painter.

Much twentieth-century Vermeer scholarship has been devoted to sorting out the proper definition of his oeuvre. Unfortunately these efforts have been plagued by the historical situation created by the sudden resurgence of Vermeer as a major master. As scholars and connoisseurs sought to extend Vermeer's limited known oeuvre, they were often victimized by forgers. The most famous Vermeer forger, although not the only one, was Hans van Meegeren.

The story of Van Meegeren's life and success as a forger is well known, particularly the incidents surrounding the *Christ at Emmaus* (fig. 56), which was published by Abraham Bredius in 1937 as a newly discovered early masterpiece of Vermeer.[56] In a sensational court trial in 1945, Van Meegeren, in order to prove that he had not sold national treasures to the Germans, admitted that he had painted the *Christ at Emmaus*.

Today, it seems incredible that the *Christ at Emmaus* was ever mistaken for a Vermeer or that other forgeries, such as *The Lacemaker* (fig. 57), discovered in 1927, were admired and praised as exquisite examples of the artist's genius. One must remember, however, that connoisseurs in the 1920s and 1930s viewed Vermeer with different expectations from those we have today. Their conception of Vermeer was then, like ours now, dictated by the environment in which they lived. Intangible elements of the forgers' interpretations were shared by connoisseurs whose expectations were formed in an earlier twentieth-century social milieu.

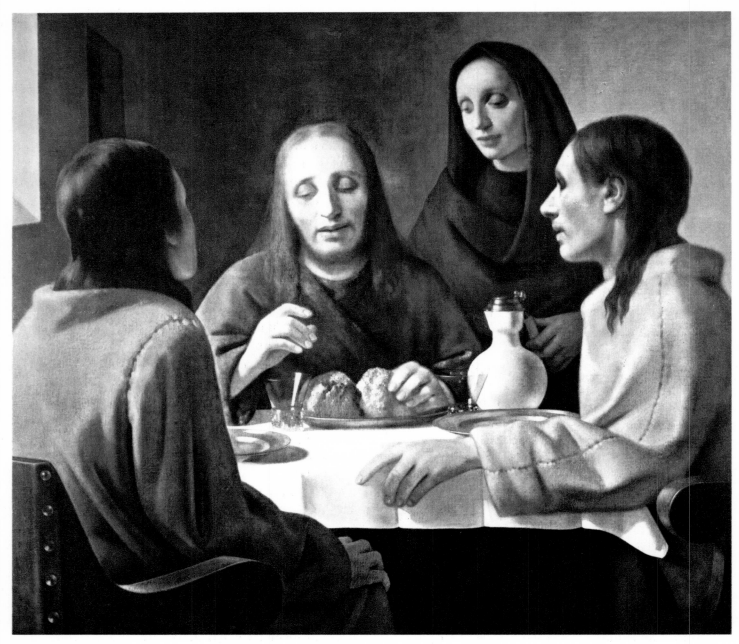

56. Hans van Meegeren. *Christ at Emmaus.* c. 1936. Oil on canvas, 46 × 50 7/8″ (117 × 129 cm). Museum Boymans-van Beuningen, Rotterdam

Seen in retrospect, for example, the haughtiness and artificiality of the forged *Lacemaker* parallel attitudes expressed in society portraits of the 1920s. As with many forgeries, their life-spans have been far shorter than those of the originals. What may have seemed a possible image of Vermeer's work in 1925 was less appropriate in 1945 and almost inconceivable in 1980.

The *Christ at Emmaus* largely succeeded as a forgery because Van Meegeren successfully anticipated the type of painting art historians might have expected from the young Vermeer. In particular, the work's obvious derivation from Caravaggio seemed to indicate that Vermeer had traveled to Italy during his apprentice years. The forger who painted *The Lacemaker* created a pastiche of familiar motifs from Vermeer's works. The theme was taken from Vermeer's little masterpiece in the Louvre (colorplate 41), but the position of the figure before the table relates more to *A Lady Writing* (colorplate 31). The basin in the foreground resembles that in the *Young Woman with a Water Jug* (colorplate 26), and is included even though a basin plays no role in the lacemaking process. To give his painting an old appearance, the forger scraped down an old canvas and induced an extensive crackle pattern in the paint by using glue as a medium rather than oil.

Today one cannot recreate the emotional response these paintings elicited from those who first viewed them, particularly because our response to them is so jarringly different. The glaring weaknesses in composition and anatomy as well as the poor quality of execution are painfully evident. The lesson to be learned is that stylistic judgments are circumscribed by limits of time and place and should, when feasible, be substantiated by thorough technical and scientific examinations.

At the very basis of any understanding of an artist's achievement is a recognition of his particular approach to his work. In the case of Vermeer the relevant questions revolve around his attitudes toward history painting, landscape, portraiture, and genre painting. They include consideration of his artistic environment and personal expectations for his art. They involve attitudes toward realism, the role of perspective and optics, symbolism and allegory. Finally, however, they concern the nature of his painting technique and his stylistic evolution, questions that are the focus of the following commentaries on Vermeer's individual paintings.

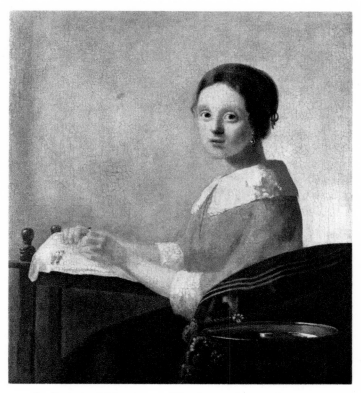

57. Imitator of Vermeer. *The Lacemaker*. 20th century. Oil on canvas, 17 1/2 × 15 3/4″ (44 × 40 cm). National Gallery of Art, Washington, D.C. Andrew W. Mellon Collection, 1937

NOTE: Figures 58 to 79 are discussed in the commentaries on the colorplates, figures 80 and 81 in note 11 on page 159

58. Jan Gerritsz. van Bronchorst. *Musical Party*. 1646. Oil on canvas, 58 3/8 × 75 3/8″ (148.4 × 191.4 cm). Copyright Centraal Museum, Utrecht

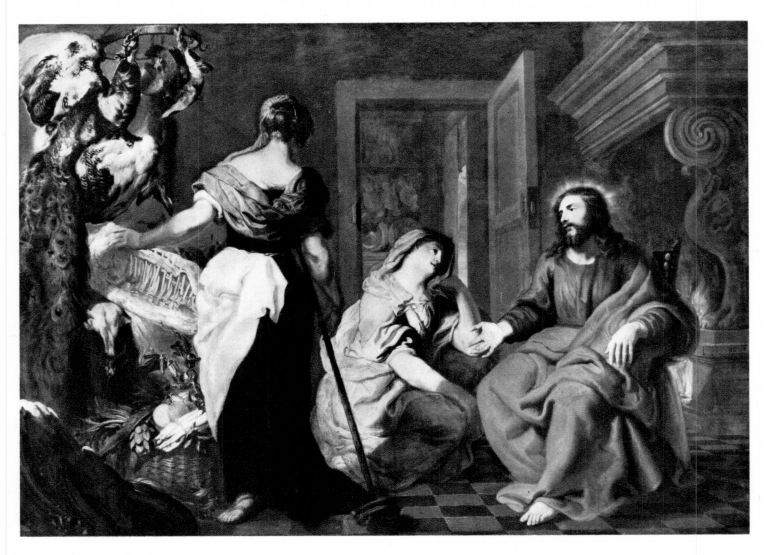

59. *Above*: Erasmus Quellinus and Adriaen van Utrecht. *Christ in the House of Martha and Mary*. c. 1650. Oil on canvas, 67 3/4 × 95 5/8″ (172 × 243 cm). Musée des Beaux-Arts, Valenciennes

60. *Left*: Leonaert Bramer. *Disciple Washing the Feet of Christ*. n.d. Watercolor, 5 × 3 3/4″ (12.5 × 9.5 cm). From a sketchbook of scenes from the New Testament. Rijksmuseum, Amsterdam

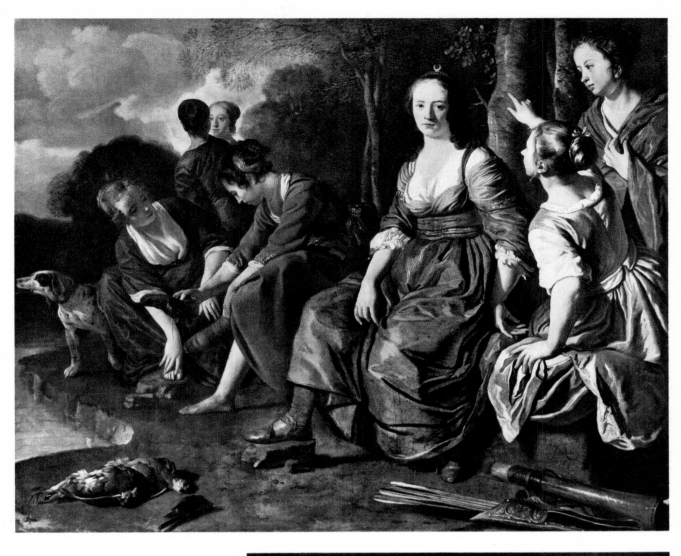

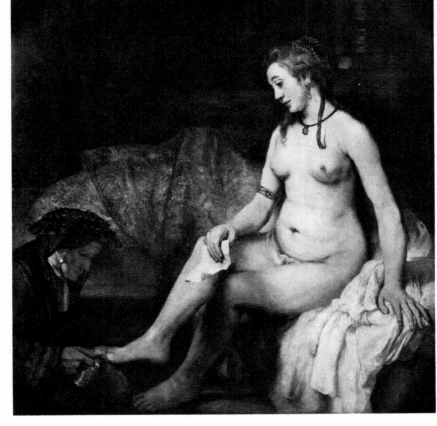

61. *Above*: Jacob van Loo. *Diana with Her Companions*. 1648. Oil on canvas, 52 3/4 × 65 3/4″ (134 × 167 cm). DDR-Staatliche Museen zu Berlin, Gemäldegalerie

62. *Right*: Rembrandt van Rijn. *Bath-sheba*. 1654. Oil on canvas, 56 × 56″ (142.2 × 142.2 cm). The Louvre, Paris

51

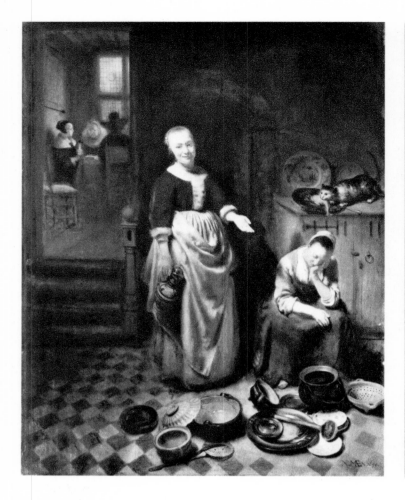

63. *Above, left*: Nicolaes Maes. *The Idle Servant*. 1655. Oil on wood, 27 1/2 × 21 1/4″ (69.9 × 54 cm). National Gallery, London

64. *Above, right*: Hier. Wierix, after Philip Galle. *Acedia*. n.d. Engraving, 7 1/4 × 5 1/4″ (18.6 × 13.6 cm). Rijksmuseum, Amsterdam

65. *Right*: Jacob de Gheyn II. *Melancholie*. n.d. Engraving, 9 × 6 7/8″ (23 × 17.5 cm). Rijksmuseum, Amsterdam

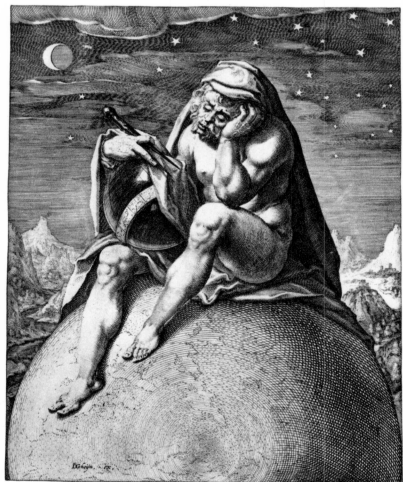

66. Otto van Veen. *Love Requyres Sinceritie*. Engraving from *Amorum Emblemata*, Antwerp, 1608, p. 55

67. Balthasar Florisz. van Berckenrode. *Map of the Province of Holland with Parts of Friesland, Gelderland, Utrecht, and Brabant*. Published 1621–29. Engraving, 36 3/4 × 57″ (93.5 × 145 cm). Collection Westfries Museum, Hoorn, The Netherlands

68. X-ray photograph of Vermeer's *A Girl Asleep*. The Metropolitan Museum of Art, New York

69. *Above, left*: X-ray photograph of Vermeer's
The Milkmaid. Rijksmuseum, Amsterdam

70. *Above, right*: Jan Steen. *The Music Master*.
c. 1659. Oil on wood, 16 1/2 × 12 1/2″ (41.9 ×
31.8 cm). National Gallery, London

71. *Right*: Frans van Mieris. *The Duet*. 1658. Oil
on wood, 12 3/8 × 9 5/8″ (31.5 × 24.6 cm).
Staatliches Museum, Schwerin

72. X-ray photograph of Vermeer's *Woman in Blue Reading a Letter*. Rijksmuseum, Amsterdam

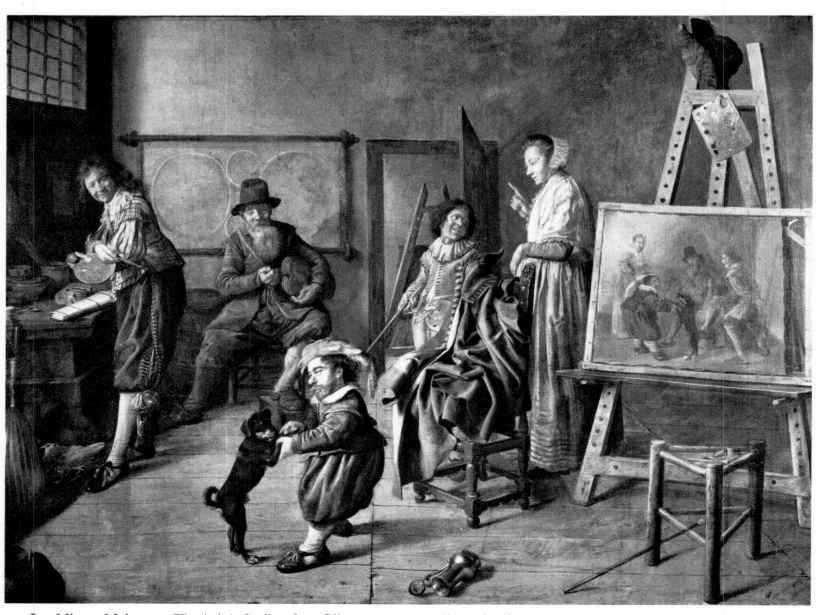

73. Jan Miense Molenaer. *The Artist's Studio*. 1631. Oil on canvas, 37 1/8 × 48 5/8″
(94.4 × 123.5 cm). DDR-Staatliche Museen zu Berlin, Gemäldegalerie

74. *Above, left*: Pieter de Hooch. *The Goldweigher*.
c. 1665. Oil on canvas, 24 × 20 7/8″ (61 × 53 cm).
Staatliche Museen Preussischer Kulturbesitz, Gemäl-
degalerie, Berlin-Dahlem

75. *Left*: Adriaen van Ostade. *The Painter*. c. 1667.
Etching, 9 3/8 × 7 1/8″ (23.8 × 18.1 cm). National
Gallery of Art, Washington, D.C. Rosenwald Col-
lection

76. *Above, right*: Photograph, through a camera ob-
scura, simulating detail from *Girl with a Red Hat*.
Photograph by Henry Beville, published in Seymour,
Dark Chamber and Light-Filled Room, 1964

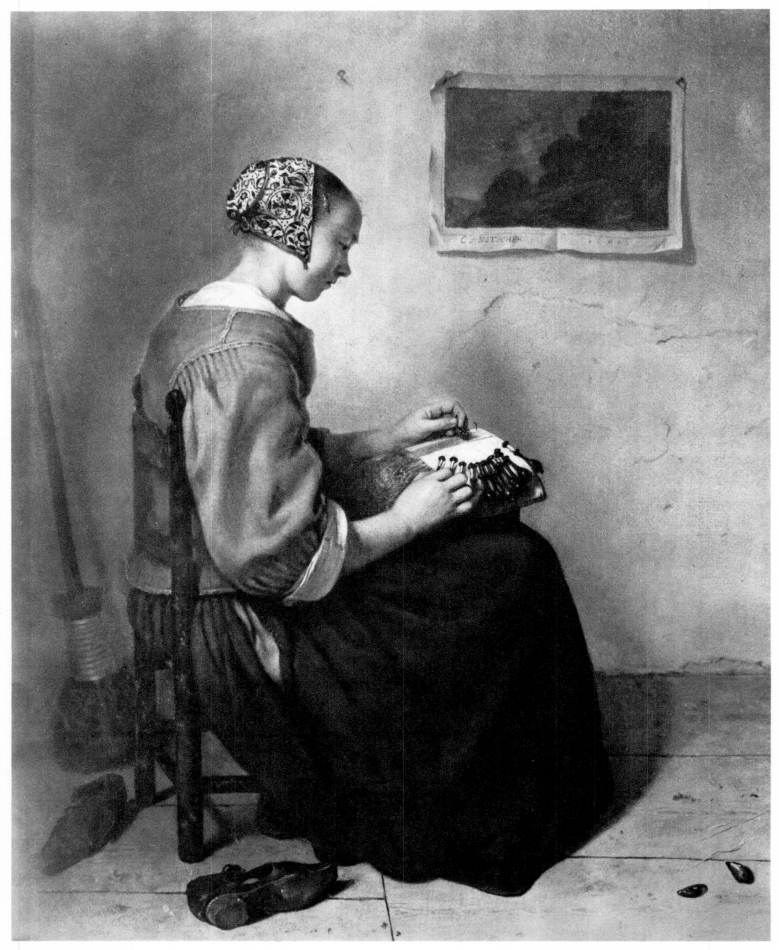

77. Caspar Netscher. *The Lacemaker*. 1664. Oil on canvas, 13 1/2 × 11 1/8″ (34.3 × 28.3 cm). Reproduced by Permission of the Trustees of the Wallace Collection, London, Crown Copyright

78. J. C. Jegher, after Erasmus Quel-
linus. *Capit Quod Non Capit.* Etching
from Guilelmus Hesius, *Emblemata
Sacra*, Antwerp, 1636

79. Jacob Cats. *Quid Non Sentit Amor?*
Engraving from *Sinne en Minnebeelden*,
Amsterdam, 1618

80. Jan Vermeer (?). *Seated Young Peasant Woman.*
n.d. Drawing, black chalk, white highlights, red ocher,
on light blue paper, 10 × 6 1/2″ (25.5 × 16.5 cm).
Kunstsammlungen zu Weimar, Graphische Sammlung
(See note 11 for a discussion of this drawing.)

81. Cornelis Bega. *Seated Peasant Woman.* n.d. Draw-
ing, red ocher chalk on paper, 8 1/4 × 6 1/8″
(20.8 × 15.5 cm). Graphische Sammlung Albertina,
Vienna (See note 11 for a discussion of this drawing.)

BIOGRAPHICAL OUTLINE

1632 On October 31, the child Joannes, son of Reynier Jansz. and Dingnum Balthasars, was baptized at the Nieuwe Kerk, Delft.

1641 Reynier Jansz. Vos, father of Vermeer, purchased the inn "Mechelen," on the north side of the marketplace in Delft. (Vermeer's father probably took the name Vos from an inn that he had previously rented, De Vliegende Vos, "The Flying Fox.")

1652 Vermeer's father was buried in the Nieuwe Kerk on October 12.

1653 Johannes Reyniersz. Vermeer and Catharina Bolnes were married in Schipluij on April 20. Leonaert Bramer had served as a witness on April 5 for the official announcement of their intention to be married.

On April 22 Vermeer cosigned a document with Gerard ter Borch.

Vermeer was registered as Master Painter in the Guild of Saint Luke on December 29.

1660 At the time of the death of one of his children, in December, 1660, Vermeer was living on the Oude Langendijk in the home of his mother-in-law, Maria Thins.

1662 Vermeer was one of the directors of Saint Luke's Guild.

1663 Vermeer was one of the directors of Saint Luke's Guild.

Vermeer was visited by the French nobleman Balthasar de Monconys.

1670 Vermeer was a director of Saint Luke's Guild.

1670 Vermeer's mother died.

1671 Vermeer was one of the directors of Saint Luke's Guild.

1672 Vermeer gave expert testimony on the authentication of twelve Italian paintings.

1675 Vermeer was buried in the Oude Kerk in Delft on December 15. At the time of his death he left eight minor children.

1676 Catharina Bolnes, widow of Johannes Vermeer, sold two paintings by Vermeer to Hendrick van Buyten, master baker of Delft, to satisfy a debt of 617 guilders and 6 stuivers.

Jan Colombier, a merchant in Haarlem, purchased twenty-six paintings owned by Catharina Bolnes to satisfy a debt of 500 guilders owed to Jannetie Stevens of Delft. On February 24, Catharina Bolnes transferred ownership of the painting known as *The Art of Painting* (*The Allegory of Painting*) to her mother, Maria Thins.

On February 29, an inventory of the painter's estate was made, including a list of the goods bequeathed to Catharina Bolnes and Maria Thins.

Antony van Leeuwenhoek was named "Curator of the estate and goods of Catharina Bolnes widow of the late Johannes Vermeer during his lifetime mr. Painter."

1680 Maria Thins was buried in Delft on December 27.

1688 Catharina Bolnes was buried in the Nieuwe Kerk in Delft on January 2.

COLORPLATES

CHRIST IN THE HOUSE
OF MARTHA AND MARY

c. 1654–55
Oil on canvas, 63 × 55 7/8" (160 × 142 cm)
National Gallery of Scotland, Edinburgh

For those who know Vermeer through paintings like *The Milkmaid* (color-plate 12) or *The Music Lesson* (colorplate 19), *Christ in the House of Martha and Mary* always comes as a surprise. This large painting of a Biblical subject, set in a dark interior, does not accord with the popular conception of Vermeer. Indeed, the style and subject matter of this painting are also difficult for Vermeer scholars to explain satisfactorily. Were it not for the distinctive signature on Mary's stool one would wonder to whom it would be attributed.[57]

The subject of the painting is an incident that occurred while Christ was visiting the two sisters Martha and Mary. Martha complained that Mary, who was sitting listening to Christ's words, was not helping with the serving. Christ answered Martha's complaint by saying: "Martha, Martha, thou art careful and troubled about many things: But one thing is needful: and Mary hath chosen that good part, which shall not be taken away from her." (Luke 10: 41–42).

Christ in the House of Martha and Mary was a favorite theme for sixteenth-century artists like Pieter Aertsen, who portrayed religious subjects in the backgrounds of kitchen scenes. This tradition continued into the seventeenth century, particularly in Flanders. Erasmus Quellinus, for example, painted this subject around 1650 in collaboration with the still-life artist Adriaen van Utrecht (fig. 59). Although their work retained elements of the sixteenth-century kitchen paintings, Quellinus's figure of Christ anticipates that in Vermeer's work.

Vermeer's representation of the theme differs from this tradition in that he focused totally on the three figures. Christ, because of his gesture and the soft glow that radiates from his head, is the dominant figure. Martha leans over to hear his words while Mary sits by his feet, her head resting on her hand. The close bonds among them are strengthened because the background, including the stairway on the left and the room in the background, is so cursively indicated.

This subject was more popular among Flemish artists than Dutch, possibly because of the religious connotations of the story. Martha and Mary represented two opposing personalities: the active and the contemplative. Christ's defense of the contemplative life suited Jesuit ideals and actually was contained within the *Spiritual Exercises* of Ignatius of Loyola. Vermeer's treatment of this subject, which focuses on the message that Christ is transmitting, may reflect his sympathetic response to the Catholic Church in the mid-1650s. The motivation for painting this work, however, is difficult to determine. Vermeer may have been trained as a history painter by Bramer, but it is hazardous to assume that he painted this work from his own inspiration. A painting of this large size may well have been commissioned.

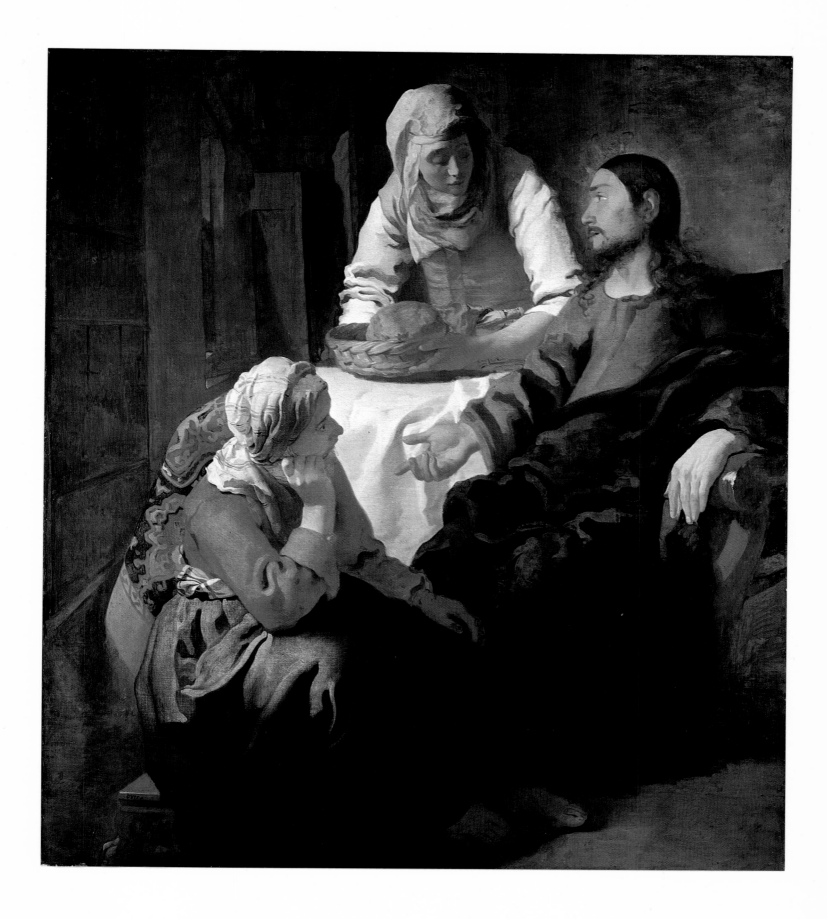

Detail of CHRIST IN THE HOUSE
OF MARTHA AND MARY

Christ in the House of Martha and Mary is thought to be the earliest known painting by Vermeer. The strongest argument for its early date is the differences in painting techniques between this work and his later ones. In no other painting does he focus so exclusively on the figures in the central core of the composition. Vermeer in his mature works was very conscious of the relationship of his figures to their environment, a concern not evident in this work. Another element of Vermeer's mature style is his interest in rendering the specific textures of objects. The breadbasket in *The Milkmaid* of about 1658–60 (colorplate 12), for example, is painted with careful attention to the character of the material and the construction of the basket. In comparison, the basket held by Martha is only scantily indicated. This superficial rendering of objects is also seen in the clothes of the figures. Folds are indicated with free-flowing brushstrokes, but ones which do not convincingly suggest the volume of the material.

Given the superficial quality of the modeling, one nevertheless senses in this work an artist who had already achieved a masterful technique of painting. The brushstrokes are certain. The interplay between opaque paints and semi-transparent ones in the shadows is effective. The conception of the scene, particularly in the way an iconographical type is transformed into an intimate confrontation of three figures, also is sophisticated.

Evidence about the nature of Vermeer's training is unfortunately difficult to determine from this work. The broad, smooth forms and triangular composition of *Christ in the House of Martha and Mary* indicate classicizing tendencies unrelated to the style of Bramer's small panel paintings. Bramer, however, also executed mural paintings that were similar in character to paintings by the Haarlem Classicists and Utrecht Caravaggisti with whom he worked (fig. 58). Thus, connections with Bramer, either directly or through his contacts with other artists, may help explain the derivation of the style of this painting.

Many attempts have been made to identify the specific source for the pose of Christ. It was, however, a standard rhetorical pose used by a number of Italian, Flemish, and Dutch artists, including Bramer (fig. 60), Quellinus (fig. 59), and Jan Steen in his *Christ in the House of Martha and Mary* (fig. 13). One must assume that Vermeer, whose father had been an art dealer and who seems to have inherited his father's business, would have had opportunities to see this particular gesture in other paintings and prints.

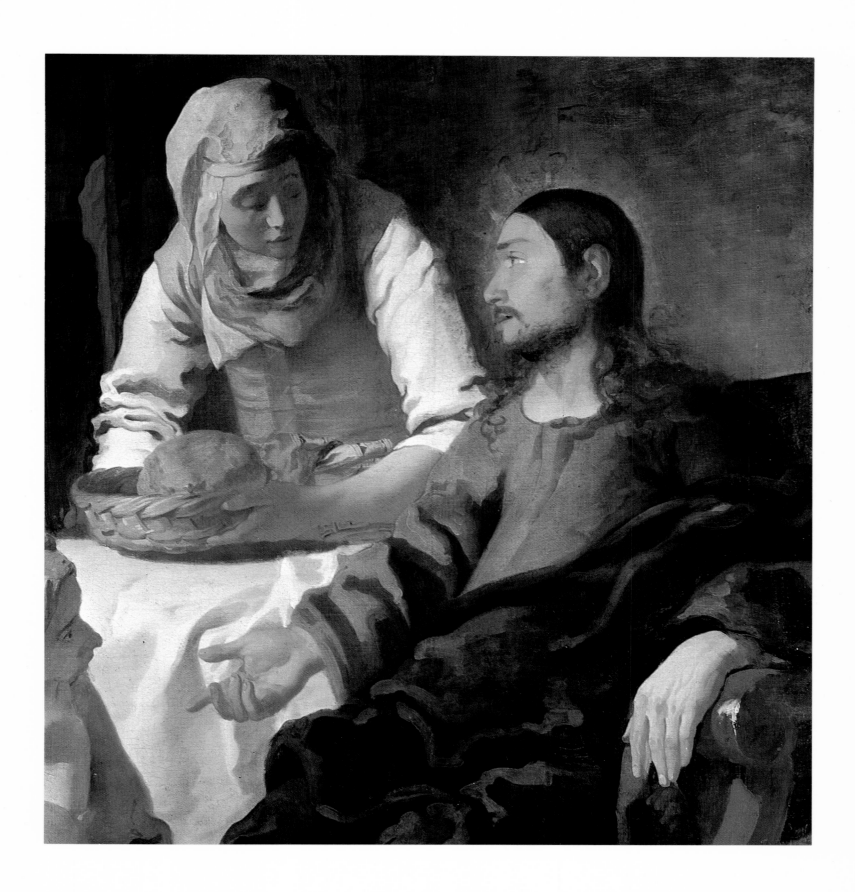

DIANA AND HER COMPANIONS

c. 1655–56

Oil on canvas, 38 3/4 × 41 3/8" (98.5 × 105 cm)
Mauritshuis, The Hague

The legends surrounding Diana are rich and varied. The most dramatic ones are those described by Ovid in his *Metamorphoses*, where her prowess as a huntress is emphasized. Ovid's stories were rich in narrative imagery and appealed to early seventeenth-century painters, who delighted in depicting exotic and unusual stories. Dutch artists, particularly Mannerists, often portrayed Diana as the goddess of the hunt, focusing on the harsh judgments that she levied on Acteon and Callisto by transforming them into beasts to be killed.

By the mid-seventeenth century, however, Diana was represented infrequently in Dutch art. One of the few to depict her was the Amsterdam painter Jacob van Loo, and a painting of his has been cited as a pictorial source for Vermeer's *Diana* (fig. 61).[58] Both these scenes differ from earlier representations of Diana: they are devoid of action and depict only a few large-scale clothed women sitting in a wooded landscape.

The similarities between the two paintings, however, are superficial. Van Loo's painting belongs to a portrait tradition where individuals were posed in the guise of mythological figures. The robes are elegant; the light is crisp. Vermeer's *Diana* is different in mood and conception. It is a heavy, somber painting. Heads are lowered, turned away, or in shadow as though some tragic grief has befallen the group. The colors are also heavy: deep yellows, oranges, blues, and purples predominate.

Diana was also goddess of the night, and this aspect of the legend is the one Vermeer portrayed. The figures are set into a dark landscape and illuminated by the moon. The only attribute of Diana in the painting is the crescent moon which she wears on her head. Diana, as goddess of the night, is also associated with death, and the type of grief evident in the painting comes closest to this meaning of the goddess. One wonders whether the tragedy that had recently befallen Delft with the explosion of the powder house in 1654 might underlie the conception of this painting.

The type of mood Vermeer wanted to evoke in this painting was different from that of the *Christ in the House of Martha and Mary* (colorplate 1), and he adopted a rich, heavy palette to achieve it. The Delft artist to whom Vermeer must have turned for inspiration was Carel Fabritius, one of the victims of the explosion. Fabritius was one of the few Rembrandt followers who understood the powerful, emotional quality of Rembrandt's work. Some of the Rembrandtesque qualities of this painting and of Vermeer's other early works could have come from studying Fabritius. One could even imagine that Vermeer derived both the pose and the somber mood of Diana from Rembrandt's magnificent painting of *Bathsheba*, 1654, in the Louvre (fig. 62).

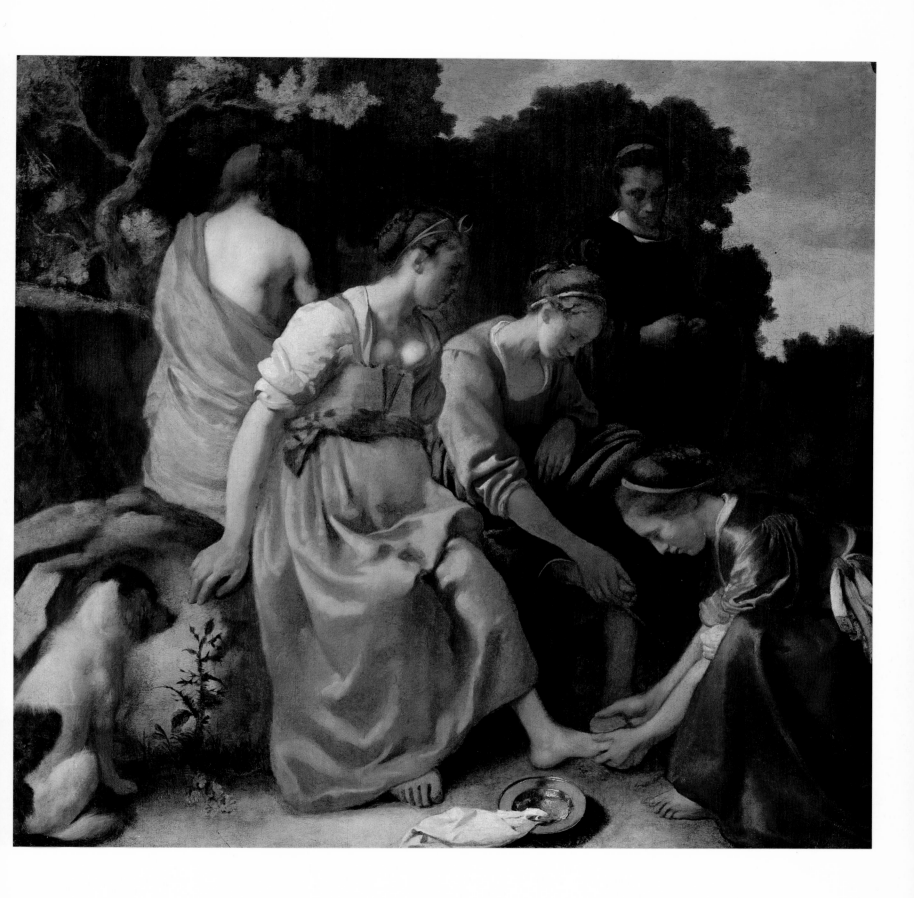

THE PROCURESS

1656

Oil on canvas, 56 1/8 × 51 1/8" (143 × 130 cm)
Staatliche Kunstsammlungen, Gemäldegalerie, Dresden

The Procuress of 1656 is Vermeer's earliest dated painting, and hence is extremely important as a touchstone for his early style. A large work, it is broadly painted with rich oranges, yellows, and reds that create a powerful effect. The figures are tightly compressed in a shallow space behind a rug that is apparently draped over a balustrade.

The inspiration for the painting may well have been Dirck van Baburen's *The Procuress* (fig. 9), which was owned by Maria Thins and which appears in the background of two of Vermeer's own compositions (colorplates 29, 46). The presence of the elegantly dressed young man on the left, holding a lute and a glass, however, lends a different character to the scene from that found in Baburen's work. The contrast of this figure type with the soldier in red was undoubtedly intentional, and Vermeer probably intended his painting to depict an episode from the story of the Prodigal Son.

The theme of the Prodigal Son was extremely common in Dutch art; moreover, artists, among them Rembrandt (fig. 24) and Gabriel Metsu, often portrayed themselves as the Son. In this painting, the self-conscious appearance and direct gaze of the figure on the left bear characteristics of a self-portrait. Even his costume, which has been identified as Burgundian and not Dutch seventeenth-century,[59] reinforces the hypothesis that Vermeer intended his painting to portray a story from the past rather than a contemporary scene. The painting thus represents an important moment in the transformation of Vermeer's early interest in mythological and Biblical scenes to ones with a genre character.

Despite this historical interest and the undeniable richness of the colors, the painting does not totally succeed. The figure on the left remains isolated from the others. Spatial effects are ambiguous and confusing. One is not certain whether the painting should be viewed from the front or from slightly below. The position and shape of the table on which the pitcher is resting are uncertain and the division of the composition by the rug is awkward. Clearly, Vermeer was beginning to experiment with a new mode of representation which he had not totally mastered. Nevertheless, whatever its failings, *The Procuress* creates a powerful impression that stems as much from the peculiar tensions within it as from its rich painterly qualities.

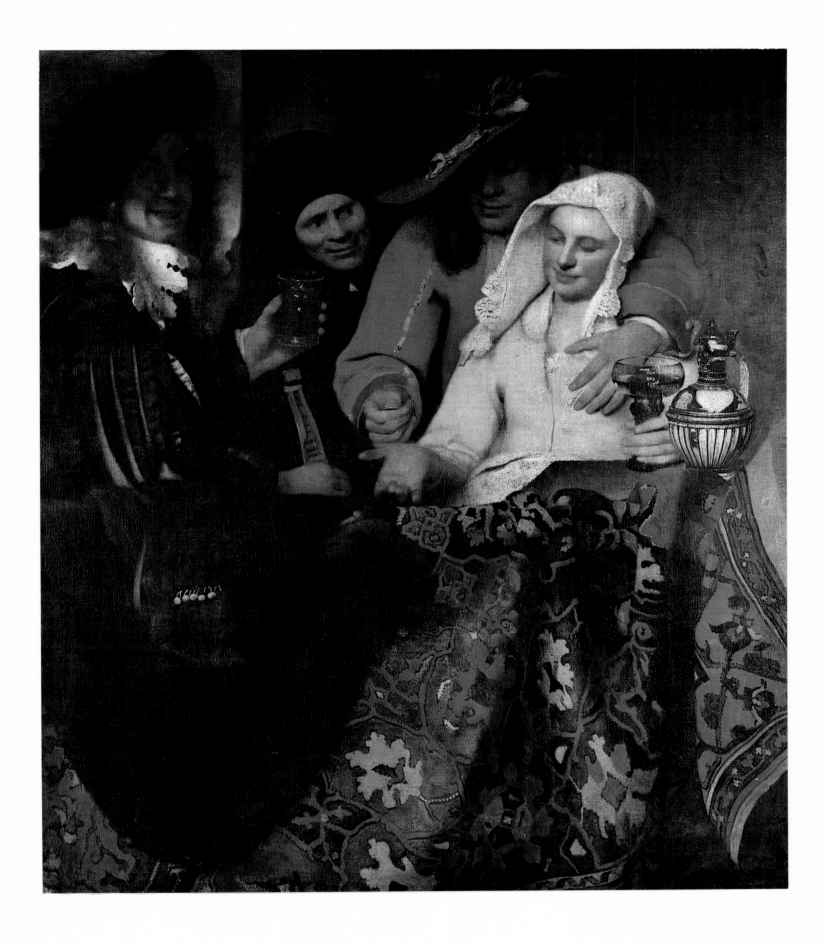

Detail of THE PROCURESS

Vermeer's range of painting techniques in his early works is as diverse as his range of subject matter. Whereas his *Christ in the House of Martha and Mary* (colorplate I) is executed in a relatively broad technique, with flowing brushwork and thin glazes, *Diana and Her Companions* (colorplate 3) is densely painted, with few visible brushstrokes and little evidence of glazes. The thick impastos of the highlights contrast strongly with the thinly painted, dark shadows. Vermeer's concern with the volume of masses was greater in *Diana and Her Companions* than in *Christ in the House of Martha and Mary*. He modeled the folds of the material in *Diana* with an awareness of the differences of texture not evident in the earlier work.

This tendency toward articulating differences in textures is further evident in *The Procuress*. As in *Diana*, Vermeer painted his highlights in a thickly applied, rich pigment. In this detail of the painting, for example, the thick paint on the woman's yellow jacket has actually run. In the woman's glass and the feathers on the soldier's cap, however, the paint is drawn out or applied thinly enough to create effects of transparency. The evolution of Vermeer's painting technique is also evident if one compares the soft, wooly appearance of the rug in *The Procuress* with its broader, more superficial rendering in the *Christ in the House of Martha and Mary*. To enhance these textural effects, Vermeer occasionally gave his surface a three-dimensional quality by applying small dabs of paint that protrude from the surface plane, as, for example, along the gold band of the soldier's jacket.

This evolution in Vermeer's technique indicates an interest in giving his images a greater sense of reality. Accompanying this interest is an attempt to portray a moment in which some action is occurring. The young man on the left raises his glass and turns toward the viewer; the soldier clasps the woman and hands her a coin. Half shadows covering the men's faces reinforce the momentary quality of the scene.

These qualities in *The Procuress* are further evidence of Vermeer's awareness of Rembrandt's work and that of his school. Communications between Delft and Amsterdam were extensive during the 1650s, and a number of artists had contacts in both cities. Emanuel de Witte, for example, continued to paint views of the Delft churches after he moved to Amsterdam. Rembrandt's students also spread his style as they moved from Amsterdam. Nicolaes Maes, whose genre paintings during the mid-1650s parallel Vermeer's works in many ways (figs. 44, 63), lived in nearby Dordrecht after 1654. No documents yet discovered indicate contact between Vermeer and Rembrandt or Rembrandt's pupils other than Fabritius, but stylistic evidence strongly suggests that contact did exist.

COLORPLATE 6

A GIRL ASLEEP

c. 1657
Oil on canvas, 34 1/2 × 30 1/8" (87.6 × 76.5 cm)
The Metropolitan Museum of Art, New York
Bequest of Benjamin Altman, 1913

One of Vermeer's most provocative early paintings is *A Girl Asleep*. A woman sits at the far side of a table, eyes closed, her head resting on her hand. The table is covered with a rich oriental rug that has been pulled up in the front. Lying partially obscured behind it are a cloth and an overturned pitcher. A chair closes the space in the foreground and emphasizes the separation of the viewer from the woman. Behind her a half-opened door allows a glimpse into a room beyond a small passageway. Except for a table, a mirror in a black frame, and a window, the back room is empty.

The orderliness of the back room is different from the cluttered, disheveled appearance of the foreground room, suggesting that Vermeer intended to establish a contrast between the two. A close equivalent to Vermeer's painting is a work by Nicolaes Maes, *The Idle Servant*, 1655 (fig. 63), in which the mistress of the house has come from the back room to request more wine from the maid only to find her asleep, the pots and pans in disarray, and the cat taking the chicken. Both Maes and Vermeer used the same pose for the sleeping, perhaps drunk, woman, one that was well known in emblematic literature as the representation of Sloth (fig. 64).[60] Both paintings, therefore, would seem to have comparable moralizing implications: that the proper conduct of one's life requires temperance and moderation.

As with most emblems, however, multiple meanings for specific poses are possible. A similar pose also signified Melancholy (fig. 65), a theme that may have specific implications for this painting. Above the girl hangs a dimly lit picture. Although only a fragment containing a leg and a mask can be seen, this image can be identified with a well-known emblem from Otto van Veen's *Amorum Emblemata* of 1608 (fig. 66).[61] The emblem, which is entitled "Love requyres sinceritie," concerns deception in love; hence the picture may offer a clue as to what has caused the girl's state of mind.

X-rays reinforce the supposition that the girl's melancholic state has a connection with love. They reveal that Vermeer initially planned to include a dog in the doorway and a man in the distant room (fig. 68).[62] Other technical examinations have shown that Vermeer enlarged the picture on the wall, perhaps because he wanted to allow space for including the mask in the picture's lower right corner.[63] Vermeer may have made this adjustment when he decided to reduce the size of *A Girl Asleep*; the painting has been cropped on all sides.

These design changes suggest that Vermeer consciously avoided the didactic narrative elements found in Maes's style and preferred a more subtle, poetic approach. The painting is clearly a transitional work, the first in which architectural elements and symbolic images are significantly used to reinforce the content of the painting.

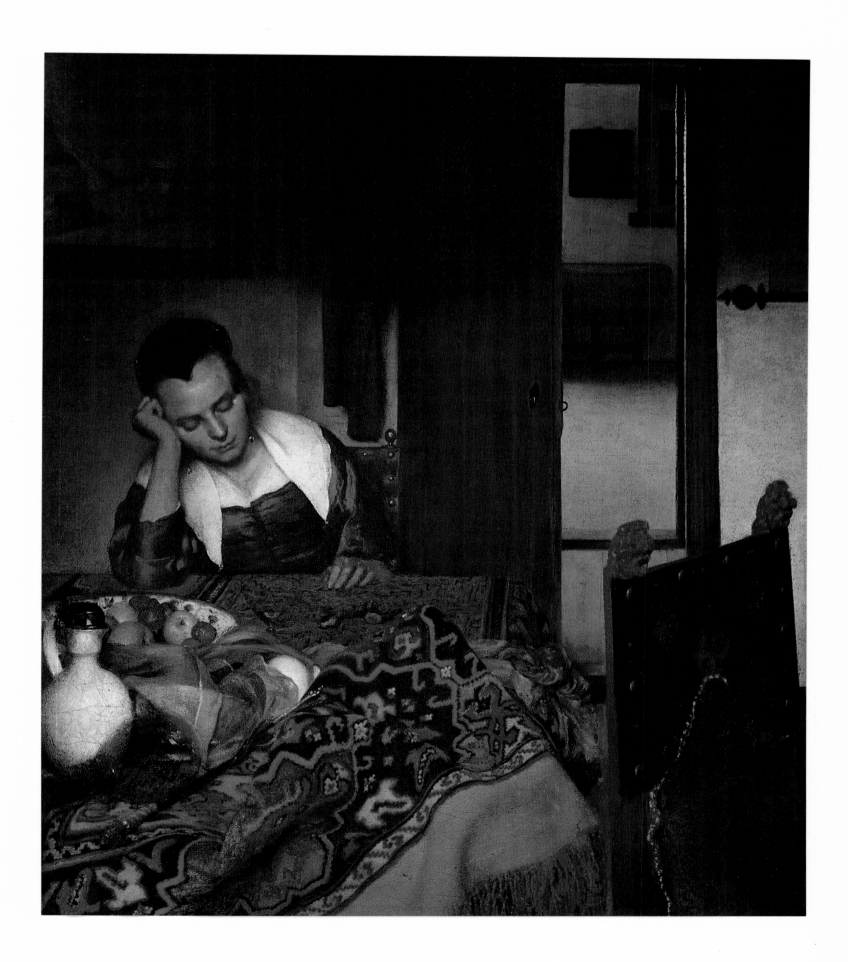

GIRL READING A LETTER
AT AN OPEN WINDOW

c. 1657
Oil on canvas, 32 3/4 × 25 3/8" (83 × 64.5 cm)
Staatliche Kunstsammlungen, Gemäldegalerie, Dresden

Vermeer's genius was in probing those moments in life when one feels alone and immersed in one's thoughts. His are essentially private works, invitations to pause and partake of the quiet intimacy of the scene. Almost as in poetry, he suggests moods and attitudes in his figures that are recognizable yet not precisely defined.

In this painting a girl stands isolated in a corner of a room before an open window. Her thoughts are totally absorbed in the letter she is reading. The walls, curtains, and table define the physical limits of her space; the reflection of her image in the glass emphasizes the inward nature of her thoughts. Her world is still. One cannot even imagine what sounds might be associated with it.

Much of this sense of intimacy is created by the barrier that Vermeer established between the figure and the viewer. As in Fabritius's *View in Delft* (fig. 23), this device allows the figure's thoughts to remain private and unviolated by the viewer's intrusion into his world. The large green curtain on the right reinforces this sensation.

X-rays have revealed that the curtain was not part of Vermeer's original conception (see fig. 29). In addition, they show that Vermeer made numerous other changes in his painting. Initially he also included a large painting of a standing cupid on the back wall. This painting is seen again in the background of two of his other works (colorplates 18, 45). This cupid is based on an emblem meaning that one should have only one lover.

Vermeer also made other changes in his composition, notably in the position of the girl. The pattern of a sleeve and a hand can be clearly seen in the X-ray to the left of their present location. Less distinct is a second profile of the head slightly in front of and below its present position. In the original profile the head is turned away from the viewer. That position accounts for the comparatively full-faced reflection in the window.

The extent of changes in this painting, as well as in *A Girl Asleep*, makes the derivation of the composition difficult to trace.[64] For instance, the original position of the girl reading a letter, turned slightly from the viewer, seen with her reflection in the window, is similar to ones found in paintings by Ter Borch (figs. 18, 19). With the change in her position this connection is not so evident. One wonders if Vermeer and Ter Borch remained in contact in the years after Vermeer's marriage and to what extent Ter Borch inspired Vermeer to adopt this mode of genre painting.

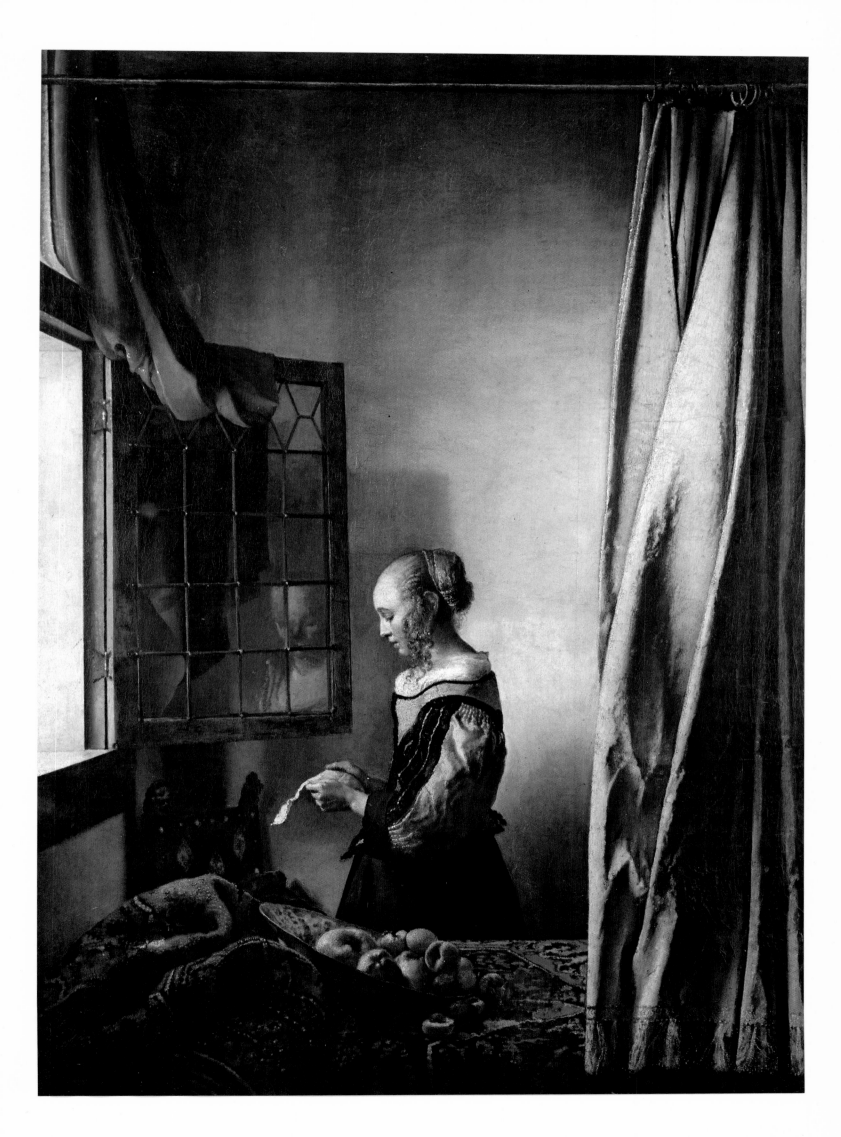

Detail of GIRL READING A LETTER
AT AN OPEN WINDOW

Vermeer, above all, was a painter of light. He had an extraordinary sensitivity to the way in which light falls on and illuminates various types of objects, whether porcelain, glass, satin, or wool. He sensed the importance of shadows for articulating space and understood the subtleties of suggesting the flow of light as it passed by and through objects. Finally, he recognized the important psychological functions of light and how its intensity and distribution affect the mood of a figure or setting.

This aspect of his genius is not apparent in his earliest works although hints of it appear in *A Girl Asleep* (colorplate 6). In that painting the dark shadow across the top third of the painting reinforces the heavy, melancholic mood. The logic of the light distribution, however, is difficult to understand, particularly since local shadows are totally absent. In this respect the *Girl Reading a Letter at an Open Window* was conceived with an entirely new awareness of the play of light in an interior space. Almost as a statement of his intentions, Vermeer placed the girl before an open window and subtly indicated the shadows created by the window frame, the curtain hanging over it, the chair, and the girl herself.

To enhance the naturalistic appearance of the scene, he also expanded upon a technique he first used in *The Procuress* for accenting the textures of materials. Instead of depicting the yellow bands of the girl's jacket with smooth strokes, he formed them with small dabs of paint, some of which are quite three-dimensional. He also used this technique on the sunlit portions of the rug on the table. He generally applied colored highlights on top of the design layer; occasionally, he drew a thin glaze over white highlights below that layer. Vermeer used a similar technique to enliven the girl's hair, although these highlights are somewhat more fluid than those on her jacket and on the rug.

Vermeer, during these formative years, was clearly still experimenting with his painting techniques and compositions. X-rays indicate that he added and subtracted objects to create quite different moods from those he had originally intended. In his attempts to evoke a mood through the setting and characterization of the figure, he also realized the importance of portraying light, shadow, and texture to achieve these ends.

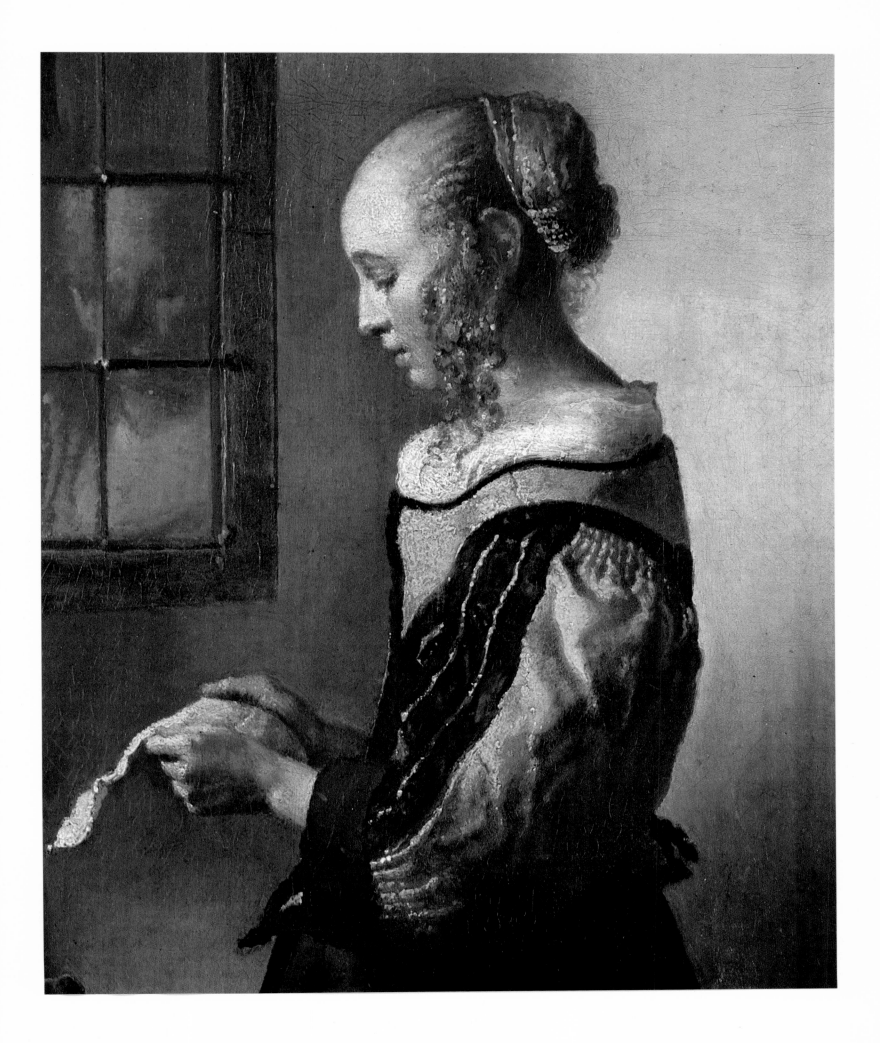

THE LITTLE STREET

c. 1657–58
Oil on canvas, 21 3/8 × 17 3/8" (54.3 × 44 cm)
Rijksmuseum, Amsterdam

Vermeer's *The Little Street* is one of his most appealing paintings. It is at once picturesque and imbued with quiet dignity. The subject is hardly the street, which is of little consequence in the painting, but rather the complex of buildings and inhabitants that faces the street. Vermeer, unlike Fabritius in his *View in Delft* (fig. 23) or Jan van der Heyden in his *Oude Kerk in Delft* (fig. 2), does not direct one along the street but across it. The viewer is presented with a flat facade of buildings which encourages him to ponder its variety and its unity.

The date of this painting is difficult to determine because its subject differs from those of other paintings by Vermeer. By the mid-1650s, Jan Steen (fig. 14) and Pieter de Hooch (fig. 16) had begun to paint street and courtyard scenes, and it seems probable that Vermeer shared in this interest at the same time. The stylistic similarities then between Vermeer's works and Pieter de Hooch's were very close, as one may see by comparing the treatment of bricks and mortar in *The Little Street* and in De Hooch's *A Dutch Courtyard* of about 1657 (fig. 16). Some scholars, however, have speculated that the Vermeer painting should date about 1661.[65] The basis of this theory is that Vermeer depicted in this painting the old people's homes directly behind his house to record their appearance before they were renovated in that year. This theory is not convincing since not only is the architecture of the buildings different from that seen in old prints, but the painting techniques are not those of Vermeer in the early 1660s.[66]

By the 1660s Vermeer became increasingly aware of the role of natural light for defining space and enhancing the mood of his paintings. Light, in this painting, does not play such an active role. By the 1660s, moreover, he had perfected a range of techniques for suggesting the various textures of objects, many of which involved using rich impastos of paint. Such textural effects are not evident in *The Little Street* despite Vermeer's obvious interest in rendering the varieties of surfaces found in the buildings.

Finally, the form of the signature, I VMeer (on the building at the far left), is virtually identical to that found in *A Girl Asleep* (colorplate 6), which dates about 1657. Although Vermeer's forms of signature are not totally consistent, this particular type is different from those found in paintings from the 1660s. This combination of factors, and the connections with De Hooch, strongly suggest a date about 1657 or 1658.

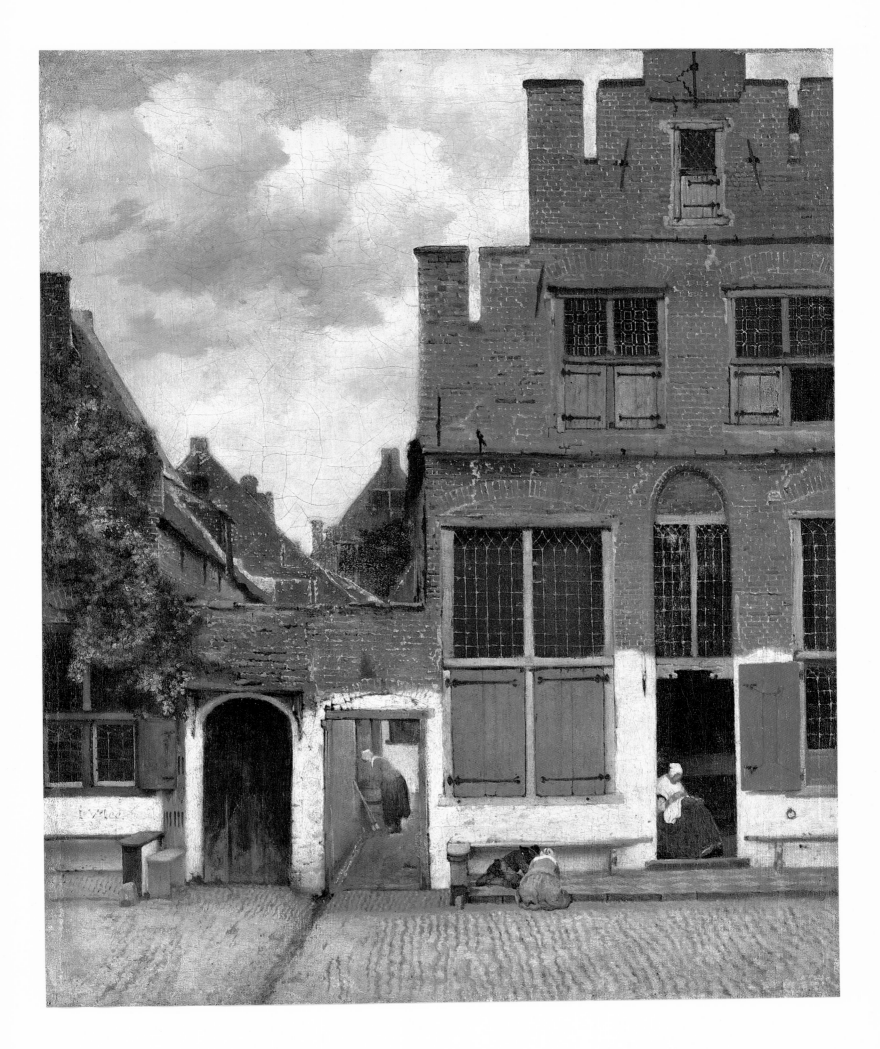

OFFICER AND LAUGHING GIRL

c. 1658

Oil on canvas, 19 7/8 × 18 1/8" (50.5 × 46 cm)

Copyright The Frick Collection, New York

One of Vermeer's most glowing paintings is the *Officer and Laughing Girl*. The light that floods the corner of the room where the couple sits is given a particular intensity by the silhouetted figure of the soldier. His black hat and red jacket form a striking contrast to the light background and yellow-green tablecloth. The girl, who leans forward slightly in her chair and smiles at the soldier, is vividly portrayed in a yellow and black jacket.

Because the costume of the girl and the painting techniques resemble those of the *Girl Reading a Letter at an Open Window* (colorplate 7), this painting is generally dated about 1658, shortly after the other. The differences in mood between these works are substantial: whereas the *Girl Reading a Letter* is quiet and restrained, this work is exuberant and stresses momentary action. The shift of emphasis may be due to Vermeer's close contact with Pieter de Hooch.[67] De Hooch, during the mid-1650s, painted a number of interior genre scenes of soldiers and women at tables (figs. 15, 17). In some of these, he also tended to situate the soldier so that the viewer peered over his shoulder; this viewpoint gave an informal appearance to the scene.

Although Vermeer seems to have adopted his subject matter from De Hooch, his conception of the scene is quite different. Vermeer brought his figures extremely close to the picture plane. He heightened the contrast of scale between the two figures and intensified contrasts of light and color. The effect is comparable to that seen in a wide-angle lens or convex mirror.[68] Vermeer may have become interested in optical devices through an association with Fabritius, and apparently sought to capture the expressive character of their images in this work.

If Vermeer did experiment with an optical device, he did not recreate its image exactly. The architecture of the room is constructed according to the laws of linear perspective. The rapidly receding orthogonals of the window frame draw one quickly back into depth. The perspective, moreover, is designed to reinforce the bonds between the two figures. The vanishing point of the window is located midway between the eyes of the soldier and the woman. Vermeer did make one modification in the perspective scheme: he drew the man's chair so that its orthogonals recede to a higher horizon than that of the rest of the room. By doing so, he enhanced the contrast in scale between the soldier and the girl.

This painting contains one of the first examples of Vermeer's precise sense of realism: the map on the back wall.[69] Wall maps, which were popular forms of decoration in Vermeer's day, are frequently found in his paintings. This map of Holland and West Friesland was designed by Balthasar Florisz. van Berckenrode in 1620 and published by Willem Jansz. Blaeu a few years later. Fortunately one example of the map still exists (fig. 67), and it confirms the precision of Vermeer's rendering.

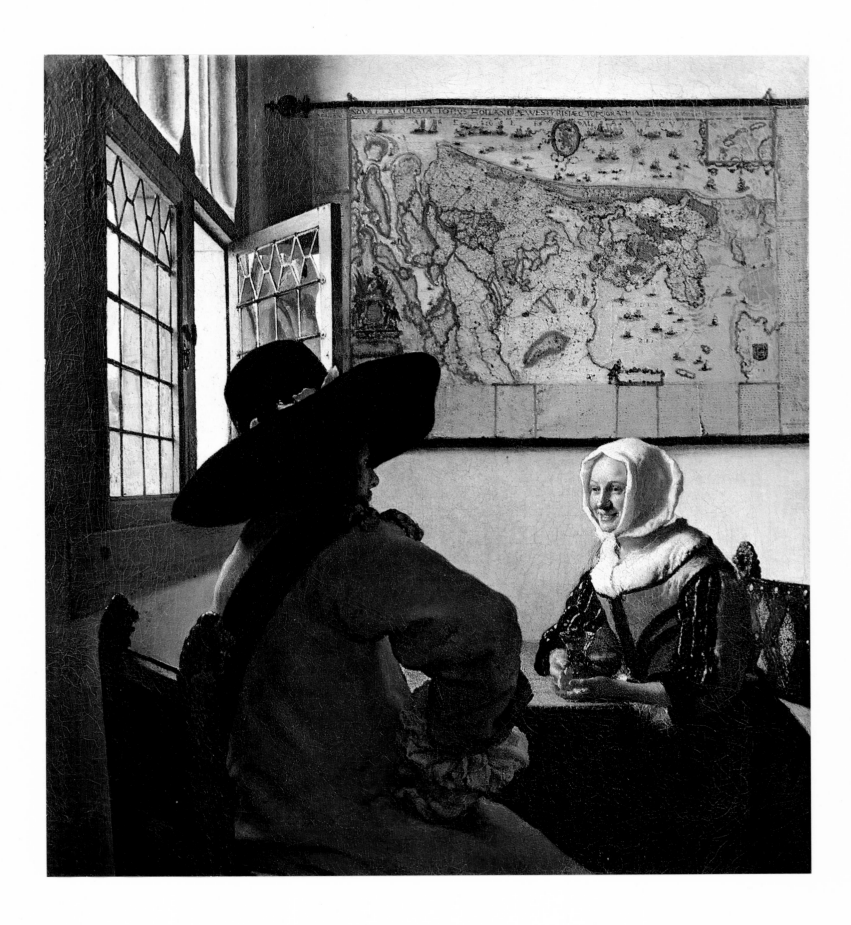

Detail of OFFICER AND LAUGHING GIRL

The light that enters through the window in this room literally sparkles across the table, the girl, and her chair. This extraordinary effect gives the painting its unusually vivid quality. To achieve this result Vermeer used the technique of painting with small dots or globules of paint that he had developed so successfully in the *Girl Reading a Letter at an Open Window* (colorplate 7). The girl in both paintings wears the same jacket with yellow stripes on the arms. In both paintings the stripes are indicated by a succession of dabs of a dense yellow paint, probably lead-tin yellow. The lion head finials and the diamond pattern on the girl's chair in the *Officer and Laughing Girl* are similarly built up with small dots of paint of various sizes and densities.

This scene's freshness also comes from the appearance of light flickering off the surface of the table. Vermeer achieved this quality by juxtaposing rather than by blending the pale green and yellow paints that comprise the color of the tablecloth. He also increased the density of the yellow along the contours of the soldier's red jacket to intensify the silhouetted effect of his body.

The precise sources for Vermeer's interest in rendering effects of natural daylight are not known. Carel Fabritius, who demonstrated an interest in the way shadows are thrown against a blank white wall in *The Sentry* (1654; fig. 22), may have induced Vermeer to render similar effects. Fabritius's experiments with optical devices may also have had an impact on this aspect of Vermeer's style, since these devices are most effective when used with strong natural light. Other possible influences were the architectural painters Gerard Houckgeest and Emanuel de Witte, who explored ways in which sunlight created patterns in the interiors of the great Delft churches. None of these artists, however, developed Vermeer's distinctive technique of rendering the effects of sunlight with these small dabs of paint.

Aspects of this technique were shared by many of his contemporaries. The still-life painter Willem Kalf (1619–1693), for example, also was interested in rendering the various textures of material substances (fig. 45). Many of the effects he achieved—the woven texture of heavy tablecloths, the grainy texture of lemon and orange peels, and the shiny surfaces of porcelain—are comparable to those seen in Vermeer's paintings. The specular reflections from silver trays are also similar. Other genre painters of the period indicated highlights with white globules of paint. Nicolaes Maes, in his *Listening Maid* of 1656 (fig. 44), for example, applies specular highlights on the sword and the cabinet on the right. Even though this technique was known to other painters, none exploited it to the extent that Vermeer did. He was the first artist who really examined how light reflects off objects and tried to devise an equivalent in paint.

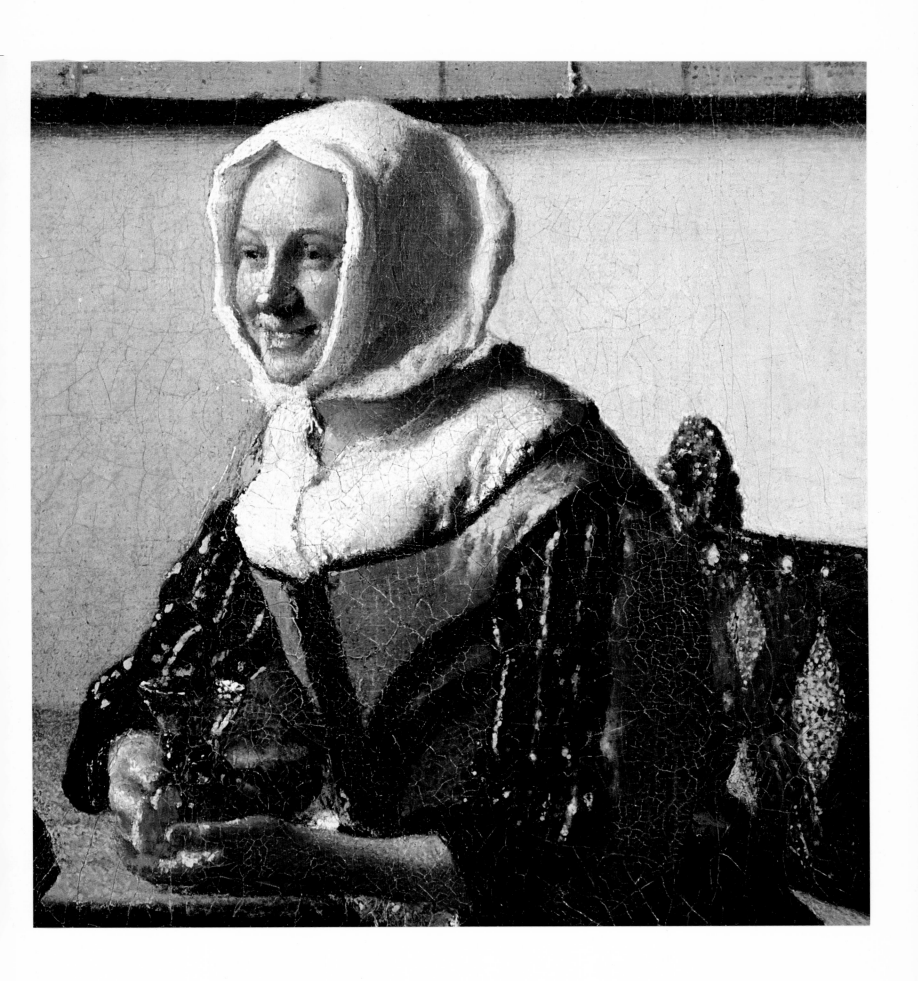

THE MILKMAID

c. 1658–60

Oil on canvas, 17 7/8 × 16 1/8" (45.5 × 41 cm)

Rijksmuseum, Amsterdam

Vermeer's genre paintings are of two different kinds: those concentrating on a single figure and those describing a social situation. Perhaps the best known and most beloved of Vermeer's single figure compositions is *The Milkmaid*. In its strength, simplicity, and directness it has come to epitomize the essence of the Dutch character. As one might expect, *The Milkmaid* was greatly admired in the nineteenth century. Vincent van Gogh and Thoré-Bürger, among others, wrote about it, but they were not the first to recognize its qualities. In the 1696 sale which contained so many of Vermeer's paintings, *The Milkmaid* sold for the excellent price of 175 florins, second in value only to the *View of Delft*, which sold for 200 florins. By the time it was sold in 1719 it was described as "The famous Milkmaid, by Vermeer of Delft, artful."[70]

For such a simple composition, *The Milkmaid* has virtually no precedents in Dutch art. Although De Hooch and Ter Borch had portrayed aspects of domestic life and had emphasized the virtues of such endeavors, neither they nor other artists had managed to capture this quality in a single figure. Part of the painting's directness comes from the bold silhouette of the woman against a bare white wall. Unlike Ter Borch and De Hooch, who avoided such distinct contours, Vermeer exploited them wherever possible. In *The Milkmaid*, for example, he reinforced the contour of the woman's back with a thin white line which is visible in a X-ray of the painting (fig. 69). This entirely unnaturalistic device had the effect of heightening the contrast of the figure against the wall and intensifying its colors. X-rays also indicate that Vermeer initially depicted an object, perhaps a map, hanging on the back wall above the woman's head. Although, as in the *Girl Reading a Letter at an Open Window*, Vermeer may have removed this background element to eliminate a symbolic reference, he also might have decided that the bare wall, with its rough texture, was the appropriate setting for the type of figure he was portraying.

Most of Vermeer's figures differ from the milkmaid in that they belong to a more elevated social class. Their clothes are finer, their furnishings more elegant, their demeanor more suited to a life of leisure and contemplation than to a practical one. Vermeer's painting techniques also differ in this work. His brushstrokes are vigorous and bold; his modeling is comparatively rough. His colors—the yellows, blues, greens, and reds—are strong and earthy. These differences of emphasis remind us how cautiously one must approach questions of chronology in his work. Progressions of style are never totally linear and vary according to the type of image being portrayed. Nevertheless, comparisons of the painting techniques of *The Milkmaid* and the *Officer and Laughing Girl* (colorplate 10) show many similarities and suggest close chronological proximity.

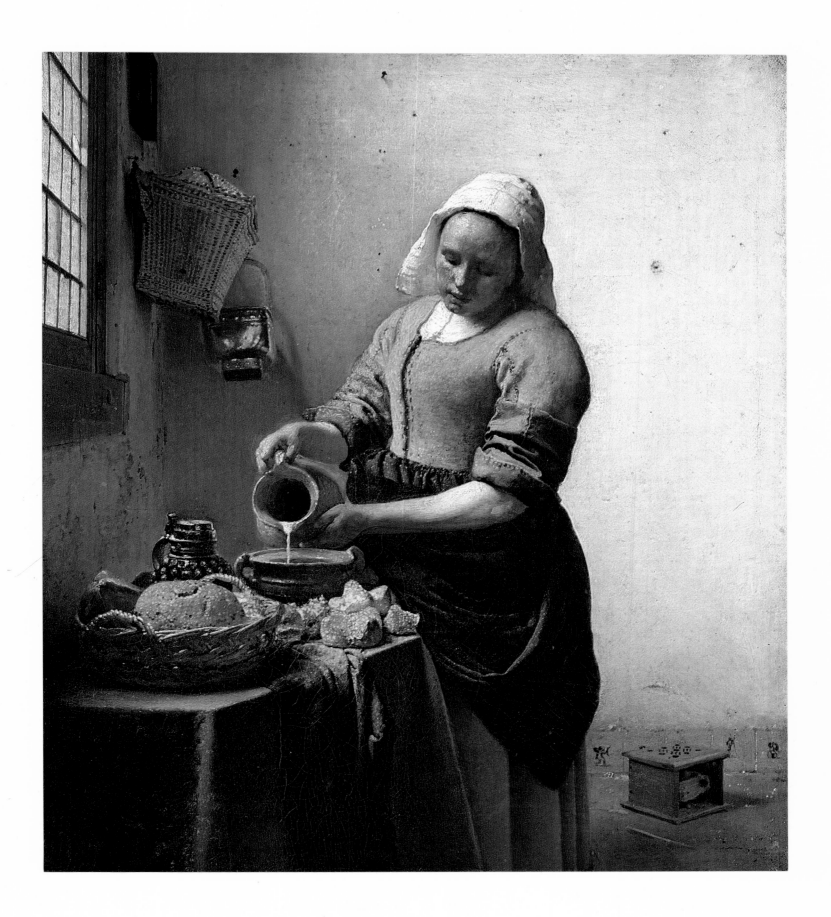

Detail of THE MILKMAID

One of the most fascinating areas of *The Milkmaid* is the still life on the table. The bread, the basket, the pitchers, the milk, and the bowl have such a vibrancy that they almost vie with the woman as the focus of the composition. Vermeer achieved their extraordinarily luminous quality by trying to suggest the way light enlivens their forms and reflects from their surfaces. He has created this effect with a complex paint structure that suggests both the rough texture of the objects depicted and their translucent qualities. The bread, for example, is painted in three layers. The lowest one is a thick, lumpy layer of lead white (this layer is the one evident in the X-ray of the painting, fig. 69). Over this he applied a thin reddish glaze through which the peaks of the lumps from the lower layer protrude in the form of white dots. Finally, he added more highlights with small dots of whitish-yellow paint on top of the red glaze. Similar techniques are found on the basket and pitcher on the table, although he varied the colors of the highlights according to the local color of the materials: for the bread and basket he used whites and ochers; for the pitcher he applied white and gray dots. Vermeer enlivened the blue cloth on the table and the woman's apron with a variety of light blue highlights and applied purple accents to the woman's cuffs.

This technique of accenting forms with small dots of paint is one Vermeer experimented with as early as 1656 in *The Procuress* and then again in the *Girl Reading a Letter by an Open Window* and the *Officer and Laughing Girl*. Yet in none of these instances did he use it to the degree apparent in *The Milkmaid*. The intensity of its use in this instance, and the peculiarly diffused quality of some of the dots, has led to speculation that Vermeer was inspired by the camera obscura. This hypothesis, however, must be carefully examined. Although highlights in unfocused images in a camera obscura are often diffused and are visually comparable to the effects Vermeer achieved in the still-life area of this painting, they are generally evident only on reflective surfaces, such as metal, polished wood, or water. On soft surfaces, cloth or bread, an unfocused image appears blurry, but diffused highlights are uncommon. Thus their appearance in *The Milkmaid* is not totally in accordance with what one would find in a camera obscura.

Given Vermeer's obvious concern over matters of perspective, color, and light, one may well imagine that he was intrigued by this optical device and by the effects that it achieved: the heightened sense of color, contrasts of light and dark, and diffused highlights. In this sense, the direction of his own stylistic evolution may have been reinforced by the types of effects he observed in a camera obscura, but it seems unlikely that he actually traced images from a camera obscura or that this device transformed his style of painting. He must have used it as he used other artistic aids, including perspective theory, emblem books, and color theory—as a source to consult and draw upon. The camera obscura certainly had an impact on Vermeer's style, but he used it selectively to create a painting and not to duplicate an image.

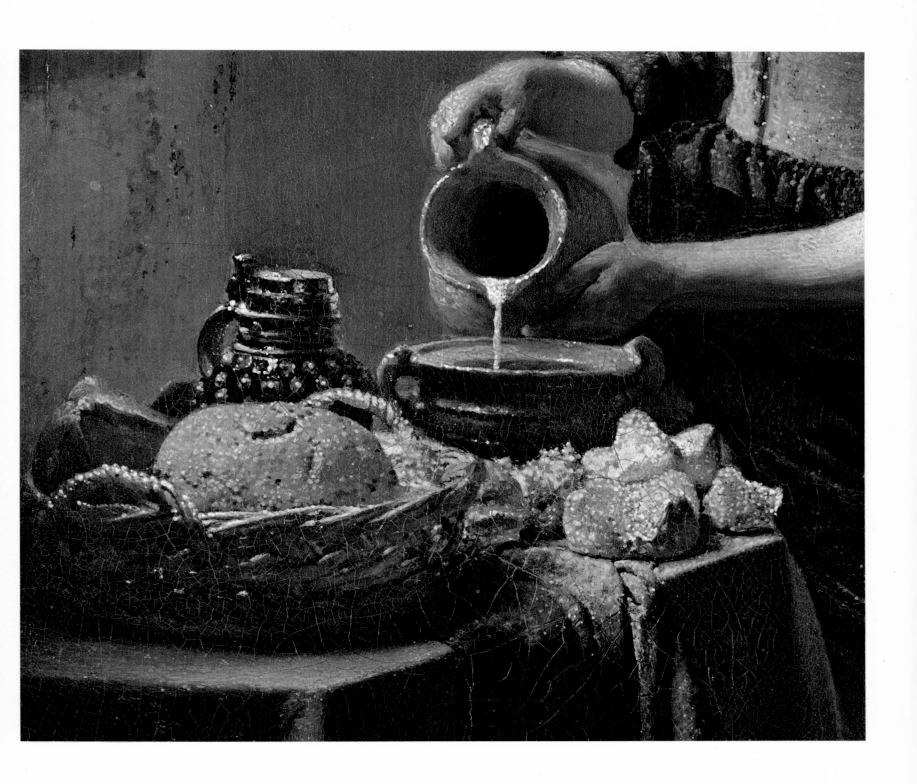

COLORPLATE 14

THE GLASS OF WINE

c. 1658–60
Oil on canvas, 25 5/8 × 30 1/4" (65 × 77 cm)
Staatliche Museen Preussischer Kulturbesitz
Gemäldegalerie, Berlin-Dahlem

In the late 1650s Pieter de Hooch developed a type of genre painting that epitomizes what has come to be known as the Delft School. In such paintings (figs. 16, 17), a group of figures is situated in a spacious, light-filled interior or courtyard. The architectural space is carefully defined, and the perspective recession of windows, ceiling beams, tiles, and bricks is accurately constructed. Figures, whether they be socializing around a table or occupied in domestic chores, tend to be set back in the space rather than situated in the foreground.

Vermeer's *The Glass of Wine* belongs entirely in this context. It is one of the clearest demonstrations of how he responded to the achievements of another artist. In this scene Vermeer depicted a spacious interior and set the figures back from the picture plane. Laws of linear perspective are rigidly and obviously followed. The subject of figures drinking around a table, and even the portrayal of a woman drinking from a glass, are taken from De Hooch (fig. 16).

One major difference exists between *The Glass of Wine* and De Hooch's prototypes: Vermeer's interior is more elegant. The figures are well dressed, the table is covered with an elaborate rug, the window contains a coat of arms, and the picture on the back wall has a gilded frame. The demeanor of the man and woman is also so proper that no explicit associations of love, such as one might make given the presence of the lute and a glass of wine, can be made.

These differences in emphasis suggest that Vermeer was attempting to translate De Hooch's type of genre painting into a form appropriate to a higher social class. In the process he also modified some of his painting techniques. Compared to the bold and free brushstrokes in *The Milkmaid* (colorplate 12), those in this painting are comparatively subdued. In particular, the clothes and faces of the figures in *The Glass of Wine* are smoothly painted. Only in the tablecloth and lion head finials did Vermeer maintain the same vigorous brushwork.

One explanation for the differences between this painting and *The Milkmaid* is that Vermeer felt a refined subject matter called for a finer technique. During this period Jan Steen (fig. 70), Frans van Mieris (fig. 71), and Gerard Ter Borch also began to paint in a refined technique and to depict figures of an elevated social status. *The Milkmaid* belonged to another tradition, and the techniques that were appropriate to it needed to be revised before they could be translated into paintings depicting a more genteel society.

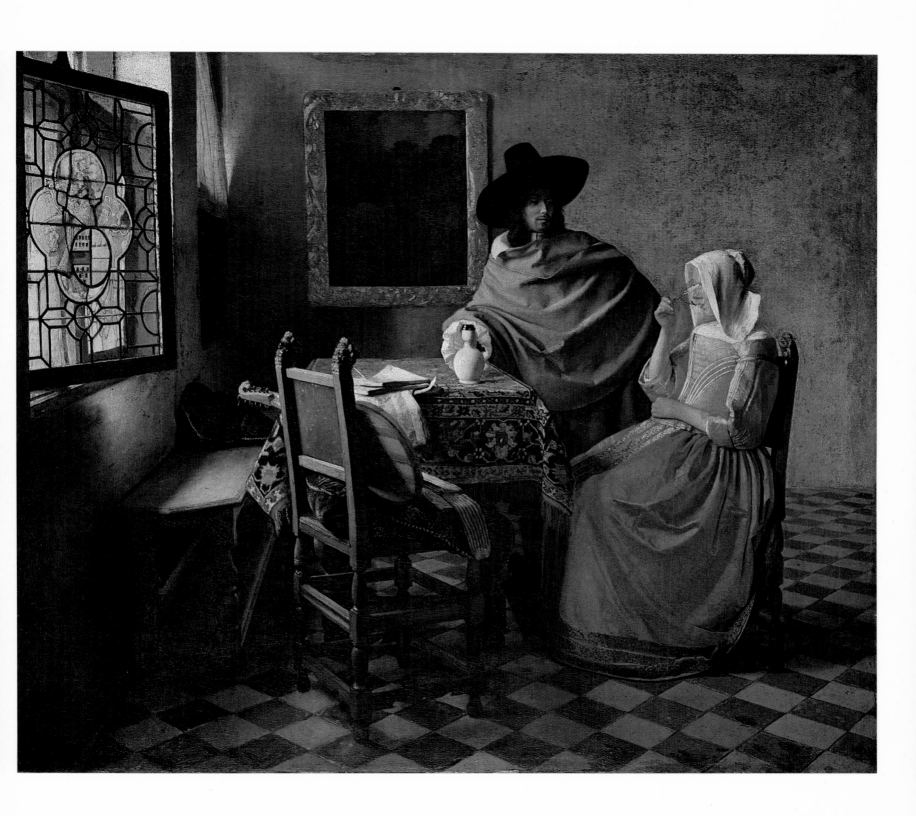

THE GIRL WITH THE WINEGLASS

c. 1659–60
Oil on canvas, 30 3/4 × 26 3/8" (78 × 67 cm)
Herzog Anton Ulrich-Museum, Brunswick

Vermeer's genre scenes are situated in rooms that can be identified by their window designs, tile patterns, and walls. One historian has determined that Vermeer painted in five rooms that reappear in various compositions.[71] We should be cautious, however, about reconstructing Vermeer's interior spaces. As with Pieter de Hooch, differences in these rooms may be the result of artistic license.

Occasionally, these considerations do matter because they help group Vermeer's paintings chronologically. In *The Girl with the Wineglass*, for example, the same spacious interior, tile pattern, and window occur as in *The Glass of Wine* (colorplate 14). Although Vermeer omitted the back window and modified the color of the tiles and the window design, the similarities suggest that the two paintings were painted in the same room and in close chronological proximity. Although the clothing of the girl in this painting is more elegant than that in *The Glass of Wine*, it could well date from the late 1650s. A similar dress is worn by a woman in Frans van Mieris's *The Duet*, signed and dated 1658 (fig. 71).

In *The Girl with the Wineglass* Vermeer portrayed a well-dressed gentleman leaning over a young woman encouraging her to drink a glass of wine that she holds gingerly in her hand. She looks out at the viewer with a smiling, almost laughing expression. Sitting behind the table is a man in a melancholic pose (see fig. 65), who is either reacting to too much wine or to the girl's obvious attraction to the other man. His mood and pose are reminiscent of those in *A Girl Asleep* (colorplate 6).

A Girl Asleep has a painting on the wall that gives a clue to its meaning. In *The Girl with the Wineglass* the picture in the background is a portrait of a gentleman with a dignified demeanor. The relationship of this painting to the scene taking place before it is not immediately apparent, and perhaps the painting has no symbolic relevance. Vermeer, however, may have intended to contrast the dignity of the portrait with the activity of the figures. The coat of arms prominently displayed in the window reinforces this assumption. It has been identified as belonging to a family who formerly lived in a house adjacent to Vermeer's,[72] and contains the figure of a woman who apparently, because of the bridle that she holds in her hand, represents the allegorical figure of Temperance. Thus, as with *A Girl Asleep*, the implications of the painting are that one should conduct one's life with temperance and moderation.[73]

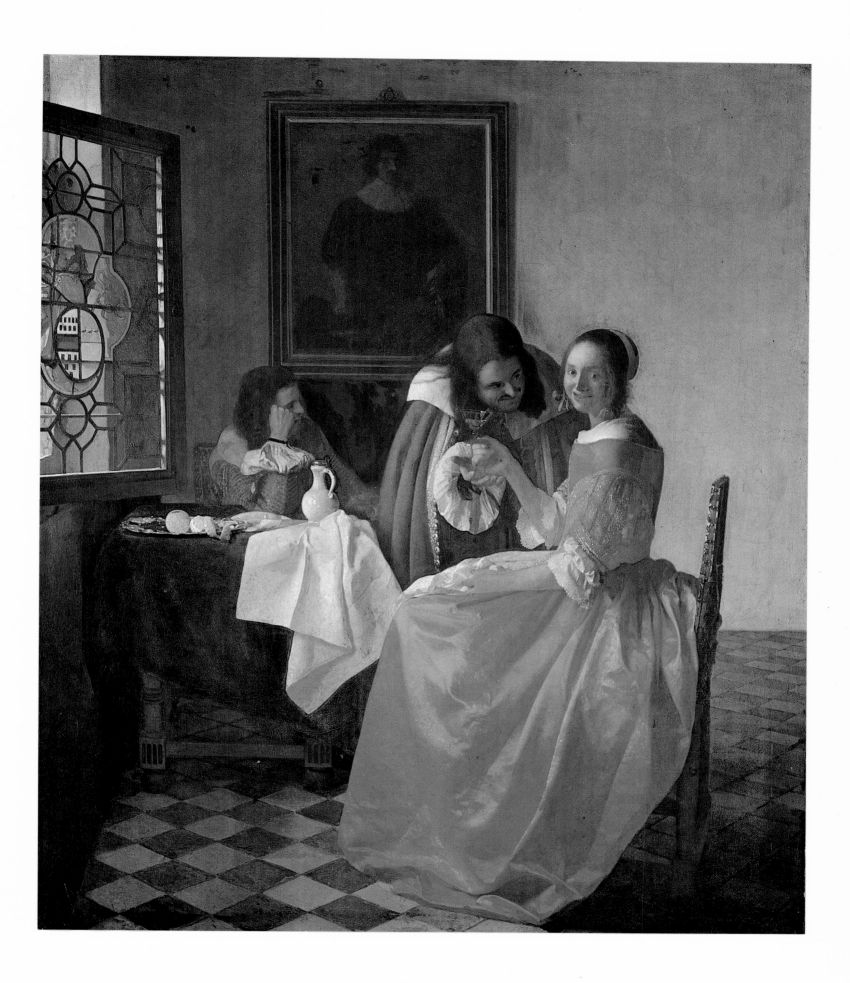

VIEW OF DELFT

c. 1660–61
Oil on canvas, 38 3/4 × 46 1/4" (98.5 × 117.5 cm)
Mauritshuis, The Hague

Cities are known to posterity for many reasons, but few owe as much of their fame to one artist as does Delft to Vermeer. The associations are valid, for not only did Vermeer live in Delft, but his paintings are imbued with its quiet charm. Vermeer's *View of Delft*, moreover, is perhaps the greatest celebration of a city's existence ever created.

The *View of Delft* is a painting for which one can never be properly prepared. Its grandeur is difficult to convey in reproductions because of the importance to the painting of scale and texture. The *View of Delft* is large, sufficiently large to draw one into its world, to allow one to sense the recession of the sky and the ripples of the water and to confront the walls guarding the city. The buildings themselves, the foreground ones thrown into shadow and those beyond sparkling in the sunshine, form an integrated yet varied pattern of shapes, colors, and textures. The brick-red roofs on the left, for example, have a rough, sandy texture; the sunlit salmon-colored roofs in the middle distance are painted with thick, undulating paint suggestive of their corrugated tile pattern.

The *View of Delft* belongs to a tradition of topographic views of cities that extends back to the sixteenth century. Maps often included a profile view of a city, and some, including one that Vermeer depicted in *The Allegory of Painting* (colorplate 33), had multiple views. Vermeer was certainly familiar with this tradition and also with painted views, since Hendrick Vroom (1566–1640), one of the foremost topographical artists of the early seventeenth century, painted two impressive views of Delft.[74] Indeed, one early topographical painting, *View of Zierikzee*, 1618, by Esaias van de Velde (fig. 7), has often been cited as a prototype for Vermeer's painting.

The *View of Delft*, however, is not a totally accurate topographical representation of the city (see pp. 32–33). Furthermore, X-rays reveal that numerous small changes have been made in the rooftops. These changes indicate that Vermeer compressed the cityscape into a dense frieze by simplifying the city's profile and spreading out its forms. He then articulated the architecture with patterns of light and dark and with selected reflections in the water. These patterns of reflections are also modified for reasons of design. Finally, he enhanced the grandeur of the setting by contrasting the horizontality of the city with the rich, full sky and the clouds that tower over it.

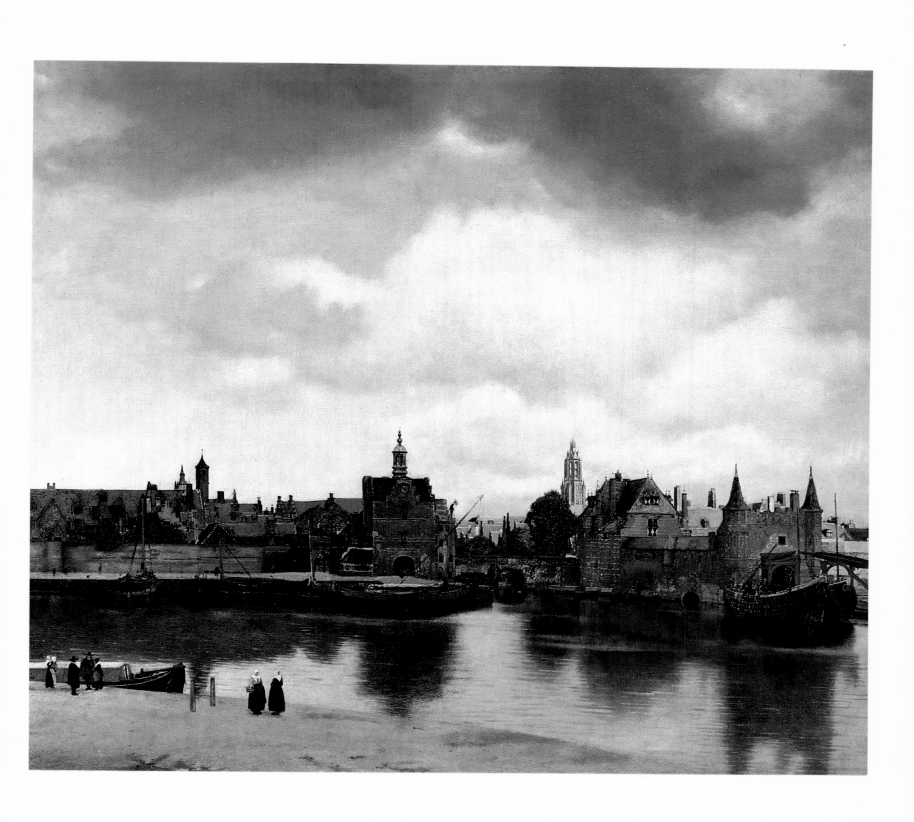

Detail of VIEW OF DELFT

In the plan of Delft (fig. 1) that appeared in Willem Blaeu's atlas of 1649, a house is shown standing at the site from which Vermeer observed the city to paint this view. Since one receives the impression that Vermeer was looking down on the figures along the near shore, one might even imagine that Vermeer looked down from an upper level of the house.[75] This information would only be of marginal interest were it not for the quite plausible hypothesis that Vermeer conceived his scene with the aid of a camera obscura.

Vermeer did not need a camera obscura to record accurately the profile of the city, and indeed, as has been seen, many differences exist between the topography of the city and the image of it Vermeer created. The hypothesis of the camera obscura gains validity not because of the apparent accuracy of the view but because of the distinctive effects of light, color, atmosphere, and diffusion of highlights along the far shore.

Because a camera obscura reduces the scale of objects but not the amount of color or light that reflects off them, color accents and contrasts of light appear even more intense than they do in natural vision. This phenomenon has the subsidiary one of minimizing effects of atmospheric perspective. In the *View of Delft* all of these phenomena are present. Contrasts of light and shade are pronounced, colors of roof tiles are vivid, and atmospheric perspective is negligible.

Along the far shore of the Schie, particularly on the boats, numerous diffused highlights appear that closely resemble those seen in unfocused images in a camera obscura. Vermeer, from almost the beginning of his career, articulated his images with small dabs, or globules, of paint to enhance textural effects. These diffused highlights differ in the *View of Delft* from those in his other paintings (with the possible exception of *The Milkmaid*); not only are they more diffuse, they are also unrelated to texture. Their purpose is to suggest the flickering of reflections off the water. Such reflections would appear as diffuse circular highlights in an unfocused image in a camera obscura. They would, however, be visible only in sunlight, not in shadows as they are painted here. Thus, even when Vermeer seems to have used a camera obscura, he modified and adjusted its image for compositional reasons.

The role of the camera obscura in Vermeer's artistic procedure must not be overestimated. He did not trace his compositions from its images, nor did he paint in a dark room copying what he saw. The camera obscura was but one means he used to experience more fully the effects of light and color in the world about him.

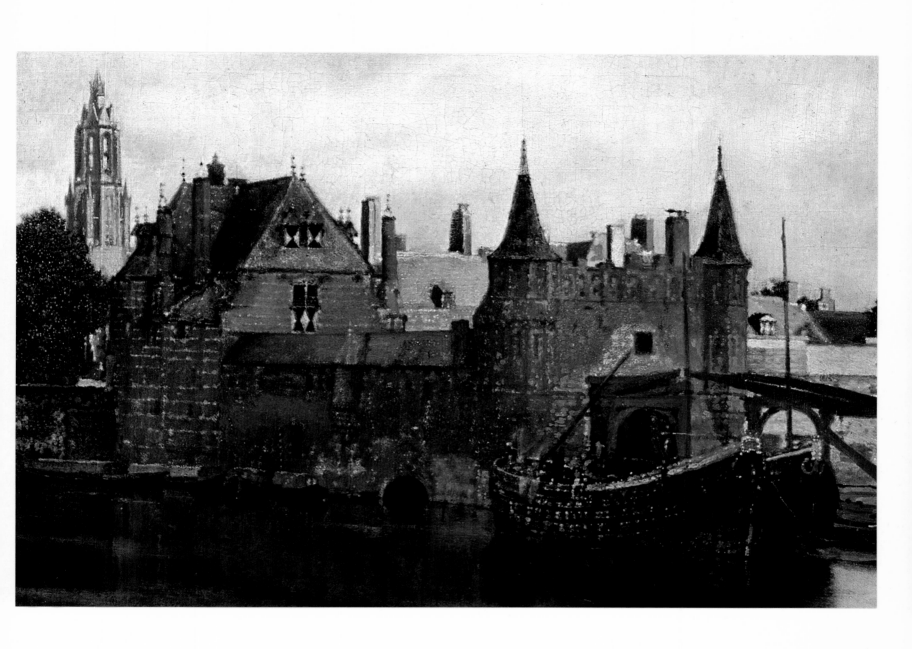

GIRL INTERRUPTED AT HER MUSIC

c. 1660–61

Oil on canvas, 15 1/2 × 17 1/2" (39.3 × 44.4 cm)
Copyright The Frick Collection, New York

Most Dutch genre painters favored scenes which included some specific action. In Jan Steen's *Music Master* of about 1659 (fig. 70) or Frans van Mieris's *The Duet* of 1658 (fig. 71), for example, figures are engrossed in each other and in the making of music. In each instance a young attendant enters the room, adding to the level of activity. Vermeer, in a number of paintings from the end of the 1650s, sought to achieve similar effects in his multi-figured genre paintings. His results, however, were mixed at best. In *Officer and Laughing Girl* (colorplate 10), *The Glass of Wine* (colorplate 14), and *The Girl with the Wineglass* (colorplate 15), his attempts at rendering an action, whether it be laughing, drinking, or smiling, resulted in rather forced and artificial poses.

In the *Girl Interrupted at Her Music* Vermeer arrived at a solution for this problem: the momentary interruption. This device allowed him to suggest movement without the need for specific gestures and facial expressions that conflicted with the essential stillness of his compositions. In this painting the gentleman and the girl make a compact group as his form gently enfolds hers. She, however, rather than concentrating on the music they hold, looks out at the viewer. Her expression is alert and expectant, but not forced. Light falls gently across her face and on her white headpiece, accenting her gaze.

Vermeer may have used this pose to emphasize the meaning of his painting. Music is often associated with love (fig. 52), an association that is reinforced in this instance by the painting on the back wall. This painting, perhaps by Caesar van Everdingen, also appears in *A Lady Standing at the Virginals* (colorplate 46) and was initially included in *Girl Reading a Letter at an Open Window* (colorplate 7). Its depiction of a cupid holding a card marked with a figure 1 is based on an emblem from Otto van Veen's *Amorum Emblemata*, 1608 (fig. 48). The emblem's motto, "Perfectus Amor est nisi ad unum," states that perfect love is but for one lover. The woman's gaze out of the picture may thus have been intended to reinforce a didactic message. Interestingly, in *A Lady Standing at the Virginals*, the woman also looks out of the painting toward the viewer.

Unfortunately, this painting is in very bad condition.[76] Only the still-life area preserves something of its original surface qualities. The birdhouse on the side wall is an addition painted later by someone else and was not part of Vermeer's design.

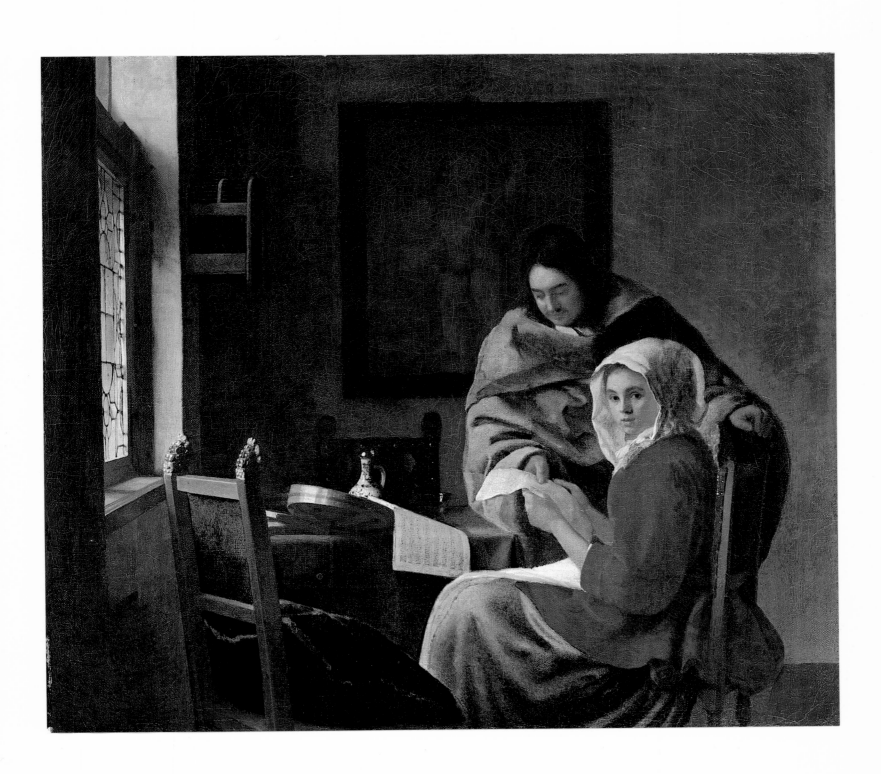

THE MUSIC LESSON
(A LADY AT THE VIRGINALS
WITH A GENTLEMAN)

c. 1662–65
Oil on canvas, 28 7/8 × 25 3/8" (73.3 × 64.5 cm)
Copyright reserved

On the far side of a sunlit room with double windows a young woman stands to play on a clavecin. A man in elegant dress watches her and listens intently. Both figures are quiet and statuesque, as though the music were measured and restrained. Indeed, this painting is one of the most refined works in Vermeer's oeuvre. In it, figures, musical instruments, picture, mirror, table, tile patterns, and chairs, however realistically presented, are conceived as patterns of color and shape.

Such abstract design principles are generally associated with the twentieth century. One cannot approach this work, however, without realizing that Vermeer calculated his compositional elements every bit as carefully as did Mondrian. The pattern of the roof beams, the repetition of black shapes on the back wall, the position of the table, chairs, and pitcher have all been painstakingly planned. Minor adjustments in the shapes of objects clearly testify to the artist's care about the precision of his composition. The pitcher on the table, for example, once had a thinner neck. Vermeer also adjusted the shape of the clavecin's lid to improve the composition. The lid is slightly wider to the right of the girl than it is to her left, a shift of alignment that lessens the tendency to visually connect the two halves of the lid design through the girl. Similar adjustments occur in at least two other paintings from this period: *A Woman Holding a Balance* (colorplate 22), where he shifted the height of the bottom edge of the picture frame, and *The Concert* (colorplate 29), where he adjusted the contour of the lid of the clavecin as it passes behind the standing woman.

Technical examinations have revealed that Vermeer initially painted the man slightly closer to the girl and then repainted his form in its present position.[77] The girl's head also was once turned more toward the man. Its position was more like that in the mirror than it is now. By moving the man away and by turning the girl's head back, Vermeer succeeded in loosening their bond and allowed them to work more coherently in the total composition.

In this work, Vermeer actually gave us a clue that the scene was posed. We can vaguely perceive the shape of his easel and perhaps the artist's box in the mirror. Vermeer's implied presence thus gives the painting a different character from those in which the figures seem to exist in their own personal world. It makes the scene somewhat colder and more calculated. At the same time, however, it makes us aware of the intellect that went into its creation.

100

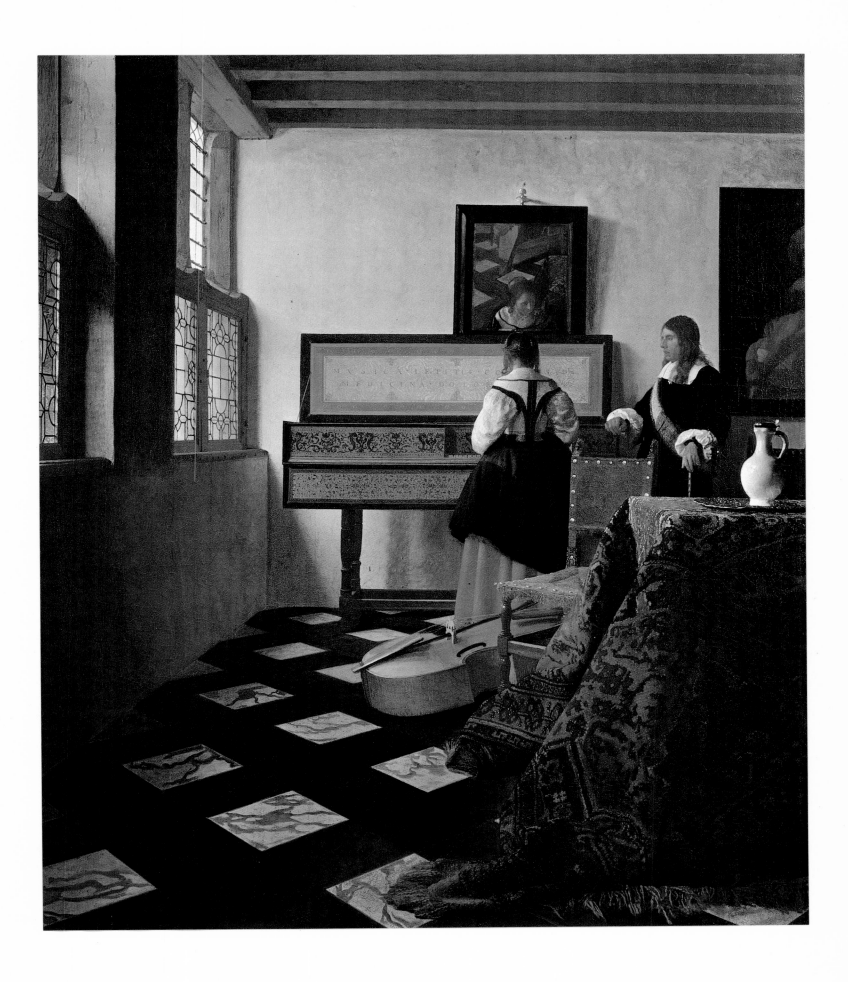

Detail of THE MUSIC LESSON
(A LADY AT THE VIRGINALS
WITH A GENTLEMAN)

However calculated the composition of this painting, it could not succeed without Vermeer's sensitive handling of light and color. Light floods the wall near the windows, but gently looses its force as it falls away from them. Shadows of objects, such as the mirror, are modulated because the light comes from different sources. Colors are also subtly adjusted according to the nature of the light that falls upon them. The letters of the inscription on the lid of the clavecin are ocher on the left of the girl but blue on her right. Similarly, the leading in the rear window is painted in ochers, but that in the adjacent window, against which the sky is seen, is blue.

The vividness of the scene is also created by the textural effects evident in the painting. Just as Vermeer depicted the tile roofs of the buildings in the *View of Delft* with different textures of paint, so here he varied his textures when representing a chair, a tablecloth, a reflection in the mirror, or a white porcelain pitcher. The brass studs on the chair, for example, are so thickly painted that they actually protrude from the surface plane. Similarly, the blue fringe of the chair cover has a bumpy texture.

Vermeer painted the table cover with a variety of layers. Over a basic ocher layer he applied the blues, yellows, reds, and oranges that combine to form the pattern of the design. These colors have been carefully applied, some densely, some thinly, to suggest the nubby character of the material. His technique for painting the pitcher, however, is quite the contrary. In this instance the surface is smooth and few brushstrokes are visible. Finally, when he wanted to depict the veins of the marble on the floor, he used broad, flowing strokes that are remarkably free and abstract.

The one area of this painting that differs in character, that lacks a similar interest in rendering textures, is the man. His figure is painted somewhat more thinly than that of the girl and with less emphasis on the definition of individual folds and materials. One wonders if Vermeer's decision to change the man's position was made sometime after the original execution of the painting, perhaps around 1665, a date that is also appropriate for the man's clothing.

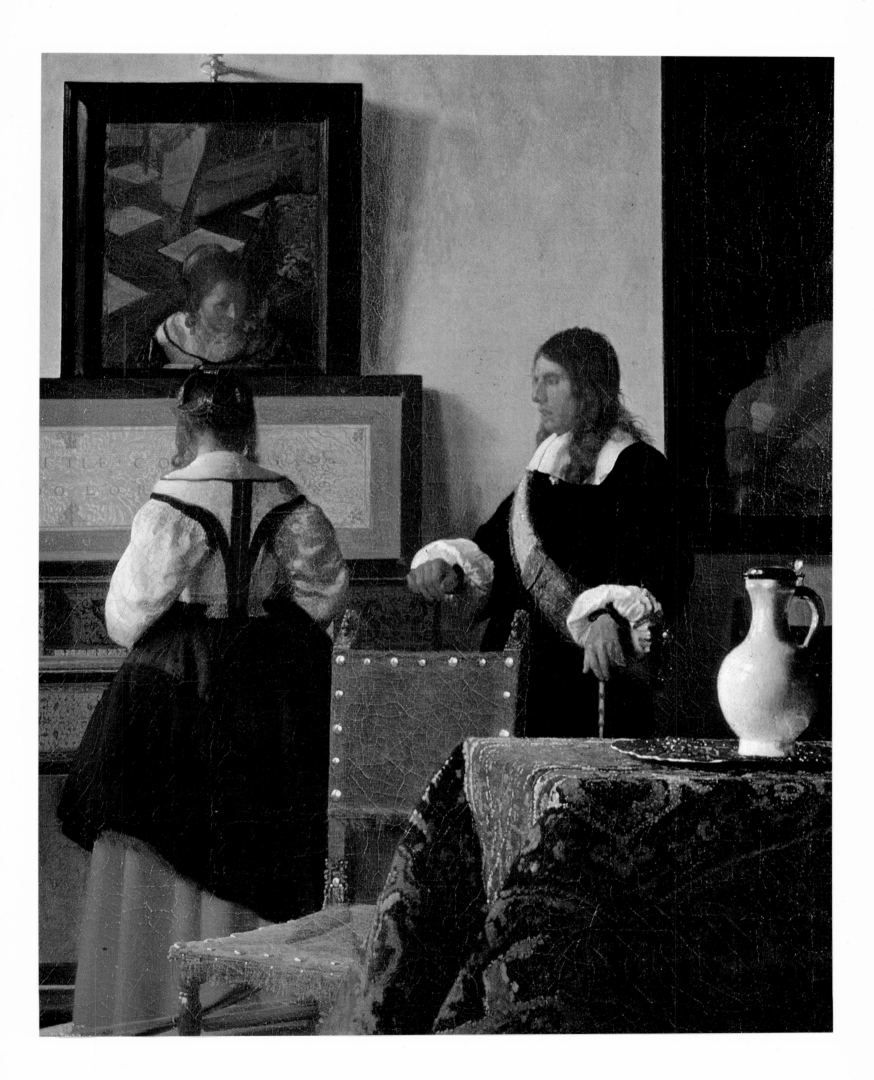

WOMAN IN BLUE READING A LETTER

c. 1662–64

Oil on canvas, 18 1/4 × 15 3/8" (46.5 × 39 cm)

Rijksmuseum, Amsterdam

Vermeer was one of the few Dutch artists to appreciate the rich range of human expression possible in intimate domestic scenes: the pause of a woman as she stands before a window holding a watering can, reading a letter, tuning a lute, or trying on a strand of pearls. Such moments in life, when one is alone and immersed in thought, are often fleeting and without consequence to others. Vermeer, however, discovered in them a poetry that he translated into images that are forever recurring. Perhaps through the inspiration of Gerard ter Borch, Vermeer first portrayed this type of subject about 1658 in his *Girl Reading a Letter at an Open Window* (colorplate 7). In the early to mid-1660s he concentrated on the theme of a single figure, alone and immersed in thought, in what must be one of the most beautiful series of images ever created.

The *Woman in Blue Reading a Letter* is perhaps the earliest of these images from the 1660s and is interesting to compare with his version from the late 1650s. Vermeer defined the space in both paintings with tables and chairs and, with the same furniture, isolated the figure from the viewer. In the *Woman in Blue Reading a Letter*, however, he simplified his composition by eliminating the window frame and curtain, and by reducing the variety of objects and shapes on the table. Whereas in the *Girl Reading a Letter at an Open Window*, the figure was part of a larger environment, in the later work she dominates it and becomes its focus.

With such a simplified composition Vermeer had to be extremely careful about the proper placement and proportion of the objects in his painting. The map on the back wall, for example, appears much larger in this painting than in his earlier *Officer and Laughing Girl* (colorplate 10). X-rays demonstrate that Vermeer originally blocked in a smaller space for the map and then extended it a few centimeters to the left (fig. 72). He also reduced the width of the woman's jacket, which once flared outward in the back, a modification that gave the woman's figure a more simplified, grander form than she originally had.

These changes also signify Vermeer's awareness of the importance of shapes between objects, or negative shapes, as they are called. Vermeer organized his composition so that the white shapes of the wall, beside the map, in front of the woman, and behind her, become positive elements in the painting. Vermeer's color harmonies in the 1660s were also simpler and more muted than in the late 1650s. Blues, whites, and ochers dominate the *Woman in Blue* while yellows, greens, reds, blues, and whites are predominant in the *Girl Reading a Letter*. The map here is painted in mute ochers and olive greens, while that in the other painting is more multicolored. The overall effect of these changes is that the image becomes even more still and quiet. The viewer can share to a greater extent the quiet moment that the woman experiences while immersed in her letter.

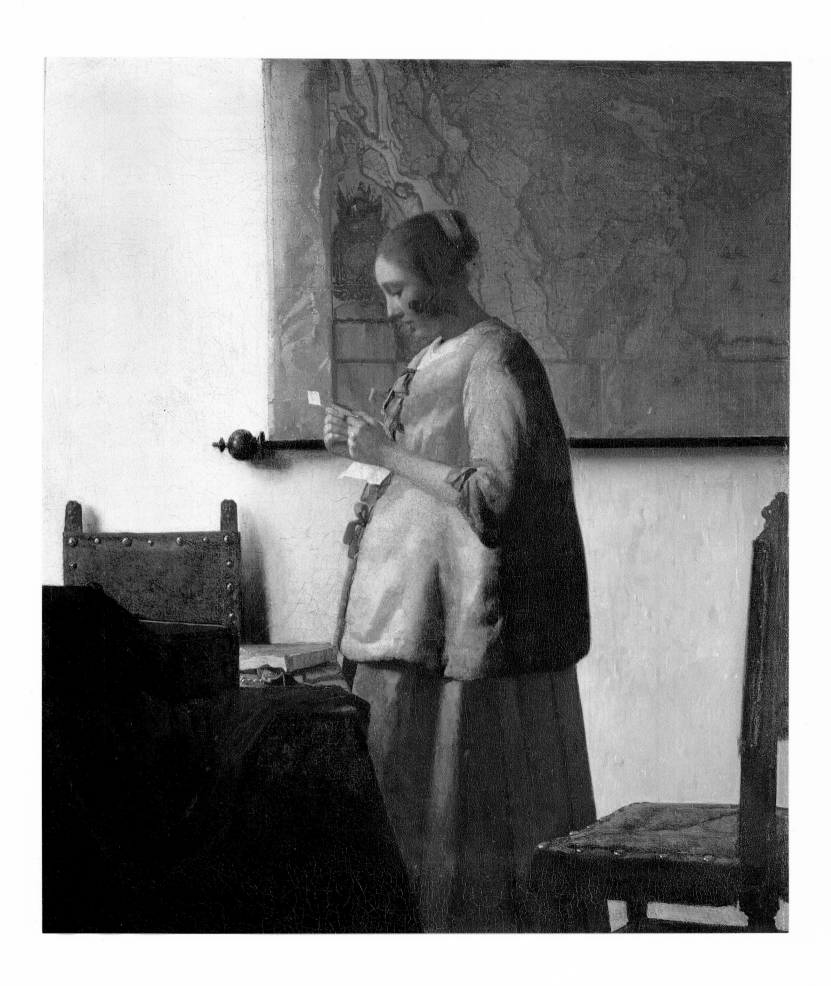

A WOMAN HOLDING A BALANCE

c. 1662–64
Oil on canvas, 16 3/4 × 15" (42.5 × 38 cm)
National Gallery of Art, Washington, D.C.
Widener Collection, 1942

In his painting *A Woman Holding a Balance*, Vermeer depicted a young woman standing before a table in a corner of a room. She gazes towards a balance gently held in her right hand. As though waiting for the delicate modulations of the balance to come to rest, she stands transfixed in a moment of equilibrium. She is dressed in a blue morning jacket bordered with white fur. Around her head is a white cap. Left untied, it falls loosely to either side of her neck, framing her pensive yet serene face. Diffused sunlight, entering through an open window before her, helps illuminate the scene. The light, warmed by the orange curtain before the window, flows across the gray wall and catches the fingers of her right hand and the balance before resting on her upper figure.

Behind the woman looms an awesome painting of the Last Judgment. Painted in mute blacks and ochers, it acts as a compositional foil to the scene taking place before it. Its dark rectangular shape, with its horizontal and vertical emphasis, establishes a quiet, stable framework against which Vermeer juxtaposes the figure of the woman. The visual association of the woman and the Last Judgment is reinforced by thematic parallels: to judge is to weigh. Christ, his arms and hands raised, sits in majesty on the Day of Judgment. His gesture, with both arms raised, mirrors the opposing direction of the woman's balance. His judgments are eternal; hers are temporal. Nevertheless, the woman's pensive response to the balance she holds suggests that her act of judgment, although different in consequence, is as conscientiously considered as that of the Christ behind her.

Most interpretations of this painting contrast the eternal values represented by the Last Judgment and the material concerns of the woman. The painting is thus interpreted as a Vanitas theme.[78] The woman has been called the personification of Vanitas.[79] These theories, however, are based on the assumption that the pans of the balance contain precious objects, generally identified as gold or pearls. Recent microscopic examinations of the painting reveal that the pans contain neither gold nor pearls but are empty.

As in so many of his other masterpieces, Vermeer avoided here the anecdotal, which lends a specific meaning to a particular gesture, but the mood that he transmits helps us interpret his basic intent. The woman does not appear tempted by the jewels that lie on the table before her: she concentrates on the balance in her hand. Her attitude is one of inner peace and serenity. The psychological tension that would suggest a conflict between her action and the implications of the Last Judgment does not exist. The balance denotes her responsibility to weigh and to balance her own actions. The mirror on the wall opposite her refers to the search for self-knowledge. In her acceptance of the responsibility of maintaining the balance and equilibrium of her life, she is aware, although not in fear, of the final judgment that awaits her.

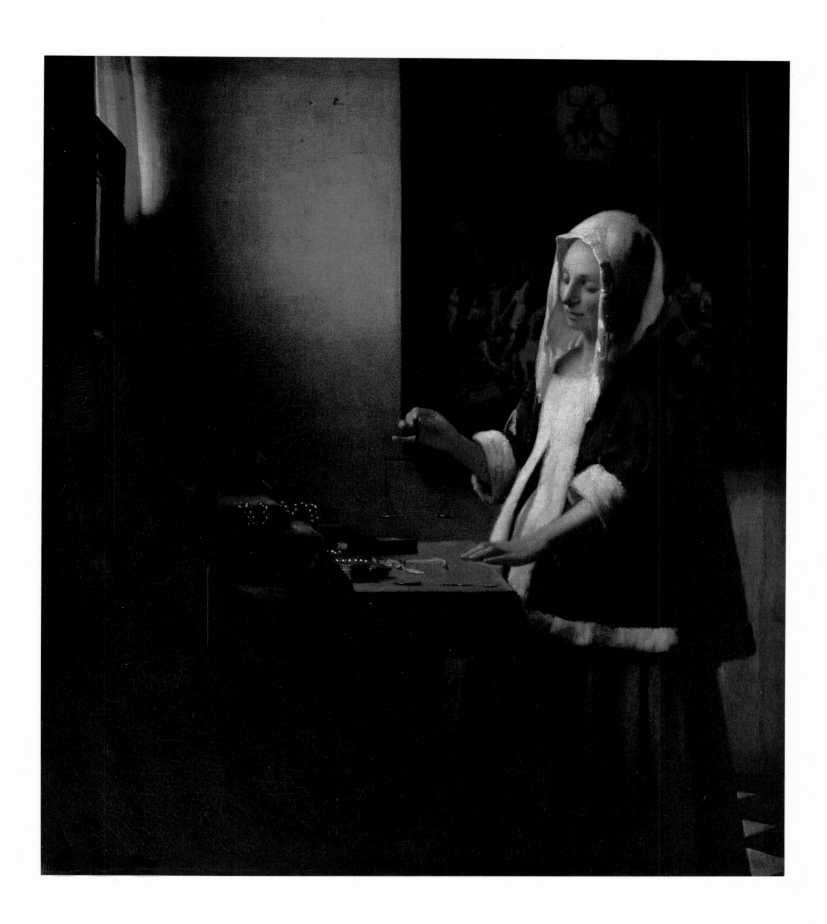

Detail of A WOMAN HOLDING A BALANCE

Stylistically, this painting offers one of the most glorious examples of Vermeer's exquisite sense of balance and rhythm. The woman, her right hand gently poised holding the scale, extends her small finger to give a horizontal accent to the gesture. Her left arm, gracefully resting on the edge of the table, closes the space around the balance and establishes an echo to the gentle arch of boxes, blue cloth, and sunlight sweeping down from the other side. The scales themselves, perfectly balanced but not symmetrical, stand poised against the gray-brown wall in a small niche of space created especially for them. Vermeer took the liberty of raising the bottom edge of the picture frame to the left of the woman to allow sufficient space for the balance. Throughout, the interplay of verticals and horizontals, of mass against void, and of light against dark, creates a subtly balanced but never static composition.

The degree of Vermeer's sensitivity can best be illustrated by comparing the scene with a close counterpart by Pieter de Hooch, *The Goldweigher* (fig. 74). Although De Hooch probably painted this scene in the mid-1660s after he left Delft for Amsterdam, it is so similar to Vermeer's painting that one can reasonably suppose De Hooch knew of it. Nevertheless, the refinements evident in Vermeer's work are lacking in that by De Hooch. The woman in De Hooch's painting is not gazing at her scales, but is placing a gold coin or weight into one of the pans. Her active gesture separates her from the rhythms and structure of the room. She is an adjunct of that space; it and the forms within it would be complete without her participation.

By contrast, Vermeer's space is contingent upon the woman's presence. The perspective lines of the mirror, for example, converge to a vanishing point at her right hand. Their coincidence, combined with the supporting structural element of the frame of the Last Judgment, reinforces the importance of the gesture and also integrates the young woman with the geometric organization of the painting.

De Hooch's woman weighs her gold before a wall richly decorated with a gilded leather covering and a half-open door leading into a second room. Neither of these elements reinforces the basic thematic gesture of a woman with a balance as strongly as does the painting of the Last Judgment. Thematically as well as structurally, De Hooch's work lacks the inner coherence of *A Woman Holding a Balance*. Finally, the serenity of Vermeer's woman as she stands contemplating her scales establishes a mood that shields her from the limitations of moment and event. Vermeer transcends the genre orientation of the scene; De Hooch, who emphasizes her actions, not her thoughts, does not.

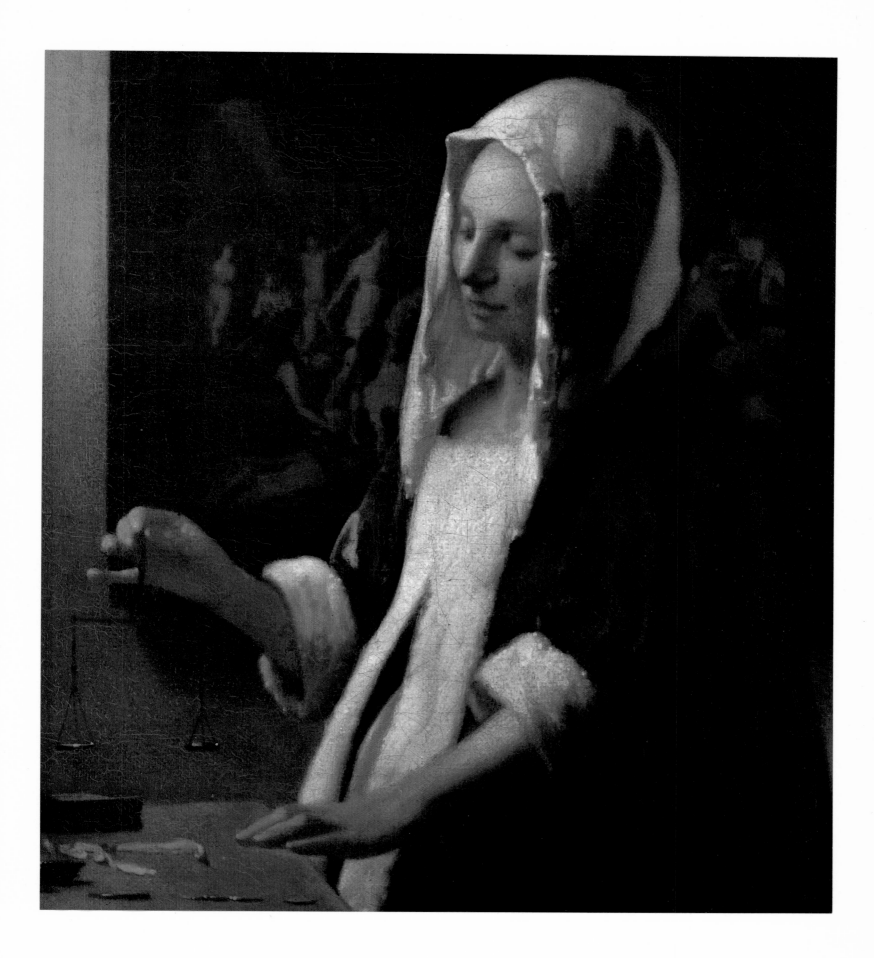

WOMAN WITH A PEARL NECKLACE

c. 1664

Oil on canvas, 21 5/8 × 17 3/4" (55 × 45 cm)
Staatliche Museen Preussischer Kulturbesitz
Gemäldegalerie, Berlin-Dahlem

The *Woman with a Pearl Necklace* portrays a woman gazing into a mirror while holding two yellow ribbons that are attached to a pearl necklace she wears. Silhouetted against a white wall, she stands behind a table and chair in the corner of a sunlit room. Vermeer, in this painting, used the compositional format he followed in the *Woman in Blue Reading a Letter* (colorplate 21) and *A Woman Holding a Balance* (colorplate 22), but gave it a more dynamic character. In each of the other paintings Vermeer concentrated on the inward thoughts of the woman and conceived of ways to present self-contained images. Likewise, in the *Woman with a Pearl Necklace* he minimized the apparent physical activity of the figure, portraying her at the moment she has the ribbons pulled taut. Her thoughts may be inward, but they are expressed through her gaze, which reaches across the white wall of the room to the mirror next to the window. The whole space between her and the side wall of the room thus becomes activated with her presence. It is a subtle yet daring composition, one that succeeds because of Vermeer's acute sensitivity to the placement of objects and to the importance of spaces between these objects.

X-rays of this painting, the *Woman in Blue*, and *A Woman Holding a Balance* present further evidence of Vermeer's attention to exact compositional arrangement. All of these paintings have damages along the edges, indicating that they were once attached to slightly smaller stretchers. This smaller format may have been the one Vermeer selected, for in each instance the composition at the reduced dimension is the more successful of the two possibilities. With each of these paintings subsequent restorers, noting that the painted composition extended over the edges of the stretcher, reenlarged the format to what they thought were its original dimensions.

This phenomenon is most striking in the *Woman in Blue*. In this painting severe paint losses have occurred across the bottom of the composition at the level of the chair seat. Vermeer may have recognized that his composition would be stronger if he eliminated the succession of small shapes created by the legs of the chair. He may have reached this decision after painting the *Woman with a Pearl Necklace*, where the bottom edge of the painting aligns with the seat of the chair.

Vermeer may have used the type of stretcher seen in a 1631 painting by Jan Miense Molenaer, *The Artist's Studio* (fig. 73), in which strong twine, strung between the linen and nails or holes in the stretcher, attached the linen to the frame. After completing his painting, Vermeer could then have selected the optimum format for his composition. He would have subsequently placed the linen on a conventional stretcher. In the process of reducing his compositions, however, painted tacking margins would have remained.

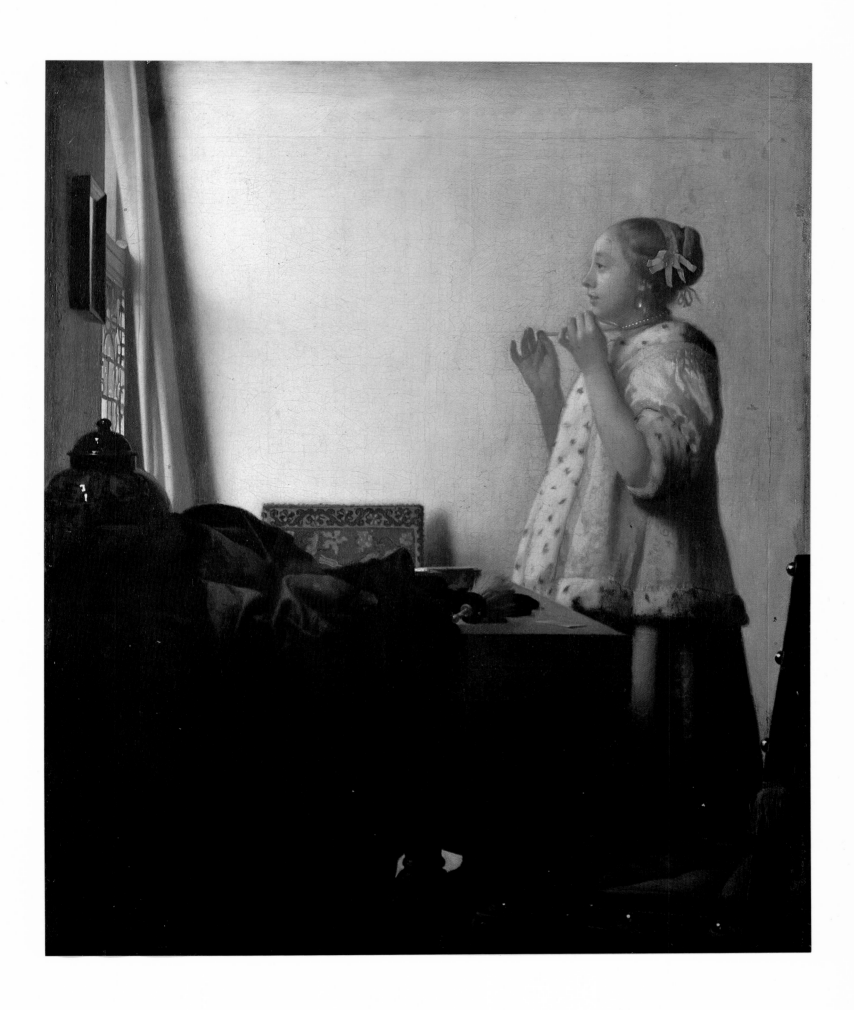

WOMAN WITH A LUTE

c. 1664

Oil on canvas, 20 1/4 × 18" (51.4 × 45.7 cm)

The Metropolitan Museum of Art, New York

Bequest of Collis P. Huntington, 1925

Vermeer, from the beginning of his career as a genre painter, tended to establish a barrier between his figures and the viewer. This compositional device served two purposes: it reinforced the sense of privacy with which he endowed his figures, and it created a feeling of depth in his paintings. In only a few instances, however, is this foreground element as dramatic as it is in the *Woman with a Lute*. Because in this painting the woman is seated and the point of view is low, the contrast between her scale and that of the lion finial chair and cloth in the foreground is emphasized. This contrast gives a greater three-dimensional impact to the painting than is evident in Vermeer's other portrayals of single figures.

Vermeer could have created this effect by following strictly the rules of single point perspective described in books by Jan Vredeman de Vries and Hendrick Hondius. Compositions based on perspective rules, however, tend to depend on orthogonals to define the space. In the *Woman with a Lute*, depth is created almost exclusively by the juxtaposition of near and far objects. Vermeer may well have used some perspective aid here, whether a glass frame or camera obscura, which operated within the single vanishing point system but which did not emphasize the need for orthogonals. Such an aid would have given him a basic framework for his composition even if the nuances of proportion and position of objects within the painting could only be worked out by other means.

The manner in which Vermeer actually refined his images is still unknown. As has been discussed, many changes are evident in X-rays of the paintings. Changes in the early genre paintings are often quite extensive, but those in his later works tend to be minor adjustments of scale and proportion rather than changes of substance. Perhaps the differences in the kinds of changes evident indicate a modification of his working procedure; perhaps he merely became more certain of his eventual intent. In any event, his works are so precisely conceived that one may imagine that he worked with preliminary drawings even though none presently exist. Pieter Saenredam, whose paintings also were very refined, evolved a system of drawings for his compositions that Vermeer might have used as well. Saenredam, after sketching his church interiors from life, constructed elaborate preparatory drawings, using rulers and compasses, and then transferred them to his panels.[80]

Unfortunately, the *Woman with a Lute* is in poor condition.[81] Much of the surface has been abraded, with the result that the delicate nuances of color and of light and shade that must once have unified the painting are no longer present.

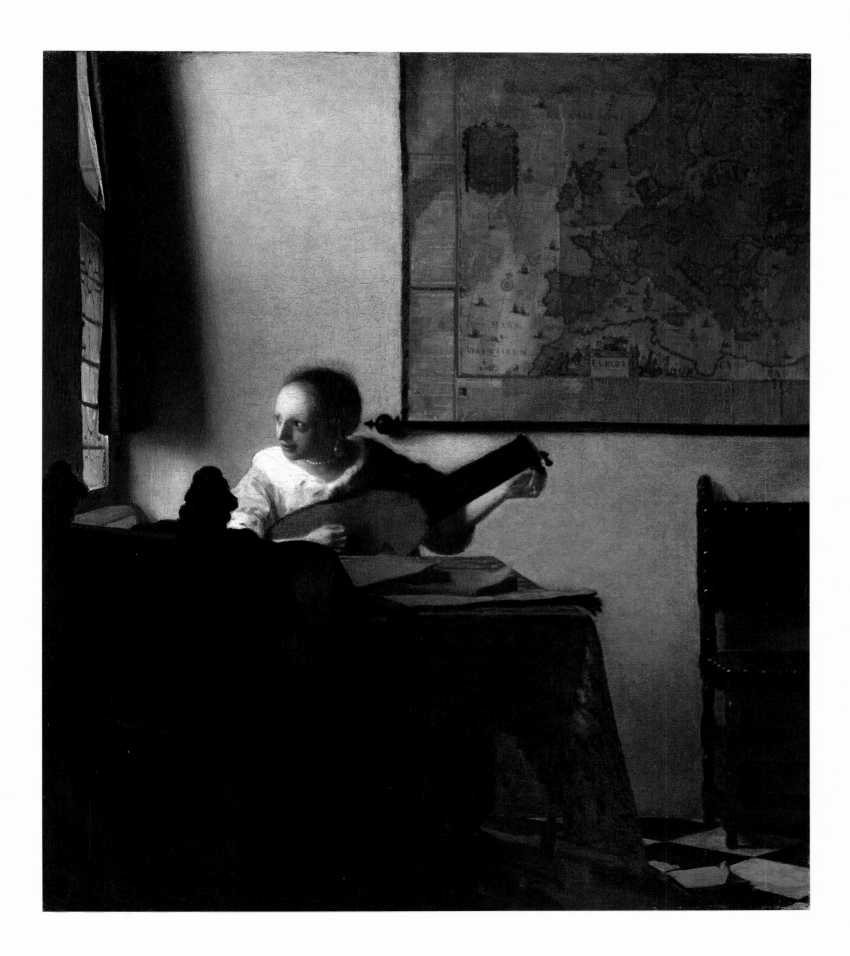

YOUNG WOMAN
WITH A WATER JUG

c. 1664–65

Oil on canvas, 18 × 16" (45.7 × 40.6 cm)
The Metropolitan Museum of Art, New York
Gift of Henry G. Marquand, 1889

Vermeer's paintings are best appreciated when one has time to discover their subtle nuances. The *Young Woman with a Water Jug* is one of his most subtle works, and one of the most rewarding to discover. The placement of every object, color, reflection, and shadow has been carefully decided with an artistic intuition that distinguishes his work from that of his contemporaries.

The subject of the painting could not be simpler. In the corner of a room a woman wearing a blue and yellow dress with a large white collar and headdress stands poised with one hand on a half-opened window and the other clasping a brass water jug. Yet the impact of the image is far greater than one would expect from such a subject. The woman's calm serenity pervades the scene. Her attitude brings to mind those moments in life when, immersed in private thoughts, one forgets limits of time and place.

Nothing in this composition is extraneous or seems out of place. The woman, as she draws back slightly from the partly open window, forms a gentle bridge linking together the two halves of the painting. The graceful curves of her figure help integrate the stricter geometrical shapes of the window, map, table, basin, and pitcher.

The sense of "rightness" that Vermeer achieves with this composition comes in part from the attention he pays to "negative shapes," those areas surrounding objects in the painting. Vermeer has created distinct patterns on the wall between the body of the girl and her extended arms, the map, the window, and the chair. These patterns are not accidental but are created by subtle adjustments of shape and proportion. Such defined shapes help bind the figure to its environment and add to the permanence of the image.

Vermeer's sensitive depiction of light as well as his structural organization give this painting its life and vitality. From the soft, transparent effects he creates in the window, through the modulation of wall color as light flows across the room, to the abstract reflection in the basin and pitcher, Vermeer captures the variety of ways light illuminates and reflects off objects in the room. The softness of the light enhances the sense of timelessness that pervades Vermeer's image of a figure in a moment of quiet contemplation.

This beautiful painting, like many of his unsigned works, was not always attributed to Vermeer. The earliest known reference to the *Young Woman with a Water Jug*, for example, an exhibition catalogue of 1838, attributes the painting to Metsu.[82] In 1878, shortly after Thoré-Bürger's articles on Vermeer, it was exhibited as a Vermeer. Amazingly, nine years later it was sold as a Pieter de Hooch.

The painting was bought by Henry G. Marquand for $800 in 1887 and given by him to The Metropolitan Museum of Art, New York, the following year. It was the first painting by Vermeer to enter an American collection.

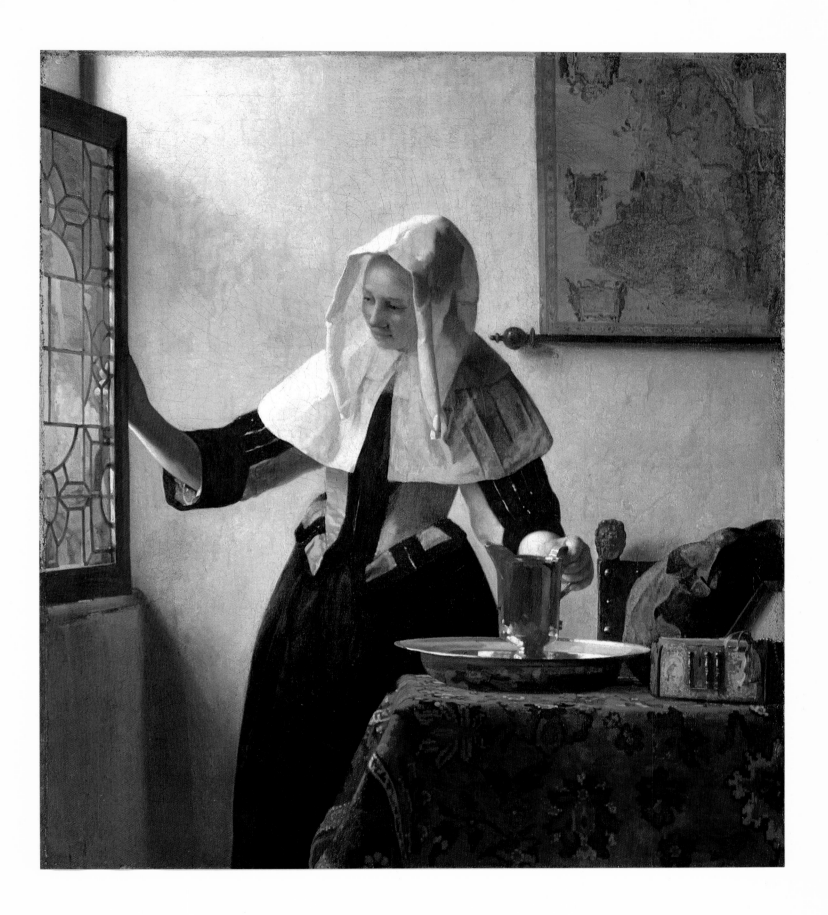

Detail of YOUNG WOMAN
WITH A WATER JUG

The delicacy of this scene extends to the techniques with which it is painted. Instead of using thick impastos as he did in the 1650s, Vermeer integrated opaque areas of paint with thin glazes. His layering of paint became more complex as he sought to enhance the richness of his image by creating a variety of transparent effects. The difference in emphasis may be seen by comparing the yellow bands on the jacket of the woman in this painting with the bands on the girl's jacket in the *Officer and Laughing Girl* of about 1658 (colorplate 10). Although Vermeer still used small dots of paint to highlight the bands here, they are thin and diffused and are placed in conjunction with soft, drawn-out yellow lines.

Vermeer generally covered his canvases with a gray or ocher ground. In this painting he applied a light ocher ground that gives a warm base for the color tonalities. He also used this ground effectively in his shadows. The shaded right side of the girl's jacket, for example, has almost no yellow pigment on it; the ground becomes the color. Shadows of folds, on the other hand, are painted with blue paints which give the material an added satiny sheen. This combination of techniques for forming shadows enhances the apparent three-dimensionality of the figure.

In other areas of the painting, Vermeer covers the ground layer with a second ground, called an imprimatura layer. In this painting a reddish-brown imprimatura layer covers much of the lower right corner. It can be seen, for example, along the upper left edge of the basin. This layer not only enhances the appearance of the reddish reflections on the basin, but also forms the base color for the tablecloth. The patterns of the tablecloth were then applied with freely brushed strokes of blues, reds, oranges, and yellows. The technique is much more fluid and transparent than that in the *Girl Reading a Letter by an Open Window* or even in *The Music Lesson*.

Vermeer, throughout his career, was particularly attentive to contours, to their rhythms, placement, and relative clarity. In this painting, for example, he carefully continued the contour of the pitcher through the girl's sleeve to create a flowing edge for the white shape between her arm and her torso. Some contours, moreover, should be accented, some should be diffused. In *The Milkmaid* Vermeer accentuated the contour of the figure with a stroke of white paint. He used a similar technique here but with a different effect. He created a diffused contour for the girl's blue skirt by brushing a thinly applied white paint along its edge. The effect on the front side of her dress is particularly beautiful as the white contour slowly graduates to pale blue along the edge of the dress.

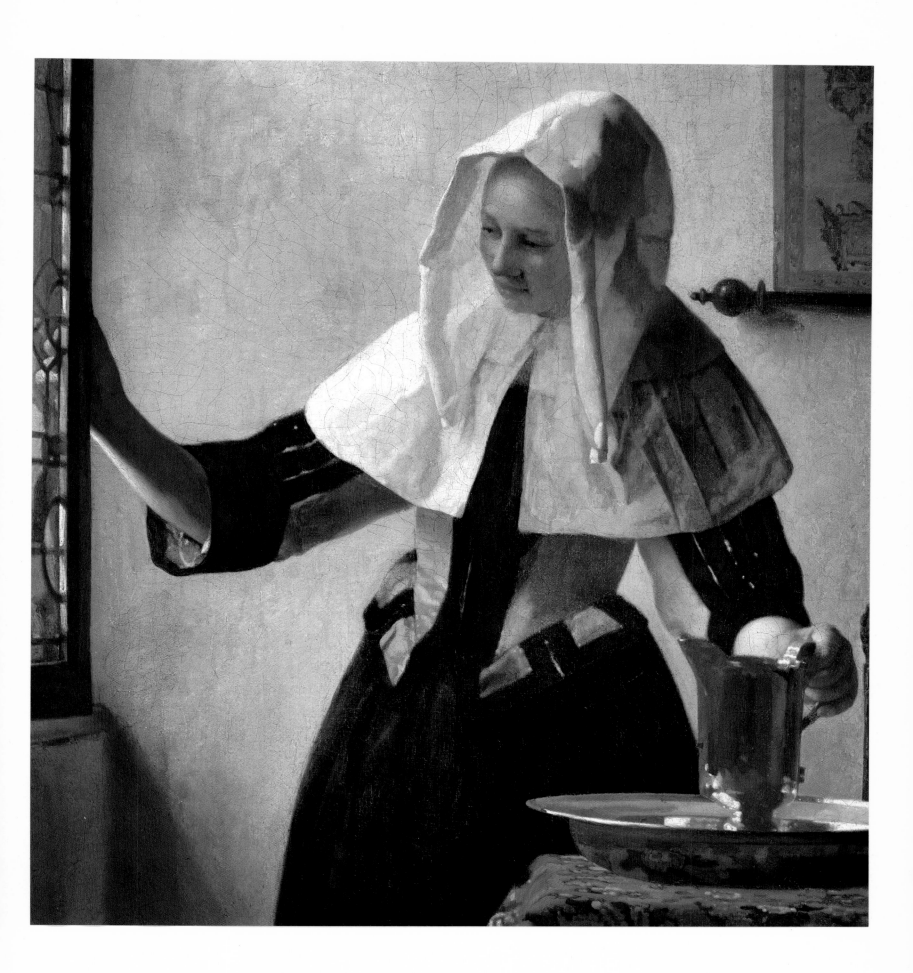

THE GIRL WITH A PEARL EARRING

c. 1665

Oil on canvas, 18 1/4 × 15 3/4" (46.5 × 40 cm)
Mauritshuis, The Hague

The Girl with a Pearl Earring is one of Vermeer's most lucid paintings. The radiant glow of the girl, as she turns toward the viewer, is completely disarming. The mood is enhanced by the pure tones of blue and yellow in her turban, a color harmony that extends throughout the painting.

In this painting Vermeer departed from his normal scheme of silhouetting figures against a white wall and placed her against a plain, dark background. He probably chose this format because he was painting a bust-length portrait. Dutch artists traditionally painted such portraits against dark backgrounds to enhance the three-dimensional effect. (White backgrounds tend to come forward and flatten figures while dark backgrounds recede.)

Because of the immediacy of the image, the *Girl with a Pearl Earring* demonstrates how different Vermeer's approach to painting is from the *fijnschilder* traditions epitomized by Gerard Dou and Frans van Mieris (figs. 20, 21). Dou and Van Mieris painted with extremely fine brushes that allowed a precise delineation of facial features and material textures. Dou, in particular, labored over his paintings for long periods of time as he patiently depicted minute details. Vermeer also painted in a patient manner, but he did not define his forms with precise lines. Indeed, he seems to have deliberately sought to avoid lines. The eyes, lips, and nose are modeled with gently modulated tones of paint. The contour of the face is blurred as Vermeer extended a thin flesh-colored glaze slightly over the background.

A similar technique, although even more freely executed, is evident in the costume. Vermeer blocked in the light blue portions of the turban with an opaque paint but created the appearance of shadows by brushing a thin blue glaze, probably natural ultramarine, over a dark ground layer.

The girl's pose has all the qualities of a portrait, yet the features are purified to the point where one does not think of this figure as representing a specific individual. Vermeer, unlike Dou and Van Mieris, refined and idealized his images. In his approach to painting, Vermeer's mature works belong to the classicizing traditions of Dutch art.

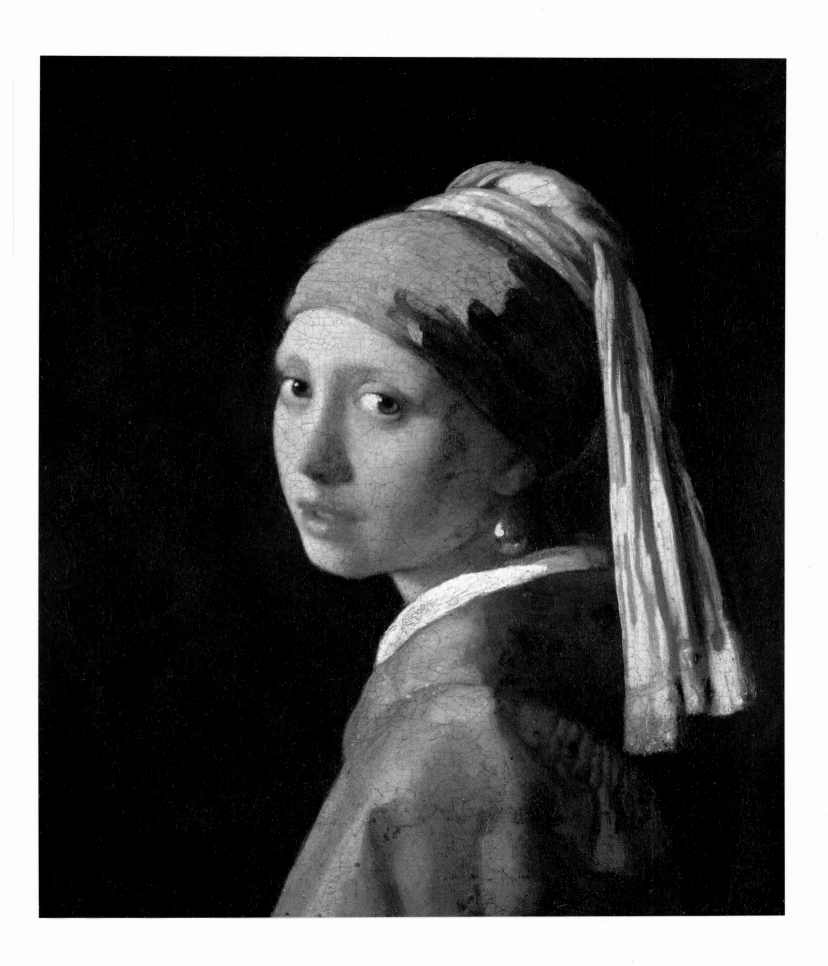

THE CONCERT

c. 1665–66

Oil on canvas, 28 1/2 × 25 1/2" (72.5 × 64.7 cm)
Isabella Stewart Gardner Museum, Boston

The Concert and *The Music Lesson* (colorplate 19) are two paintings that point out the difficulties of interpreting precisely the meanings of Vermeer's works. The theme of music is a frequent one in Dutch art and is generally associated with love and seduction. Paintings by Steen, Van Mieris, and Metsu often include a small statue of Cupid surmounting a door or mantlepiece as a reference to the underlying emotional context of the scene. Associations with love and seduction are also evident in the general attitudes of the figures in these paintings. The music instructor frequently appears more than professionally interested in his student and her progress as a musician.

Vermeer, however, did not provide such clear meanings for his paintings. His choices of objects offered tantalizing suggestions, but the attitudes of his figures remain surprisingly neutral. In the background on the right of *The Concert*, for example, hangs *The Procuress* by Baburen (fig. 9). The subject of this scene has often been thought to indicate the nature of the relationship of the three figures involved in the concert before it.[83] These figures, however, are earnestly concentrating on their music, and do not, in themselves, reinforce the licentious nature of the scene portrayed on the wall.

If we assume that Vermeer intentionally placed *The Procuress* and the landscape to its left on the wall, how are we to interpret this scene? One solution could be that the figures were meant to be in contrast to the paintings rather than to represent, as it were, a *tableau vivant*. Music was also used as a symbol for harmony and as a salve for the soul.[84] With such an interpretation, we note also that the landscape in the clavecin is peaceful and arcadian whereas that on the wall is rugged, in the manner of Jacob van Ruisdael. It includes a dead tree trunk, a motif Ruisdael was fond of using to indicate death and decay.

In this sense the theme of *The Concert* parallels that of *The Music Lesson* more closely than one might expect. One may rightly question the appropriateness of the title of *The Music Lesson*. The gentleman, who is very properly dressed, seems more intent on listening than on instructing. No written music is evident in the formal and spacious interior. As in *The Concert*, the theme seems to be the mollifying effects of music on the human soul. On the cover of the clavecin is written: *Musica Letitiae Co[me]s Medicina Dolor[um]* (Music: Companion of Joy, Balm for Sorrow). By placing the girl so that her back is to us, Vermeer effectively underplayed the importance of her personality and of any relationship between her and the man, allowing us to ponder the significance of music in our lives.

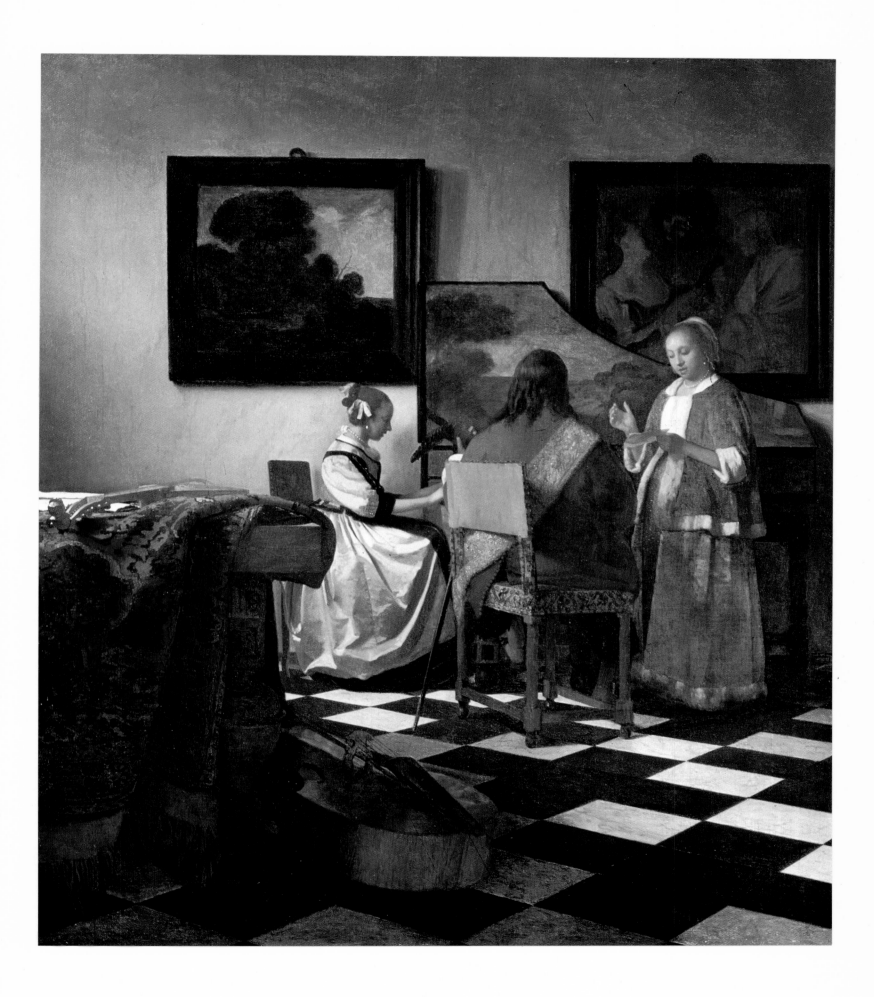

Detail of THE CONCERT

The similarities between *The Concert* and *The Music Lesson* (colorplate 19) are such that they have often been dated at the same time.[85] Both the conception of the scene and the painting techniques of *The Concert*, however, place it around 1665–66, sometime after the conception of *The Music Lesson*. The mood of *The Concert* is more relaxed than that of *The Music Lesson*. The figures seem to belong naturally to the room and to participate in the rhythm of the music. The ease in their demeanor probably resulted from Vermeer's experiences in depicting the series of single figures during the years 1662 to 1665.

The evolution of Vermeer's painting techniques parallels this advance in conception. In *The Music Lesson* he attempted to simulate a number of specific textures by varying the ways he applied his paints: the table covering had a rough, woven appearance; the tassels on the chair cover were indicated with thick paint to enhance their three-dimensional effect. These interests are no longer apparent in *The Concert*. The table covering now has a relatively abstract character. Although the pattern is still defined and small highlights flicker from its surface, one does not sense the same interest in rendering the appearance of woven wool that was previously apparent.

The ways in which the women's yellow jackets are painted are also strikingly different in the two paintings. In *The Music Lesson* the paint is densely applied. Shadows are almost totally created by a thin glaze that covers this opaque layer. In *The Concert* the colors of the dress are painted more sparingly. Shadows, particularly in the skirt, are formed with the ground color rather than with glazes over opaque yellows. The effect of the painting is softer and more delicate than that of *The Music Lesson*.

Unfortunately, this change to a more delicate technique created serious problems of physical condition. Some paintings from the mid-1660s, including *The Concert* and the *Woman with a Lute* (colorplate 25), have suffered from abrasion. Perhaps Vermeer recognized this potential problem, for he painted in this manner for only a short while. In his later works his style became crisper and his paint denser; he depended less extensively on glazes and transparent effects to create his images than he did in *The Concert*.

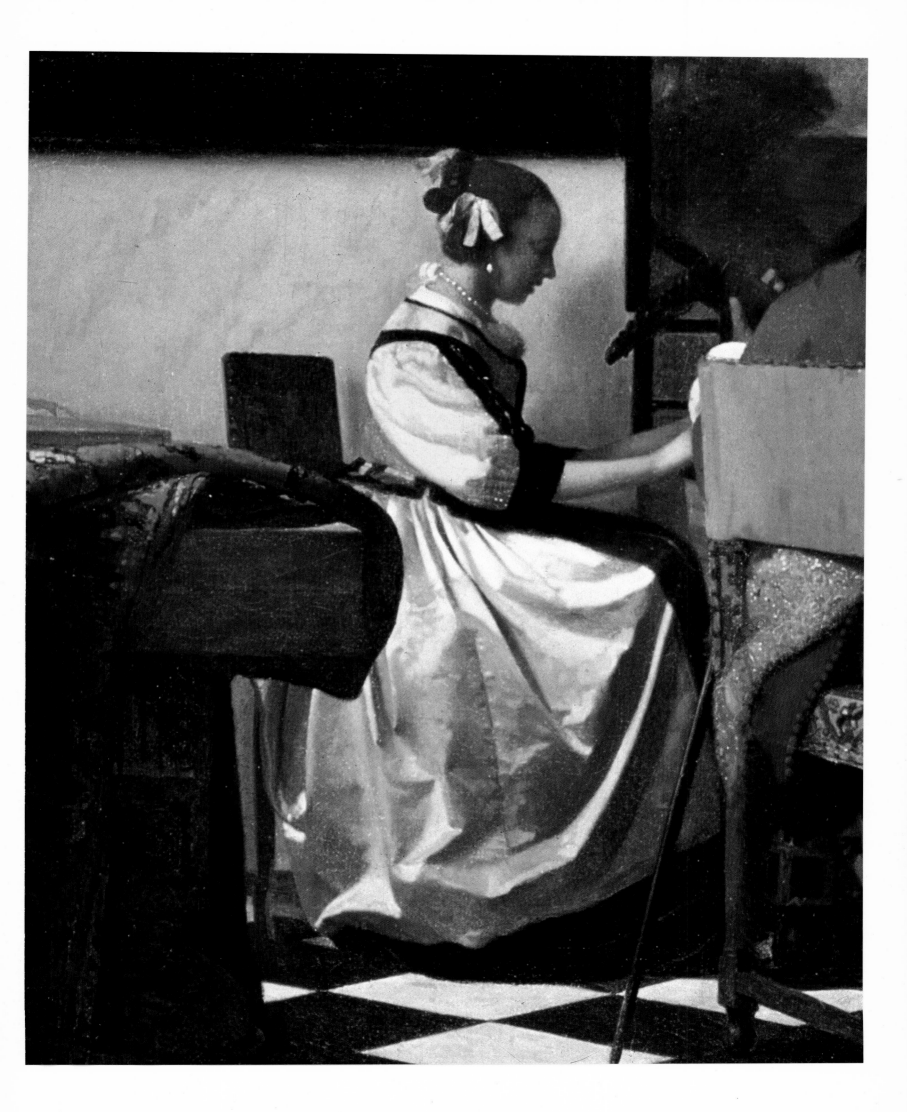

A LADY WRITING

c. 1665–66

Oil on canvas, 17 3/4 × 15 3/4" (45 × 39.9 cm)
National Gallery of Art, Washington D.C.
Gift of Harry Waldron Havemeyer and Horace Havemeyer, Jr.,
in Memory of their Father, Horace Havemeyer, 1962

To a greater extent than any other Dutch artist, Vermeer captured the delicate equilibrium between the physical stillness of a setting and the transient actions of individuals within it. In this painting an elegant woman, dressed in a lemon-yellow morning jacket bordered with ermine, sits before a table. She holds a quill pen firmly in her right hand. Her left hand secures the paper upon which her pen rests. Although prepared to write, she has looked up from her task and regards the viewer with a slightly quizzical expression. As in so many of his paintings, Vermeer has not explained the significance of her gaze. This characteristic has led to criticism that his paintings lack psychological penetration, but it is also an essential ingredient in the poetic suggestiveness of his images.

A Lady Writing is signed with a monogram (which cannot be seen in this reproduction) on the lower frame of the picture on the back wall. Like most of Vermeer's paintings it is not dated. Its painting style and technique, as well as the woman's clothing and hairdo, however, relate to other works that appear to belong to Vermeer's mature phase, the mid-1660s. The woman's elegant yellow jacket, for example, appears in three other paintings by Vermeer from this period, the *Woman with a Pearl Necklace* (colorplate 24), the *Woman with a Lute* (colorplate 25), and the *Mistress and Maid* (colorplate 36). The inkwells and the decorated casket on the table are similar to those in the *Mistress and Maid*.

A Lady Writing belongs to an inconographic tradition found in works by many of Vermeer's contemporaries, particularly Gerard ter Borch and Gabriel Metsu. Perhaps the closest comparison is to Ter Borch's *Woman Writing a Letter* (fig. 18). Painted some ten or eleven years earlier than Vermeer's work, Ter Borch's painting is a superb example of this thematic tradition. Although the degree of elegance in *A Lady Writing* reflects the sophisticated social climate of the 1660s, both artists depicted a young woman alone in a room, engaged at writing.

Yet Vermeer's focus is not, like Ter Borch's, on the act of writing but rather on the woman as an individual within a specific setting. Indeed, the painting may be as much a portrait as a genre scene. The woman looks directly at the observer, she is painted with a great deal of individuality, and she is proportionately large and close to the picture plane. One wonders whether Vermeer took the thematic tradition of the letter writer and used it as a point of departure for this portrait.

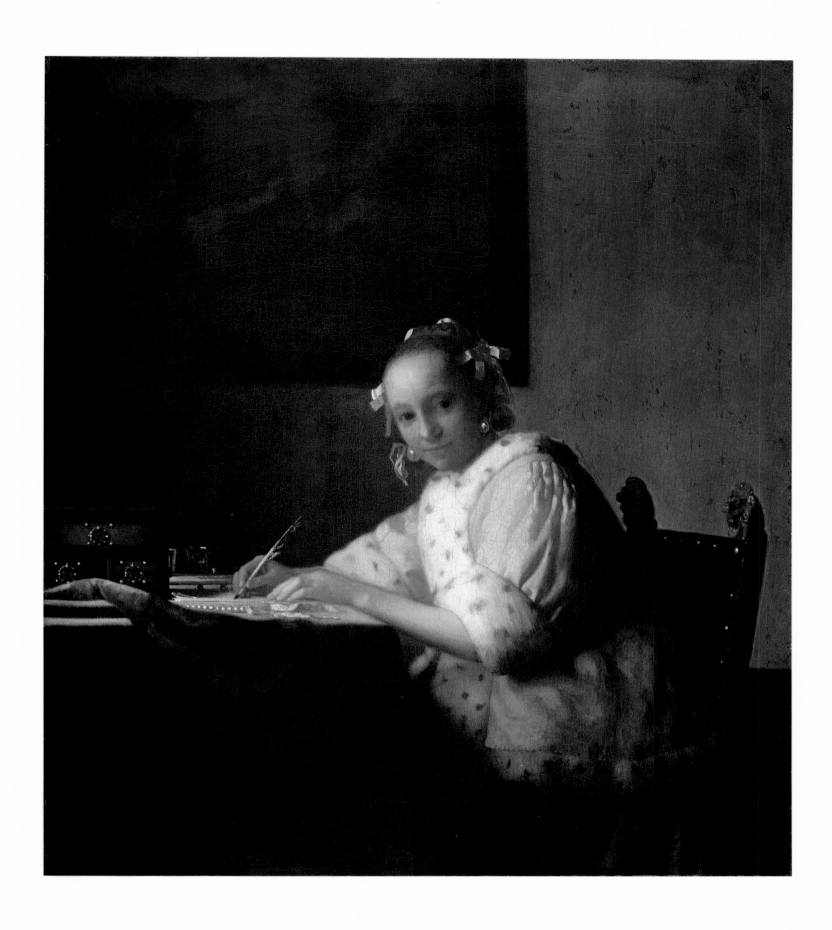

Detail of A LADY WRITING

One of the most remarkable aspects of Vermeer's painting technique is the soft, diffused appearance of his surfaces and contours. Despite the apparent precision of his paintings, his forms are not defined and modeled with lines but through a complex interaction of opaque and semitransparent paint layers. Vermeer often used thin layers to tone down bright opaque colors. He modulated the folds of the yellow jacket, for example, by painting a brown glaze over the basic color layer. The face consists of an opaque light paint over which he applied semitransparent gray-brown layers to further define the features and provide shading.

In the shaded areas where semitransparent glazes are most prevalent, Vermeer's technique lent his forms a distinctive luminosity. His shadows are not pure surface phenomena; they are rich and velvety because light is able to penetrate through to the underlying color. As in so many instances, Vermeer sensed how light and color interact on forms and was able to translate into paint his visual response to these optical effects.

This capacity of his is nowhere more evident than in his treatment of highlights and contours. As strong light strikes soft objects—fur, cloth, and flesh, for example—it penetrates and causes their contours to appear diffused to the eye. Hard objects generally maintain their solid contours, although glass or silver may reflect specular highlights. Occasionally, objects silhouetted against a light background seem surrounded by a nimbus that accentuates the contrast of the two.

It is fascinating to note the different ways Vermeer achieved these optical effects. To create diffused contours he often pulled one color slightly over the edge of another. For example, he softened the outer contour of the woman's cheek here by brushing the background tone slightly over it. He reversed the procedure in the woman's right hand where he brushed a thin flesh tone over the adjacent background. Along the contour of the woman's right sleeve he created the impression of soft fur both by drawing his paint over the background color and by retaining a slim border of grayish ground between the dense paint of the sleeve and the background.

Vermeer's technique for painting highlights on pearls differs from this procedure. The pearls lying on the table consist of a thin paint layer covered by an opaque one. The two layers were probably painted wet-in-wet, because the edges of the upper layer flow gently into the one underneath. A greater division between the two layers can be seen in the decorative pearls on the face of the letter box. With fluid strokes of a thin grayish paint, Vermeer first indicated the position of the pearls and then highlighted them with a touch of opaque white.

THE ALLEGORY OF PAINTING

c. 1666–67

Oil on canvas, 47 1/4 × 39 3/8" (120 × 100 cm)
Kunsthistorisches Museum, Vienna

The artist in his studio is a fascinating theme in Dutch art because it tells us so much about the artists' techniques and attitudes toward their profession. Jan Miense Molenaer's painting (fig. 73), for example, provides information about the artist's easel and manner of stretching his painting. Adriaen van Ostade's etching of the artist in his workshop, from about 1667 (fig. 75), shows an artist painting (perhaps a landscape) from a sketchbook propped on a stool and from drawings strewn on the floor. In both instances, however, these artists sought to emphasize that their profession was an honorable one. The inscription under Ostade's print stresses that the painter can achieve fame, as did the renowned Greek artist Apelles, by deceiving the eye. Molenaer's reference to the elevated status of the artist is more subtle than Ostade's, but equally suggestive. Against his worktable lies a lute. Music had traditionally belonged to the liberal arts, and the lute's presence in the studio helped emphasize that painting also should be accorded this distinction.[86]

Despite allusions to the importance and deserved fame of the artist, Molenaer's and Van Ostade's works primarily represent the artist's activities in his studio. Vermeer's aim in *The Allegory of Painting* was different: to emphasize the importance of the art of painting. Vermeer did not identify the artist. He portrayed him from behind, dressed in a fanciful costume from a past era. The importance of the artist's work is evident in the elegant room in which he paints, with its chandelier, lush curtain, and chairs. Most significantly, the artist is portraying an allegorical figure, Clio, the muse of History.[87]

Clio is posed as described by Cesare Ripa, as a girl with a crown of laurel, symbolizing Fame, and holding a trumpet and a volume of Thucydides, symbolizing History.[88] Vermeer's implication is that the artist's inspiration and source of fame should be the muse of History. This meaning accords with seventeenth-century art theorists who stressed that history painting—the representation of stories from the Bible and mythology as well as allegorical scenes—was the highest category of painting.

Vermeer implied that careful attention to the muse of History did not necessarily bring immediate fame to the artist. The large wall map of the United Netherlands indicates that the artist's work will enhance the fame of his country. The town views flanking the map suggest that the artist will bring renown to individual cities as well.[89] As has been mentioned, Bleyswijck stressed this theme in his contemporary description of Delft. Citizens bring fame to their cities even though their contributions can only be appreciated after their deaths. In this respect, Vermeer's artist, seen from the back, takes on a personal as well as an abstract connotation.

(*See frontispiece for a further discussion of this work.*)

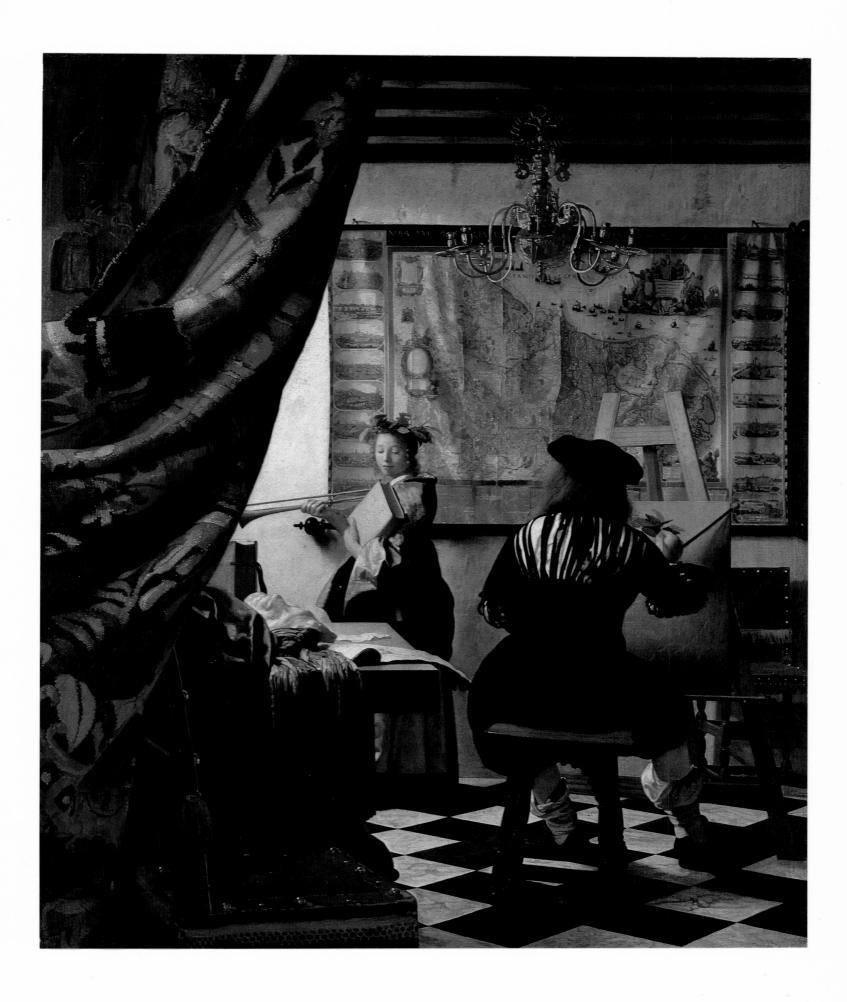

THE GIRL WITH A RED HAT

c. 1666–67
Oil on wood panel, 9 1/8 × 7 1/8" (23 × 18 cm)
National Gallery of Art, Washington, D.C.
Andrew W. Mellon Collection, 1937

The Girl with a Red Hat is a sensuous painting. As the girl turns outward, mouth half opened, her eyes seem lit with expectancy. The lushness of her blue robes, the flame red of her hat, and the subtle interplay of green and rose tones in her androgynous face give her a vibrancy unique among Vermeer's paintings. The sensual attraction of this painting is one of its great joys, but it also makes objective appraisals of its relationship to Vermeer's other paintings difficult.[93]

One of the major differences between this little painting and Vermeer's other works is that it is painted on a wood panel. The hard and smooth surface of wood does not absorb paint to the extent that canvas does; hence the surface is more luminous. His brushstrokes also seemed to flow over this smooth surface more fluidly than over canvas, increasing the luster and sheen of the work. Throughout this painting, one senses Vermeer's exquisite use of color. He painted the shadowed area of the underside of the red hat in a deep purple hue that relates the red to the blue of the robes. He toned the shaded portions of the girl's face, her forehead, eyes, nose, and right cheek, with a greenish glaze, the complement of red, and then accented the cheeks with the orange-red reflections of the hat. The eye is highlighted with a touch of turquoise paint; the mouth has a pink highlight.[94] As he had done in *A Woman Holding a Balance* (colorplate 22), Vermeer imbued the blue robes with an inner warmth by painting them over a reddish-brown ground. He then accented folds and areas of reflected light with yellow highlights.

Vermeer may have painted on panel to simulate effects seen on the hard ground glass of a camera obscura. In no other painting does he capture so closely as in this one the appearance of diffused highlights. An experimental photograph made several years ago for Charles Seymour through a camera obscura duplicated almost exactly the effects Vermeer achieved in this painting (fig. 76).[95]

Even with this small painting, Vermeer did not trace his image from the camera obscura, but, as in other instances, adjusted his forms to accommodate his composition. Upon close inspection it is apparent that the lion head finials are too close to each other and that they are not correctly aligned. The finials, moreover, face the viewer, whereas if they belonged to the chair upon which the girl sits, they should face her.[96] As in Frans Hals's *Portrait of a Young Man* (fig. 6), only the back of the lion's head should be visible. Vermeer probably made these adjustments to avoid the cramped, awkward feeling of Hals's sitter, with his arm over the edge of the chair.

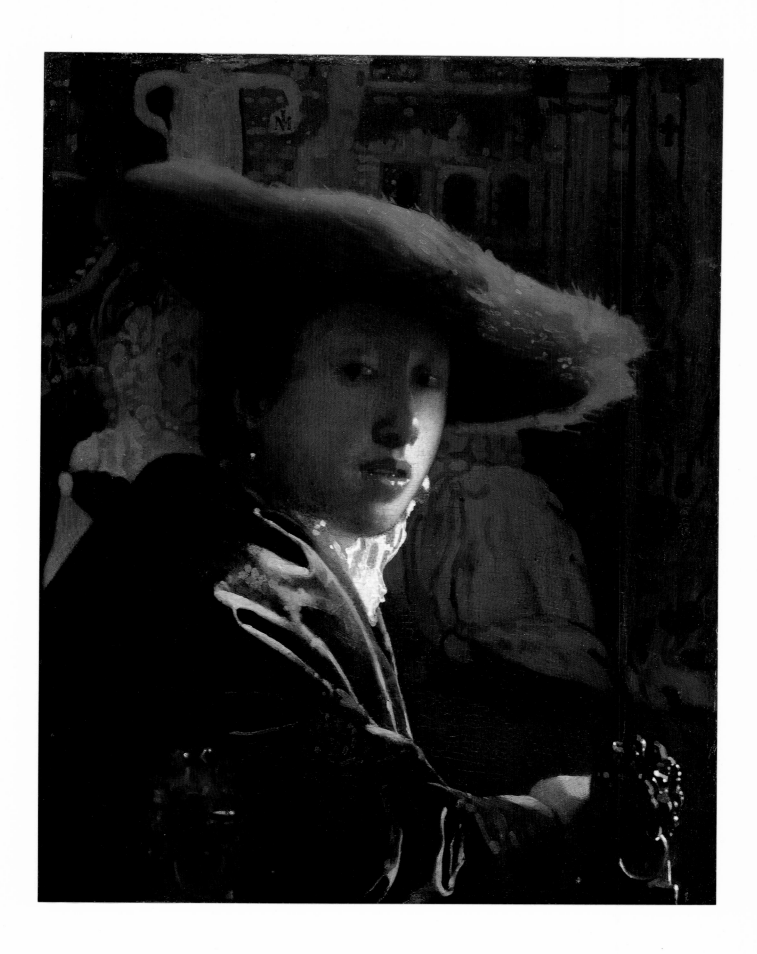

PORTRAIT OF A YOUNG WOMAN

c. 1666–67
Oil on canvas, 17 1/2 × 15 3/4" (44.5 × 40 cm)
The Metropolitan Museum of Art, New York
Gift of Mr. and Mrs. Charles Wrightsman, 1979

For an artist with a small range of subjects, Vermeer achieved a variety in his compositions that is truly remarkable. In only one instance, the *Portrait of a Young Woman*, is a dependency on other examples in his oeuvre obvious. The pose of the girl in this painting is reminiscent of *The Girl with a Pearl Earring* (colorplate 28), while the loose robes she wears and the position of her arm are derived from *The Girl with a Red Hat* (colorplate 34). The derivative nature of the pose makes it difficult to approach the painting as a separate entity. Comparisons are extremely easy to make between these paintings, and the results, rightly or wrongly, are seldom in favor of this work.

The *Portrait of a Young Woman* possesses some very fine qualities, even if it does not have the universal appeal of *The Girl with a Pearl Earring* or *The Girl with a Red Hat*. The face is delicately modeled; nuances of light and shade are subtly suggested. The contours and features are softly modeled, for Vermeer, as in other paintings from the mid-1660s, avoided defining them with crisp lines. Color nuances are also evident; light reflecting from the robe casts a bluish shadow on the girl's chin and cheek.

One major difference between this painting and the others mentioned is that this appears to be a portrait whereas the other two are idealized studies. The girl's relatively wide, flat face and small nose are not as naturally graceful as the faces in the other paintings. The *Portrait of a Young Woman* also creates a slightly discordant effect because the smooth, refined technique Vermeer used in the face contrasts with the freer brushwork of the robes. Finally, the foreshortening of the arm is not very successful.

These weaknesses have suggested to many that the painting should be dated in the 1670s, when the quality of Vermeer's work is thought to have declined,[97] but during that period Vermeer painted with a much crisper style than is evident in this work. In terms of painting technique and conception a date of about 1666–67 seems most acceptable for this painting.

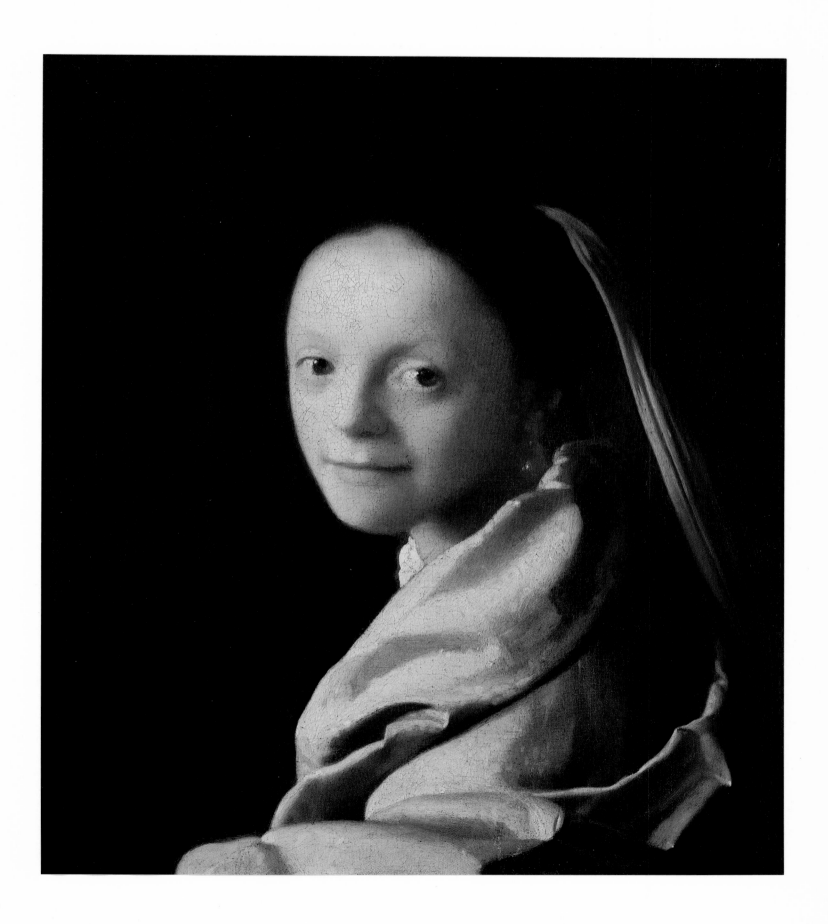

MISTRESS AND MAID

c. 1667–68
Oil on canvas, 35 1/2 × 31" (90.2 × 78.7 cm)
Copyright The Frick Collection, New York

One of the most prevalent themes in Vermeer's paintings from the late 1660s is the letter writer (see also colorplates 39 and 42). Unlike his earlier representations of women with letters (colorplates 7, 21, and 31), where he isolated one individual with the letter, these later versions all include a maid with her mistress. The introduction of the maid adds a new element to the theme: the expectations and anxieties that surround the arrival of a letter.

In this painting the mistress, dressed in a yellow jacket with an ermine border, sits at a table. Her hand rests on a letter she had been writing before being interrupted by the maid. Her left hand has risen involuntarily to her chin, an unmistakable gesture of surprise and concern. The maid's forward gesture as she offers the letter reinforces the contrast in their attitudes.

Vermeer's figures from the early 1660s are usually portrayed at a moment when their movements have ceased. In the *Mistress and Maid*, he explored a different set of dynamics: a focus on implied movement. This new emphasis may partially explain his decision to paint these figures against a dark background. Against a light background figures are visually locked into a specific framework, while a dark background is more suggestive.

Vermeer also had other reasons to experiment with a dark, undefined background. He had found that his bust-length figure studies were particularly luminous against dark backgrounds. They also enhanced the three-dimensional quality of the figures since the modeling blended into the background. Interestingly, despite the successful use of this format here, it is the only instance we know in which he used an undefined background for a large composition.

The enhanced three-dimensional quality also results from the large scale of the figures and the fullness of the modeling. Compared to the *Woman with a Pearl Necklace* (colorplate 24), this painting reveals a much more rich modeling of the mistress's yellow jacket. The folds are more pronounced and are articulated with increased clarity. The woman's hands are more simply poised and create quieter rhythms. A subtle abstraction of forms and color becomes evident. The mistress's eye is barely indicated; the shadow along her left arm is an unexpected purple.[98] The result is a powerful image, suggestive of movement and psychological interaction yet maintaining a classical dignity.

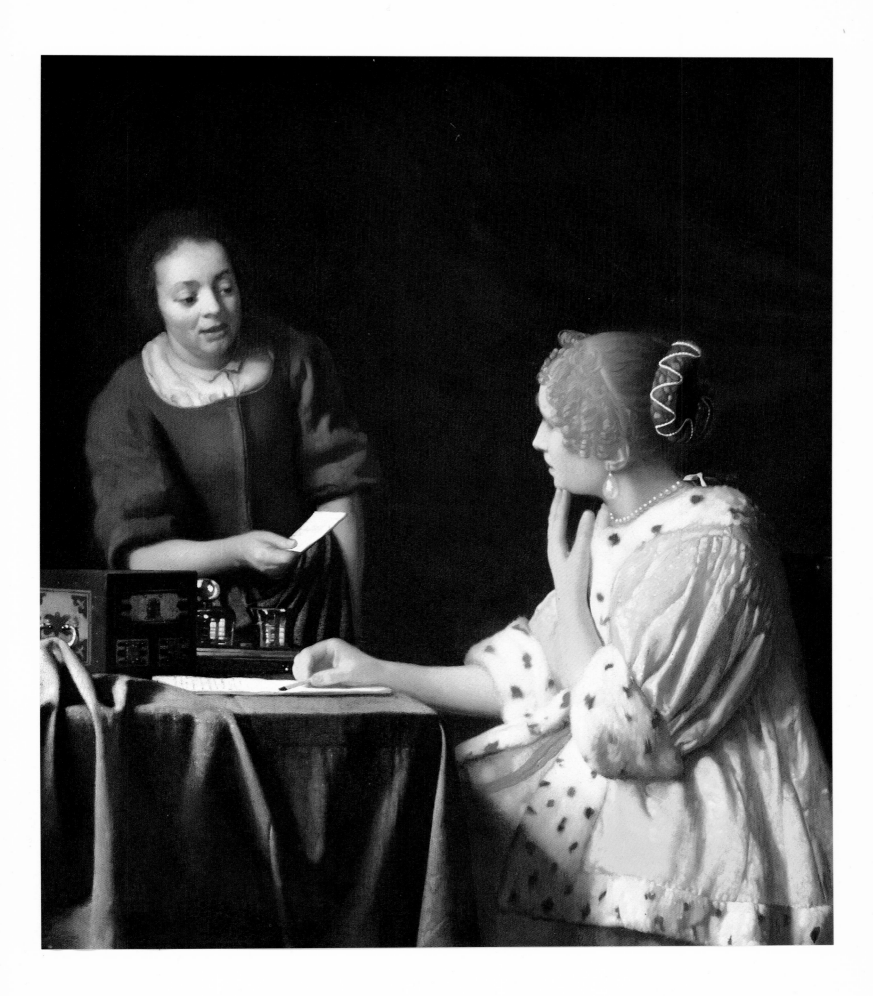

THE ASTRONOMER

1668

Oil on canvas, 19 5/8 × 17 3/4" (50 × 45 cm)
Private Collection, Paris

The Astronomer and *The Geographer* are two exceptional paintings in Vermeer's oeuvre. They are the only ones that focus exclusively on a male figure and the only ones to depict figures involved in scholarly pursuits. These paintings, which are approximately the same size and have similar formats and subject matter, were probably conceived as pendants. They are recorded together as early as 1713 and were sold as pendants again in 1720 and 1729.[99] This discussion of *The Astronomer* and *The Geographer* will be integrated because of the many connections between the paintings.

The Astronomer is one of the two dated paintings by Vermeer and thus gives us a secure basis for assessing his mature style.[100] The scene is one that follows a tradition of scholars in their study: a rather somber room, with a desk, a bureau, books, scientific instruments, and a scholar intent on his work. This figure, dressed in a loosely fitting blue robe, is shown rising from his chair and reaching for a brightly colored globe. As are Vermeer's other cartographic sources, this celestial globe by Jodocus Hondius, first published in 1600, is accurately depicted. A number of constellations are shown, including the Great Bear on the left, the Dragon and Hercules in the center, and Lyra on the right.[101] Before the globe are an astrolabe, a pair of dividers, and an open book which the astronomer has obviously been consulting. Behind him on the chest is a technical chart with three circular forms.

The accuracy with which Vermeer rendered these scientific devices and their relevance to astronomy suggest that either Vermeer, the sitter, or a patron was extremely familiar with the science. Likewise, *The Geographer* contains only elements closely associated with the discovery and charting of the earth. The scholar in this painting stands behind the table, dividers in hand, peering out a window. A large nautical map on parchment lies unrolled before him. Two similar maps lie rolled up on the floor. On the wall is a large sea chart of Europe which, because of its decorative cartouches, may have been intended for framing as well as for technical use. Standing on top of the cupboard is a terrestrial globe which also was designed by Hondius and published as a pair with the celestial globe.

Since neither of these paintings appeared in the Dissius sale of 1696, they may have belonged to a separate collector, presumably someone interested in astronomy and geography. In Delft at that time there lived a scientist who had achieved an outstanding reputation in these disciplines, Antony van Leeuwenhoek. Although Van Leeuwenhoek is better known for his discoveries with

continued on page 138

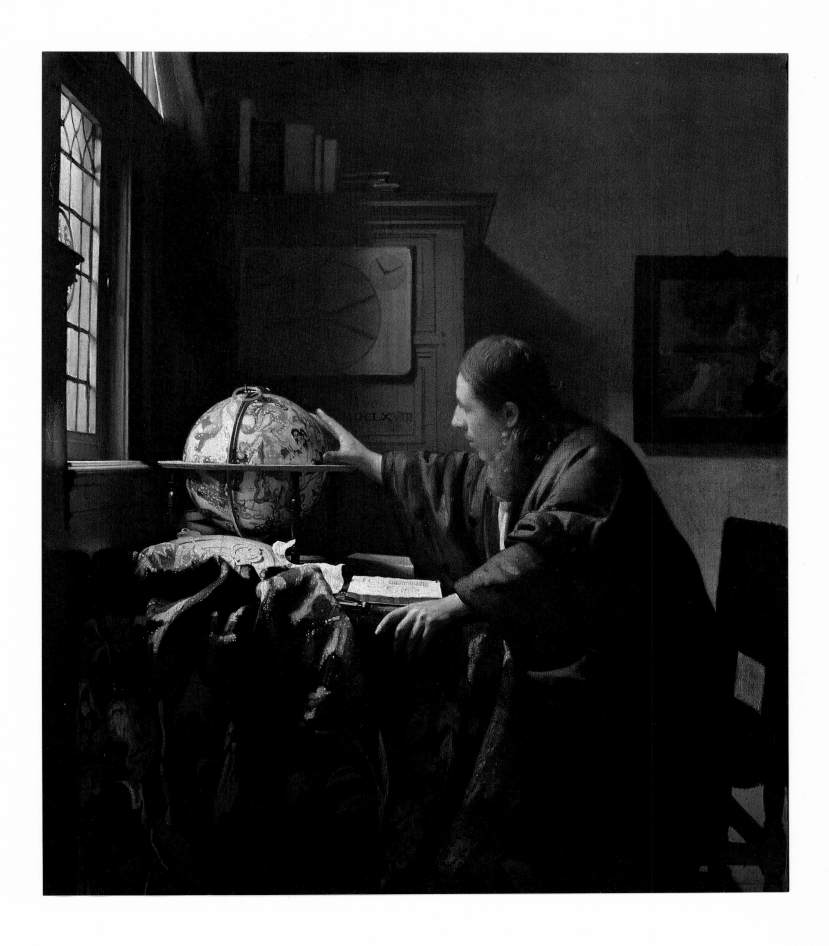

THE GEOGRAPHER

c. 1668–69

Oil on canvas, 20 7/8 × 18 1/4" (53 × 46.6 cm)
Städelsches Kunstinstitut, Frankfurt

continued from page 136

the microscope, Reinier Boitet, in his *Beschryving der Stadt Delft*, 1729, emphasized that he was also so skilled in "navigation, astronomy, mathematics, philosophy, and natural science . . . that one can certainly place him with the most distinguished masters in the art."[102]

Van Leeuwenhoek could well have been the sitter for the portraits as well as the patron. He was thirty-five years old in 1668, a plausible age for the figure in the paintings. Interestingly, a portrait of Van Leeuwenhoek of 1686 by Jan Verkolje has similar features and includes, along with a microscope, a celestial globe (fig. 3). If Van Leeuwenhoek can be connected with these portraits, his later involvement with Vermeer's estate can be better understood.

The juxtaposition of these two disciplines may also have had some symbolic significance. The study of the universe and the study of the earth represented two diverse realms of human thought. They also had theological implications: the study of the heavens was often connected to the spiritual realm and the study of the earth to understanding God's plan for man's passage through life.[103]

The objects Vermeer placed on the back walls of these paintings reinforce the theory that he intended the meanings of these paintings to be complementary. In the background of *The Astronomer* Vermeer hung a painting with a Biblical scene, *The Finding of Moses*. Traditionally, the life of Moses was thought to prefigure that of Christ: the close correspondences in the events of their lives were seen as testament to the unity of God's design throughout history. The Finding of Moses and his welcome reception prefigured the eventual reception of Christ's ministry by the community of the faithful. This event also came to be associated with the guidance of Divine Providence.[104] If, then, the astronomer reaches for the celestial globe, he is in essence reaching for spiritual guidance.[105]

The sea chart on the wall of *The Geographer* does not have explicit religious connotations but, seen in conjunction with *The Astronomer*, it may imply the need to chart one's course through the world, and thus symbolically through life. The geographer's room is more brightly lit than that of the astronomer, as though his realm of knowledge were more rational and less mysterious than the astronomer's. He looks forward into the light, dividers in hand, with assurance that with proper guidance and careful calculation he has the tools to chart the proper course in life.

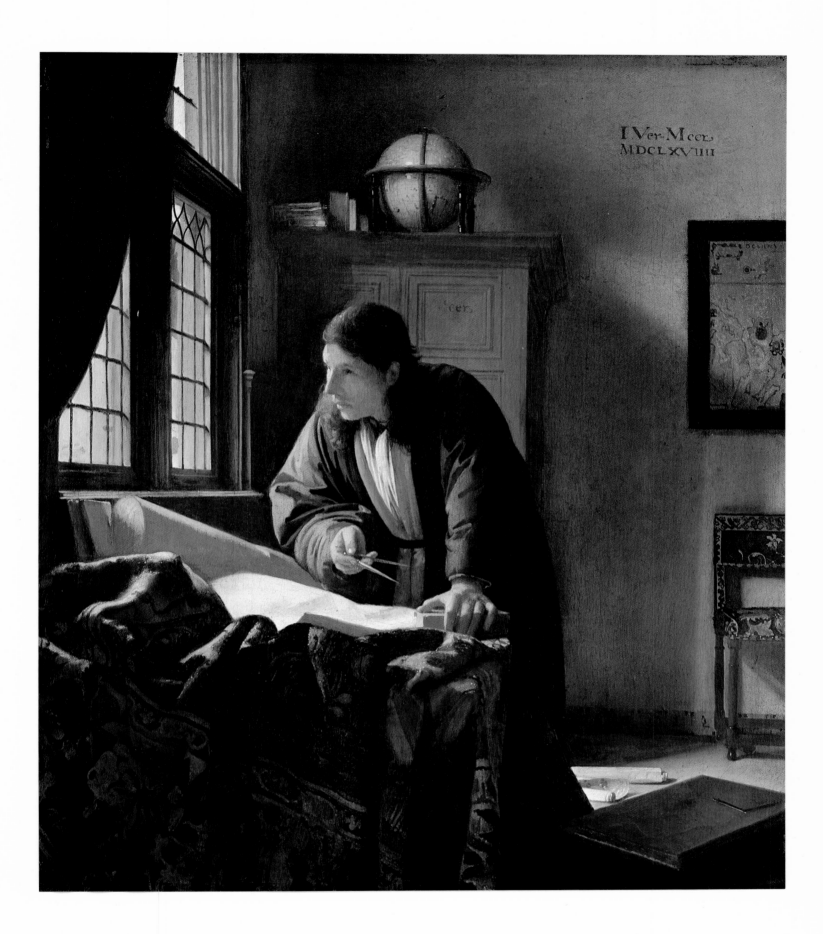

THE LOVE LETTER

c. 1669–70
Oil on canvas, 17 3/8 × 15 1/8" (44 × 38.5 cm)
Rijksmuseum, Amsterdam

A recurring concern for Vermeer was the creation of the semblance of privacy in his paintings. To achieve this effect he used many devices. He placed figures behind large pieces of furniture, tables, or chairs to separate them from the viewer. He hung curtains in the foreground or placed his figures on the far side of a large room. Invariably he portrayed people in moments when they were preoccupied with some activity or with their own thoughts and were unaware of being observed. The culmination of this interest in portraying those private, unguarded moments in life is *The Love Letter*. In this remarkable painting Vermeer, in a way that anticipates the "keyhole" realism of Degas in the nineteenth century, portrayed the figures through a doorway.

Prototypes for Vermeer's composition are not known. It is as though he focused on a scene occurring in the background of a Maes (fig. 63) or De Hooch (fig. 34) painting. One wonders if the idea came to him through his experiences with a camera obscura, since a portable camera obscura is most effective when it is directed towards a sunlit scene from a darkened room.

The success of the illusion Vermeer created is enhanced by the contrast of light and dark and by differences in the precision of focus in the two rooms. The foreground objects are painted in soft, muted tones. The map on the left wall, for example, is barely recognizable. It comes as a surprise to learn that the map is identical to the one so clearly rendered in the *Officer and Laughing Girl* (colorplate 10).[106] Likewise, the folds of the cloth hanging over the chair are merely suggested by soft lines without being modeled.

The figures and objects in the back room, however, are crisply painted with precise contours and defined colors. The geometric purity of the black picture frames, their shadows, the gilded leather wall covering, and the fireplace establishes a framework against which the figures are placed. A comparison with *The Astronomer* and *The Geographer* (colorplates 37, 38) reveals that nuances of shading and light are lacking here. The figures themselves are simplified, and one does not sense much interest in their individual personalities.

These contrasts in technique between the foreground and the sunlit room were clearly deliberate since Vermeer wanted the viewer to focus on the scene occurring in the room. In establishing this contrast Vermeer developed a crispness in his rendering of light and color that he would pursue in his later works. Thus this painting is extremely important for understanding the origin of Vermeer's late style.

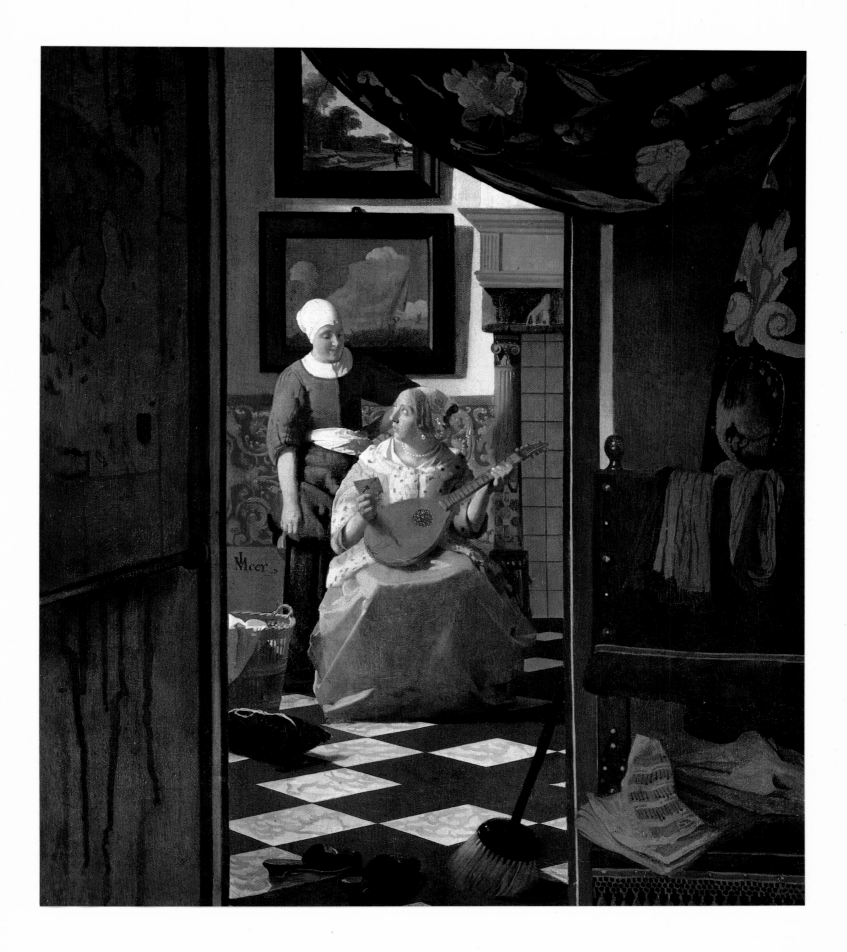

Detail of THE LOVE LETTER

Dutch society evolved during the 1660s into a far more refined culture than that of the preceding decade. The Dutch people, who had struggled so valiantly against the Spanish, had also achieved great economic prosperity. In the process they developed a taste for fashionable clothes and furnishings. The changes in taste are evident in Vermeer's paintings. In *The Love Letter* an elegantly dressed woman sits in an interior that is much more richly decorated than those found in his paintings from the 1650s. The elaborate marble and wood mantlepiece and the gilded leather wall covering indicate substantial wealth. Whether this luxurious interior reflects the standards of living in Vermeer's household or whether it was devised to suit contemporary tastes in paintings is not known. In any event, this type of interior does not lend itself easily to portrayals of the intimate scenes that Vermeer preferred. Vermeer's solution to this problem— removing the viewer from the woman's room—is thus all the more ingenious.

This intimacy is particularly appropriate for the subject matter of the love letter. As in the *Mistress and Maid* (colorplate 36), Vermeer focused on the moment before the contents of the letter are known. The woman has stopped playing on her instrument and turns toward the maid. Her look is at once questioning and concerned. Unlike the *Mistress and Maid*, however, this painting contains clues about the nature of the letter in pictures on the wall. The seascape of the calm sea is a good omen, as is the idyllic landscape hanging above it. Similar paintings occur in Metsu's pendants *Lady Reading a Letter* and *Man Writing a Letter* (figs. 50, 51), painted about 1666–67, strengthening the supposition that they were chosen for their thematic implications. Beside the woman in both Vermeer's and Metsu's paintings is a linen basket and on the floor are shoes. These objects may refer to domestic virtue just as the globe near the man in Metsu's painting indicates his scholarly pursuits.

The similarities in Metsu's and Vermeer's paintings demonstrate the degree to which iconographic traditions were shared by Dutch artists. Since Metsu and Vermeer were working with comparable subject matter at about the same time, one may confidently compare their iconographies. A danger exists, however, in reading meanings too literally into paintings. One is not always certain that symbolic implications are intended or that the meanings of the iconography were known to the artist. This area of scholarship is still evolving, and many questions still need to be answered.

THE LACEMAKER

c. 1669–70
Oil on canvas (attached to panel), 9 5/8 × 8 1/4" (24.5 × 21 cm)
The Louvre, Paris

Lacemaking is a job that takes enormous concentration, and in *The Lacemaker* Vermeer captured, above all, the intensity of this task. He placed the young girl against a blank wall to eliminate external distractions. She is bent over her work; her hands, holding the bobbins and the pins fast, are engaged in their task. A large blue sewing cushion in the foreground holds red and white threads.

The painting is small, as is appropriate for the subject; yet Vermeer expended every bit as much care on it as on his larger compositions. As with *The Astronomer* and *The Geographer* (colorplates 37, 38) he must have studied his subject carefully, because he has portrayed the art of lacemaking accurately. His low point of view, however, was chosen to illustrate not the technique but the act of lacemaking. In comparison, Caspar Netscher's charming painting of the same subject (fig. 77) offers far more information about the number of bobbins required and the arrangement of the pins, but lacks the intensity of Vermeer's version.

In *The Lacemaker*, as in *The Girl with a Red Hat* (colorplate 34), Vermeer created diffused effects in the immediate foreground that clearly indicate different depths of field. In this instance the red and white threads falling out of the sewing cushion are almost indecipherable because of the abstract way they are painted. In both *The Lacemaker* and *The Girl with a Red Hat* these diffused effects are similar to ones seen in the unfocused image of a camera obscura, and Vermeer may have conceived both of these small paintings with its aid.

Stylistically, however, the paintings differ. *The Lacemaker* is painted with crisper, more simplified forms. The roundness of the girl's head, for example, resembles that of the maid in *The Love Letter* (colorplate 39). Similarly, the dense yellow of her jacket, in which folds are relatively undefined, is comparable to that of the mistress in the same painting. The abstract curls of the girl's hair silhouetted against the white wall also resemble those of the girl in *The Guitar Player* (colorplate 44), which dates from the 1670s. These stylistic comparisons suggest that Vermeer painted this work about 1669–70.

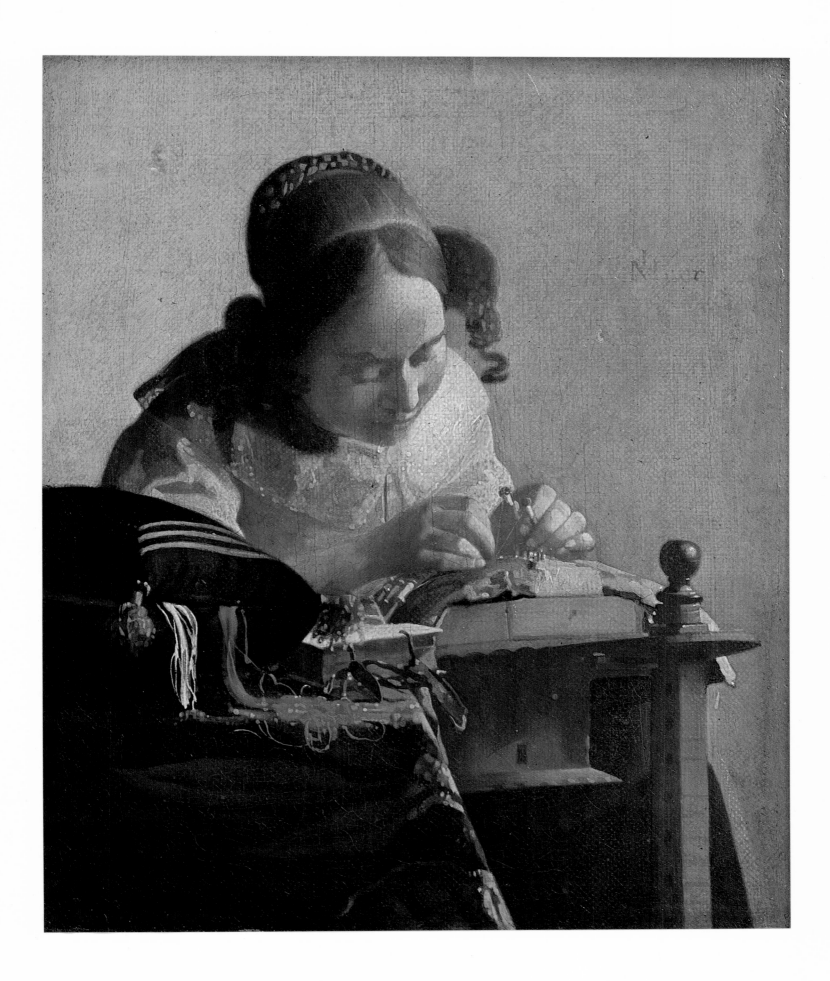

LADY WRITING A LETTER WITH HER MAID

c. 1670

Oil on canvas, 28 × 23" (71.1 × 58.4 cm)

Collection Sir Alfred Beit, Bart., Blessington, Ireland

Vermeer's paintings from the 1670s are not as much admired today as his paintings from the 1660s. They appear colder than his earlier works: interest in portraying human psychology seems lacking, and the compositions are less restful and self-contained. Although these changes may be due to a decline in his artistic powers, they do characterize the stylistic evolution of Dutch art as a whole. In appraising these paintings one must try first to understand the conception underlying them before judging them on the basis of Vermeer's approach of the 1660s.

The *Lady Writing a Letter with Her Maid* is instructive in this respect, for it stands as a bridge between the paintings of the 1660s and those of the 1670s. Although the quiet restraint of the figures and the subject matter remind one of the paintings of the 1660s, this is the first work in which Vermeer began to experiment with a centrifugal composition (one in which the focus is drawn away from the center of the painting).

Vermeer explored another variant of the letter-writing theme here: the attitude of the maid who awaits the letter she must deliver. In both the *Mistress and Maid* and *The Love Letter*, the maid is a necessary complement to the reaction of the mistress to the letter. In this instance, instead of drawing together the two forms, Vermeer turns them apart. Psychologically and emotionally they are in different worlds. The mistress is involved with her letter; the maid stands quietly waiting, arms crossed, but turns away and gazes toward the window. Only the strong geometric shape of the black picture frame binds them together visually.

Despite the quiet attitudes of the figures, a slight tension is apparent in the painting which becomes more pronounced in the works of the following years. In the *Allegory of the Faith* (colorplate 43) and *The Guitar Player* (colorplate 44), figures explicitly direct their attention away from the center of the painting. Vermeer seems to have sought this effect because he was no longer satisfied with the self-contained quality of his earlier work.

Even if Vermeer was experimenting with new compositional premises, he continued to use the same visual vocabulary to enhance the meaning of his paintings. The large picture on the back wall, for example, represents the Finding of Moses, the theme of a painting that also appeared, although in a much smaller scale, in *The Astronomer* (colorplate 37). One wonders whether it also refers here to Divine Providence, expressing a desire that the person for whom the letter is intended will have been cared for and protected. Its symbolism would then parallel that of the seascape on the back wall of *The Love Letter*, albeit with a religious connotation rather than a romantic one.

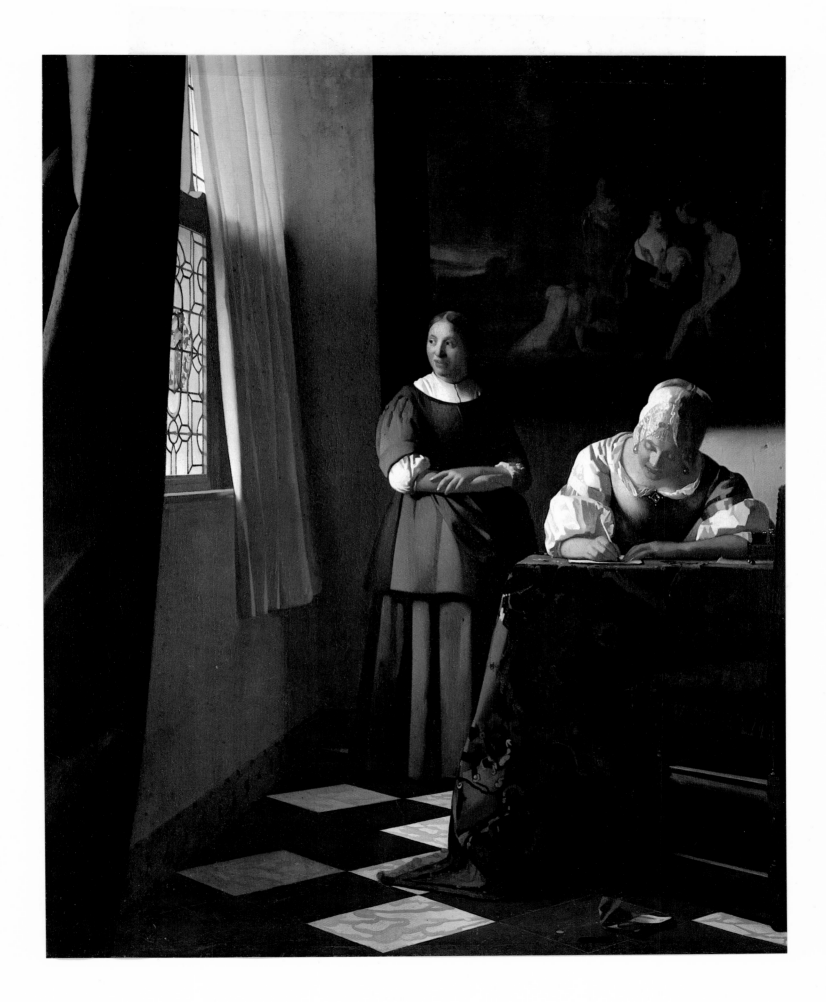

ALLEGORY OF THE FAITH

c. 1671–74
Oil on canvas, 45 × 35" (114.3 × 88.9 cm)
The Metropolitan Museum of Art, New York
Bequest of Michael Friedsam, 1931
The Friedsam Collection

Part of Vermeer's genius was that he understood his own limits. He was able to perfect his style and continually modify his techniques and approach to his subject matter because he selected his range of subjects so rigorously. Within his oeuvre the level of quality is uniformly high. Indeed, no other artist ever painted such a high percentage of masterpieces. Vermeer made only one mistake, the painting traditionally known as the *Allegory of the Faith*. This painting is an impressive tour de force, beautifully painted, with a fascinating iconography, but as a work of art it is a failure.

Vermeer's intent was to paint an allegory of the Catholic faith, and for that purpose he devised, or was given, a very specific iconography. All the elements in the painting—including the glass sphere hanging above the woman which symbolizes the ability of the human mind to contain the vastness of the belief in God (fig. 78)—reinforce the specific meaning of the allegory.[107] The problem with the painting, however, is that the image itself has no intrinsic reality. It can only be viewed as a reference to what it means. On its own pictorial merits, the image is rather silly and contrived.

The demands placed on Vermeer in this painting did not suit his temperament. The precision of his style and his insistence on basing his art on his specific surroundings could not accommodate such an abstract concept. *The Allegory of Painting* (colorplate 33), which obviously served as the prototype for this work, succeeded because we can imagine an artist painting a model dressed as Clio, and we can accept the idea of an artist being inspired by the muse of History. In the so-called *Allegory of the Faith* the abstract concept and the reality of the physical surroundings do not work in conjunction with each other. For instance, the presence of a crushed snake in a Dutch interior is jarringly wrong.

One can excuse the work's failure by insisting that Vermeer's composition was prescribed by the Jesuits, for whom it seems to have been painted,[108] but to do so is beside the point. Other artists, including Rubens and Bernini, created masterpieces in works based on programs given to them by the Jesuits. For Vermeer, abstract concepts had to be expressed through physical objects and recognizable human situations. The symbolism in his other paintings is premised on the reality of his image, and without that foundation the meaning has no conviction.

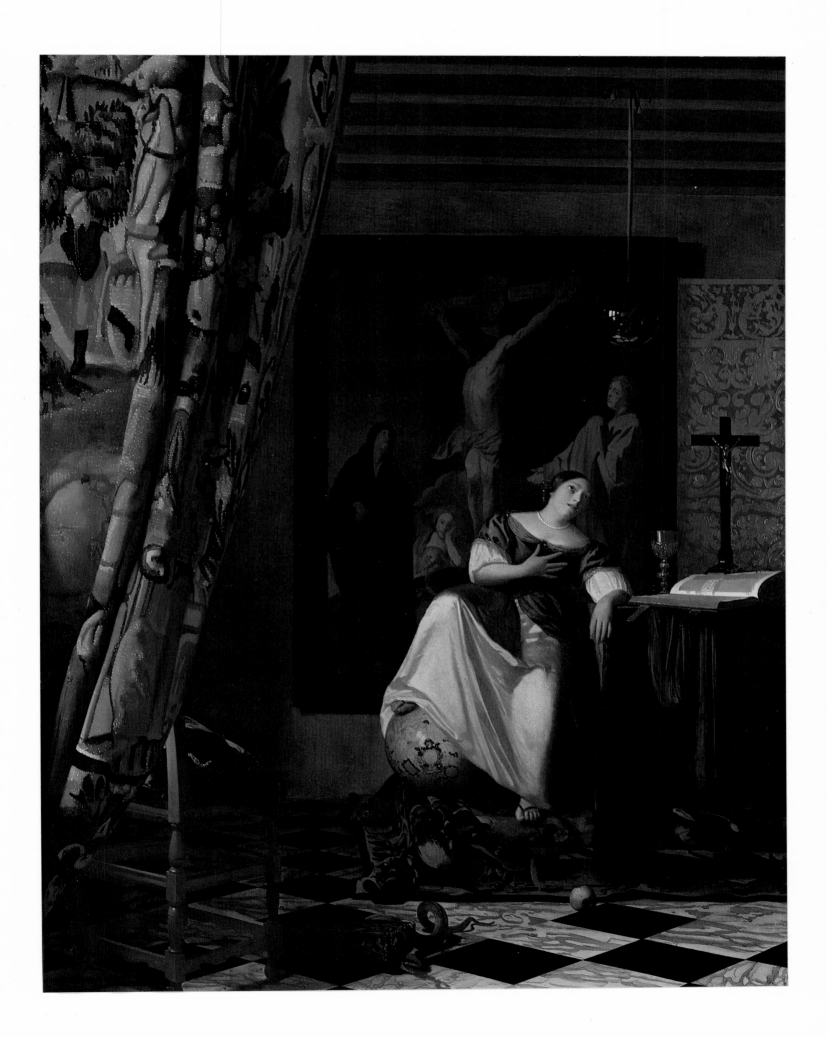

THE GUITAR PLAYER

c. 1672

Oil on canvas, 20 7/8 × 18 1/4" (53 × 46.3 cm)
The Iveagh Bequest, Kenwood, London

The Guitar Player is one of the most beautiful examples of Vermeer's late style. The crispness of his image and the radiant colors give the painting a glowing quality. Vermeer, in his paintings of the 1670s, was no longer concerned with describing specific textures of materials. Brushstrokes became freer and more expressive than in his earlier works as he emphasized patterns of color rather than textures. Vermeer modeled the girl's dress and jacket, for example, with sharply defined planes of color. The subtle modulations in folds and contours that he formerly created by applying glazes over opaque paints are no longer evident.

The face also is treated differently. Its expression is outward and not self-contained. The nuances of shading that suggested qualities of character and personality have been replaced by distinctly separate areas of light and shade. The interest in pattern is evident in the ringlets of hair silhouetted against the wall.

In addition to the changed emphasis of his painting technique, Vermeer also built this composition on a different principle. As in the *Lady Writing a Letter with Her Maid* (colorplate 42) and the *Allegory of the Faith* (colorplate 43), he drew the focus of his composition away from the center of the painting. The girl is placed so far to the left that her arm is cut by the edge. Light falls to the left and a landscape hangs behind the girl on the back wall. The off-center composition is further emphasized by the direction of the girl's glance. The reasons for this compositional arrangement are not known, but Vermeer probably was reacting against the balanced, contained quality of his earlier work.

One might suspect that a pendant existed which would have balanced this painting, but a document seems to provide evidence to the contrary.[109] In January, 1676, slightly more than a month after Vermeer's death, his widow, Catharina Bolnes, appeared before the notary in Delft to settle a debt of 617 guilders and 6 stuivers with Hendrick van Buyten, master baker in the town. On that occasion she sold two paintings to him, one representing "two persons one of whom is writing a letter and the other with a person playing a guitar." One of the paintings involved in this revealing document is the *Lady Writing a Letter with Her Maid*; the other is probably *The Guitar Player*. Vermeer's widow almost certainly would not have separated *The Guitar Player* from a pendant if one had existed.

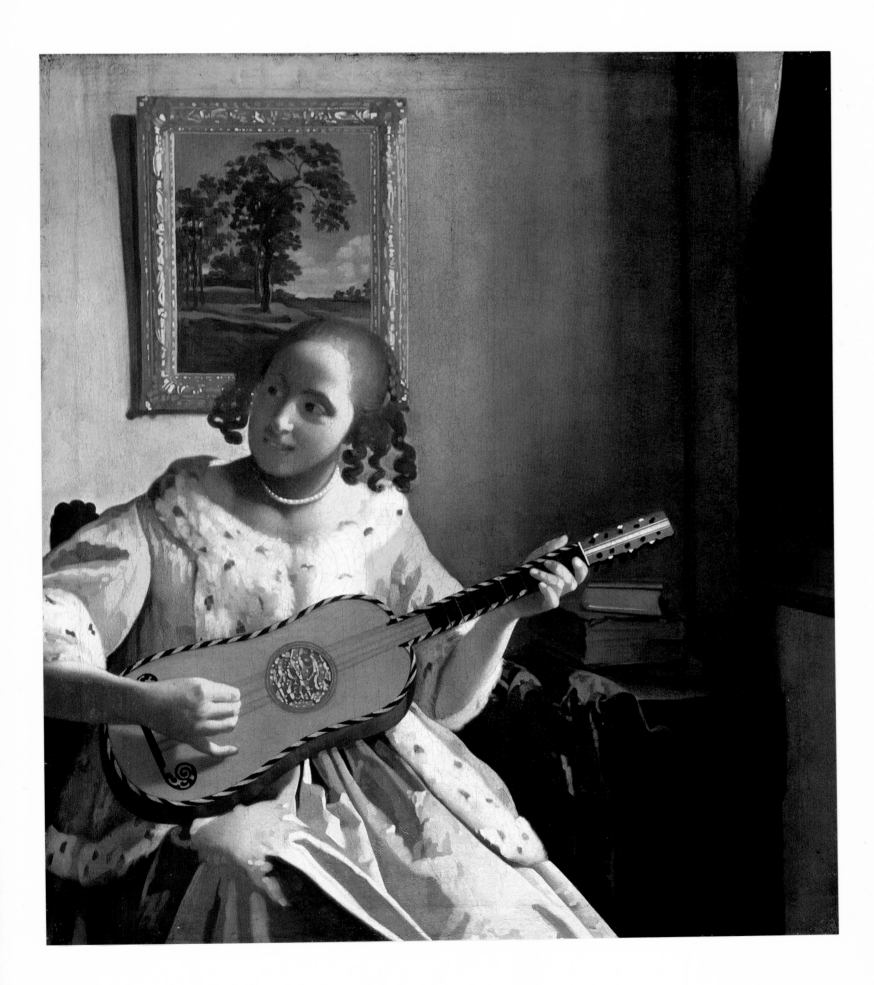

A LADY STANDING AT THE VIRGINALS

c. 1673–75
Oil on canvas, 20 3/8 × 17 3/4" (51.7 × 45.2 cm)
National Gallery, London

A Lady Standing at the Virginals and *A Lady Seated at the Virginals* (colorplate 46) hang together today at the National Gallery, London. Historical accident has brought them together, but similarities of scale, subject matter, and technique suggest that Vermeer may have conceived them as a pair. They are, however, an unusual pair, and it is not at all certain that they belong together. Most pendants, if they do not portray husband and wife, reflect contrasting or complementary themes, but in these works the attitudes of the two women are so similar that clear differences in meaning are not evident.

If Vermeer intended the paintings to be contrasted thematically, he chose to do so by means of the paintings on the back walls. The painting of the standing cupid holding a card aloft in the background of *A Lady Standing at the Virginals* is familiar from other examples (colorplate 18, fig. 48). It signified that love should be confined to only one person. *The Procuress*, hanging on the back wall of *A Lady Seated at the Virginals*, is the painting by Baburen that Maria Thins had inherited and that also appears in the background of *The Concert* (colorplate 29). Its emphasis on illicit love may well have been intended as a contrast to the pure love symbolized by the cupid. The differences in light in the two paintings could have complemented such a contrast. The shade is drawn in *A Lady Seated at the Virginals* whereas the room is brightly lit in this painting.

The contrast of pure and illicit love suggested by the pictures on the back wall, however, does not seem borne out by the attitudes of the figures in the paintings. They are both playing virginals, and are both looking out at the viewer. Their dress is nearly identical. Perhaps the fact that one is standing and one is seated has some implication, but none is presently known. As in *The Concert*, moreover, one must not necessarily assume that the figure of the seated woman should be identified with the character of the scene in the background picture. She also could represent a contrast to *The Procuress*. In an emblem by Jacob Cats, for example, we see a figure playing on a lute, while a second instrument lies unused beside him (fig. 79). The meaning of this emblem is that the resonances of one lute echo onto the other, just as two hearts can exist in total harmony even if one is absent. With this interpretation the two London pictures could have similar meanings rather than opposite ones.

The uncertainties surrounding the meanings of these paintings are not unique in Vermeer's works. Often, totally opposing interpretations of his paintings are plausible. Much of the confusion stems from deliberate ambiguities in the works themselves and probably will never be completely resolved.

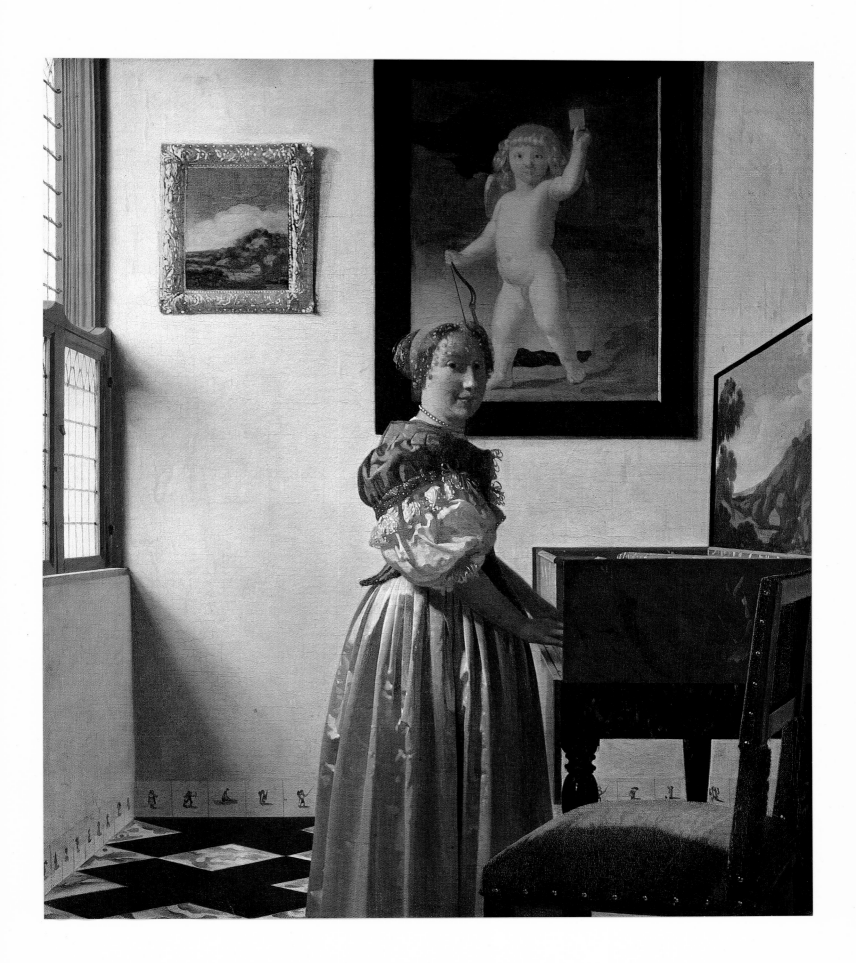

A LADY SEATED AT THE VIRGINALS

c. 1673–75
Oil on canvas, 20 1/4 × 17 7/8" (51.5 × 45.5 cm)
National Gallery, London

In *A Lady Standing at the Virginals* (colorplate 45) and *A Lady Seated at the Virginals*, Vermeer avoided the unsettled compositional schema of *The Guitar Player* (colorplate 44). As with his choice of subject matter and iconography, he reverted to his paintings of the mid-1660s for restrained, balanced compositions. The pose used for this work, for example, was essentially that of *A Lady Writing* (colorplate 31). Although this dependency on earlier models suggests that Vermeer's creative energy had begun to lag, he had little choice but to return to these prototypes, being by nature an artist who felt most comfortable in a balanced, measured environment. He could not express the natural movement of a figure in a relaxed pose with the ease of a Metsu (fig. 51) or a Steen (fig. 70). His attempt to expand his types of composition in *The Guitar Player* resulted in an interesting but awkward painting.

In his late works, Vermeer's interest in the surface appearance of objects had contradictory effects. His brushwork became more abstract as it was freed from the role of describing surface textures. *A Lady Seated at the Virginals* is the most extreme example of this approach in his oeuvre and thus probably was his last painting. The highlights on the gilded picture frame and on the lady's blue dress are as much abstract patterns of color as definitions of structure. Throughout the painting, the color has an extremely vivid, pure quality. This same concern for surface patterns and the resulting simplification of forms, however, resulted in figures who remain bland and expressionless. None of the nuances of human psychology in his earlier works are present here.

These last two paintings, in subject matter and style, are in many respects a natural culmination of Vermeer's evolution as an artist. While they contain echoes of much of his preceding work, they expand upon them, particularly in the abstraction of the brushwork. Whether or not these paintings are superior to his earlier work is another question. Vermeer's genius rests on the delicate interrelationship between human psychology and compositional pattern. In these late works his attention to individual human attributes was subordinated to design and color, and an important element of Vermeer's uniqueness as an artist was lost.

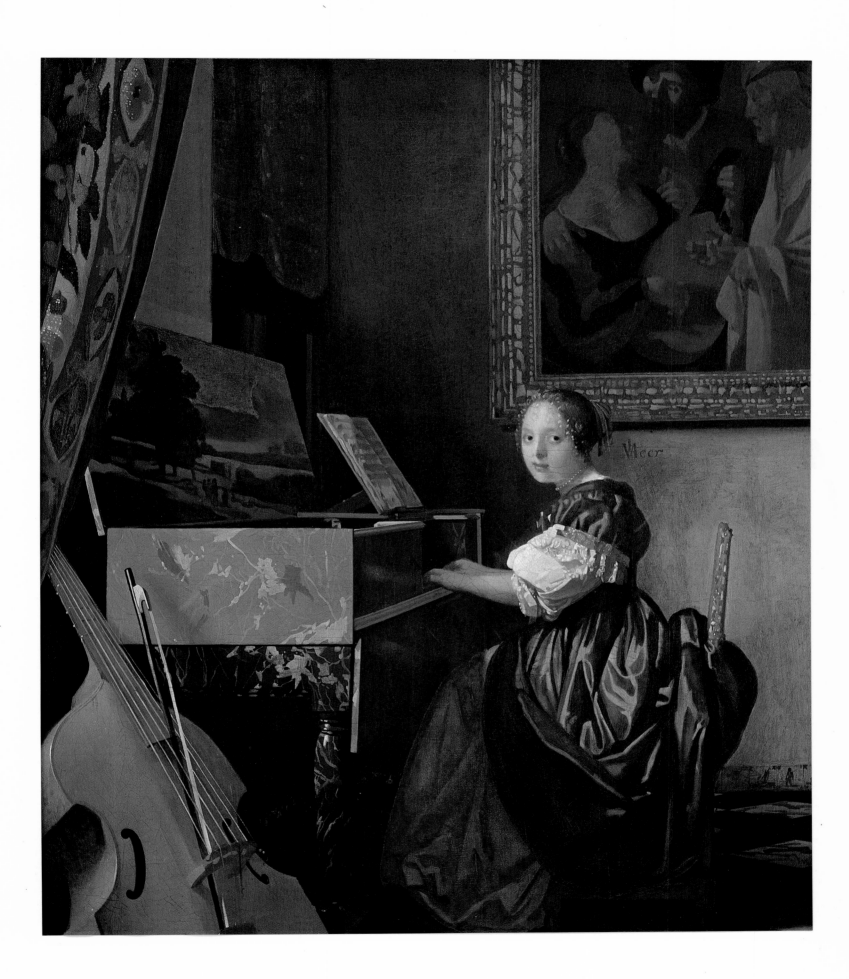

CIRCLE OF VERMEER

YOUNG GIRL WITH A FLUTE

c. 1666–67
Oil on wood panel, 7 7/8 × 7" (20 × 18 cm)
National Gallery of Art, Washington, D.C.
Widener Collection, 1942

Vermeer had no known pupils and little influence among other seventeenth-century Dutch artists. Nevertheless, it seems improbable that he never had a young student (or even one of his own children) come to work under his direction. The question is relevant because the *Young Girl with a Flute*, despite its similarity to Vermeer's paintings, does not seem to be by him.[110]

Problems of attribution necessarily involve many factors, including style, technique, costume, and the materials with which a work is painted. Interpretations of these factors are always subjective and frequently hinge on one's concept of the range of possibilities that exist for the artist in question. Vermeer's techniques of painting, for example, evolved in a recognizable way. When techniques appear in a painting that cannot be placed easily within our perception of Vermeer's evolution, we question the appropriateness of the attribution.

The *Young Girl with a Flute*, like *The Girl with a Red Hat* (colorplate 34), is painted on wood. Partially because of their wooden supports and similar small scale and partially because of subject matter, these two works are frequently cited as pendants. Despite many stylistic similarities, however, the differences in the quality of these paintings are surprisingly great. The off-center position of the subject in *The Girl with a Red Hat* allows her hat and face to become the central focus of the painting. Light fills the open, receptive concave shape formed by her contours. The position of the *Young Girl with a Flute* has no such inner logic. Her hat, left shoulder, and right hand are awkwardly cut by the edge of the panel.

In addition to its less successful composition, the handling of the paint here is less assured than in *The Girl with a Red Hat*. While in both works the blue jacket is highlighted with yellow strokes, here logical grouping of the highlights and sureness of execution both are lacking. In some ways the style of painting appears alien to Vermeer. The girl's right hand, awkwardly cut by the edge of the panel, lacks any substantial form. Also, the hand and the thumbnail are painted with a thick impasto unlike his characteristic techniques.

Although such stylistic comparisons argue against an attribution to Vermeer, a number of factors point to the seventeenth-century origin of this painting. The jacket is similar in style to those seen in paintings of the 1660s (see colorplate 22). The pigments used, natural ultramarine and lead-tin yellow, are frequently found in seventeenth-century paintings.[111] The panel on which the *Young Girl with a Flute* was painted dates from the late 1650s.[112] The evidence thus indicates that this painting was executed by an artist who was familiar with Vermeer's work, but not by the master himself.

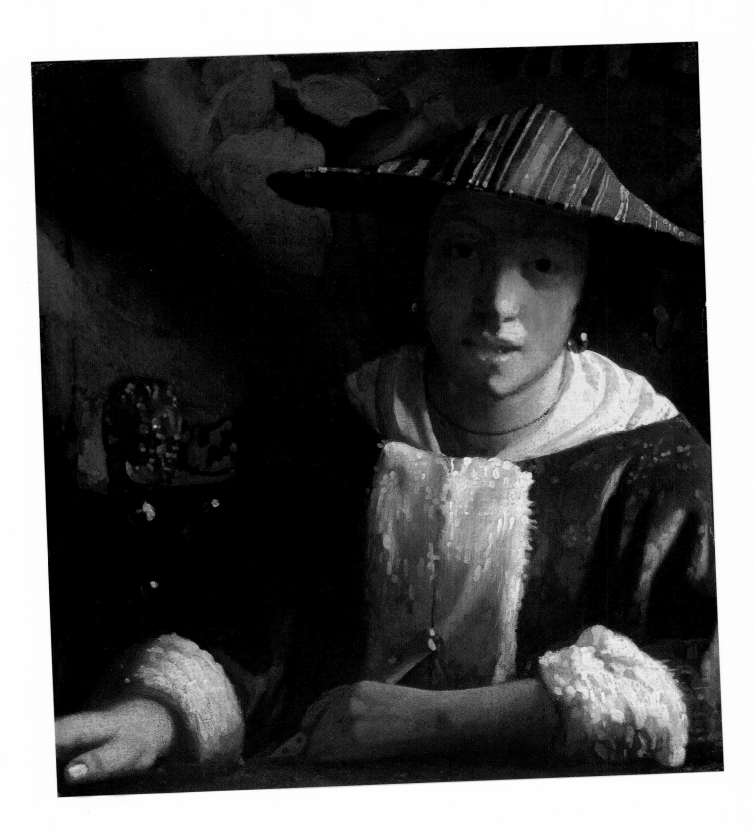

NOTES

1. On October 31, 1632, the Baptismal Register of the Nieuwe Kerk, Delft, lists "the child Joannis, father Reynier Janssoon, mother Dingnum Balthasars. . . ." Vermeer was buried in the Oude Kerk on December 15, 1675.

2. An excellent compilation of documents published before 1976 is included in Albert Blankert, with contributions by Rob Ruurs and Willem L. van de Watering, *Vermeer of Delft* (Oxford, 1978), revised from Dutch edition: *Johannes Vermeer van Delft 1632–1675* (Utrecht/Antwerp, 1975). This material has now been supplemented by extensive archival discoveries by J. M. Montias, in "New Documents on Vermeer and his Family," *Oud-Holland*, XCI, 1977, 267–87, and in "Vermeer and his Milieu: Conclusion of an Archival Study," *Oud-Holland*, XCIV, 1980, 44–62.

3. The actual number of paintings accepted varies slightly from author to author. A. B. de Vries, *Jan Vermeer van Delft* (London/New York, 1948); L. Gowing, *Vermeer*, 2nd ed. (London, 1971); L. Goldscheider, *Johannes Vermeer, the Paintings* (London, 1967) all accept thirty-five paintings. P. T. A. Swillens, *Johannes Vermeer, Painter of Delft 1632–1675*, trans. by C. M. Breuning-Williamson (Utrecht/Brussels, 1950); and Blankert, *Vermeer*, accept only thirty-one paintings without reservation.

4. *The Geographer* is dated 1669, but the date appears to be a later addition. Whether the date is based on a lost inscription is not known.

5. For specific dates given to Vermeer's paintings by various scholars see the catalogue in Blankert, *Vermeer*.

6. *Ibid.*, documents 2, 5, 8.

7. *Ibid.*, document 13.

8. *Ibid.*, document 42.

9. Montias, "Vermeer and his Milieu," 52–58.

10. Blankert, *Vermeer*, document 42.

11. The drawing most frequently associated with Vermeer is a study of a seated woman in Weimar (fig. 80), which has a monogram VM on the foot warmer. The monogram seems to have been executed in a different chalk from the rest of the drawing and probably is not by the hand of the artist. M. A. Scott, who is preparing a dissertation on the Haarlem artist, Cornelis Bega, has kindly suggested to me that the Weimar drawing could have been done by Bega (fig. 81) or one of his Haarlem contemporaries.

12. Blankert, *Vermeer*, 9.

13. *Ibid.*, document 59.

14. *Ibid.*, document 40. A complete transcription of this important inventory of Vermeer's possessions was published by A. J. J. M. van Peer, "Drie collecties schilderijen van Jan Vermeer," *Oud-Holland*, LXXII, 1957, 92–103.

15. Blankert, *Vermeer*, document 51. Peer, "Drie collecties," suggests that a painting of a "woman wearing a necklace" listed in the inventory may be by Vermeer. Peer also believes that, after Vermeer's death, Dissius bought his paintings at a public auction on March 15, 1677. However, from the documents (Blankert, *Vermeer*, documents 51, 52), it appears that only one painting of Vermeer's, *The Allegory of Painting*, was to be sold on that occasion.

16. Montias, "Vermeer and his Milieu," document 11.

17. Blankert, *Vermeer*, document 21.

18. *Ibid.*, document 37.

19. *Ibid.*, documents 45, 50, 51, 52, 54.

20. For Leeuwenhoek see: Clifford Dobell, *Anthony van Leeuwenhoek and his "Little Animals"* (London, 1932; repr. New York, 1960); A. Schierbeek (and Maria Rooseboom), *Measuring the Invisible World, The Life and Work of Antoni van Leeuwenhoek FRS* (London and New York, 1959); A. Schierbeek, *Antoni van Leeuwenhoek* (The Hague, 1963).

21. Much information about Leeuwenhoek's early life is in: Reinier Boitet, *Beschryving der Stadt Delft* (Delft, 1729), 765–70.

22. Stylistic connections between Rembrandt's paintings and early works by Vermeer have been frequently noted. Wilhelm Bode, *Rembrandt und seine Zeitgenossen* (Leipzig, 1906), even included Vermeer as one of the followers of Rembrandt.

23. D. P. Snoep, "Honserlaersdijk: Restauraties op Papier," *Oud-Holland*, LXXXLV, 1969, 270–94, reconstructs part of the interior of this palace. He also illustrates the kinds of illusionistic paintings of musicians, seen from below, which decorated the interiors.

24. J. G. van Gelder, "De Schilders van de Oranje-zaal," *Nederlands Kunsthistorisch Jaarboek*, II, 1948–49, 118–64.

25. For Bramer see: H. Wichmann, *Leonaert Bramer, sein Leben und seine Kunst* (Leipzig, 1923).

26. The painting by Baburen has been identified as one that Maria Thins inherited (see Blankert, *Vermeer*, document 7). The other two paintings appear to be the ones listed in Vermeer's estate as "a painting representing Cupid" and "A large painting, being Christ on the Cross" (*Ibid.*, document 40).

27. *Ibid.*, document 10. Montias, "New Documents," 28of., found another document that states that Bramer was a witness at the baptism of one of Vermeer's children. The marriage between Vermeer and Catharina Bolnes took place on April 20, 1653, at Schipluij, a small Catholic community on the outskirts of Delft. Montias sees the location of the wedding ceremony as further evidence that questions of religion were at the basis of Maria Thins's objections to the marriage.

28. For further information on these artists see: Hans Jantzen, *Das Niederländische Architekturbild* (Leipzig, 1910); Ilse Manke, *Emanuel de Witte 1617–1692* (Amsterdam, 1963); Walter Liedtke, "Architectural Painting in Delft: 1650–1675," dissertation, Courtauld Institute, London, 1974; Lyckle de Vries, "Gerard Houckgeest," *Jahrbuch der Hamburger Kunstsammlungen*, XX, 1975, 25–56; Arthur K. Wheelock, Jr., *Perspective, Optics, and Delft Artists Around 1650* (New York, 1977), 221–60.

29. Quoted in Wheelock, *Perspective, Optics, and Delft Artists*, 237, 256, note 42.

30. *Ibid.*, 238, 256f., note 44.

31. Montias, "New Documents," document 46a.

32. For a full discussion of this poem see Blankert, *Vermeer*, document 22. Information on Fabritius in this section is based on Wheelock, *Perspective, Optics, and Delft Artists*, 191–220, also published separately as "Carel Fabritius: Perspective and Optics in Delft," *Nederlands Kunsthistorisch Jaarboek*, XXIV, 1973, 63–83.

33. First published by A. Bredius, *Oud-Holland*, VIII, 1890, 228. See also: K. E. Schuurman, *Carel Fabritius* (Amsterdam, 1947), 56.

34. The attribution of this painting has long been disputed. For the literature and an argument that the painting is not by Fabritius see the exhibition catalogue, *Rembrandt After Three Hundred Years* (Chicago: Art Institute, 1969), no. 56.

35. Samuel van Hoogstraten, *Inleyding tot de Hooge Schoole der Schilderkonst: anders de Zichtbaere Werelt* (Rotterdam, 1678), 24f. This discussion appeared in a different form in Wheelock, "Perspective and Its Role in the Evolution of Dutch Realism," in *Perception and Pictorial Representation*, ed. by C. F. Nodine and D. R. Fischer, New York, 1979, 110–33.

36. An excellent study of this painting has been written by Dr. A. Mayer-Meintschel and members of the Restoration Department of the Dresden Gemäldegalerie. This important article on the Vermeer paintings in Dresden is planned for the *Jahrbuch der Staatlichen Kunstsammlungen*, 1981.

37. Eugène Fromentin, *The Old Masters of Belgium and Holland*, trans. by Mary C. Robbins(New York, 1963), 135.(First published as *Les Maîtres d'Autrefois Belgique-Hollande*, 1882.)

38. "is commonly used by the most excellent masters." Hendrick Hondius, *Institutio Artis Perspectivae* (The Hague, 1622), 17.

39. John Bate, *The Mysteries of Nature and Art* (London, 1635), 155–57.

40. Walter A. Liedtke, "The 'View in Delft' by Carel Fabritius," *Burlington Magazine*, CXVIII, 1976, 61–73. For this author's response to Liedtke's interpretation see: *Perspective, Optics, and Delft Artists*, preface, 4–11.

41. For literature on Vermeer and the camera obscura see: A. Hyatt Mayor, "The Photographic Eye," *The Metropolitan Museum of Art Bulletin* (New York), V, 1946, 15–26; Charles Seymour, Jr., "Dark Chamber and Light-filled Room: Vermeer and the Camera Obscura," *The Art Bulletin*, XLVI, 1964, 323–31; Heinrich Schwarz, "Vermeer and the Camera Obscura," *Pantheon*, XXIV, 1966, 170–80; Wheelock, *Perspective, Optics, and Delft Artists*, 283–301; idem, "Zur Technik Zweier Bilder die Vermeer Zugeschrieben Sind," *Maltechnik-Restauro*, LXXXIV, 4, 1978, 242–57. Daniel A. Fink's study, "Vermeer's Use of the Camera Obscura: A Comparative Study," *The Art Bulletin*, LIII, 1971, 493–505, is unreliable.

42. Quoted in: Arthur K. Wheelock, Jr., "Constantijn Huygens and Early Attitudes towards the Camera Obscura," *History of Photography*, I, 1977, 93–103.

43. This view underlies the theories of Swillens, *Johannes Vermeer*; Fink, "A Comparative Study"; and, to a certain extent, Blankert, *Vermeer*.

44. Wheelock, *Maltechnik*, 248ff.

45. E. de Jongh, "Realisme en Schijnrealisme in de Hollandse Schilderkonst van de zeventiende Eeuw," in *Rembrandt en Zijn Tijd*, exhibition catalogue, Paleis voor Schone Kunsten, Brussels, 1971, 143–94.

46. Herbert Rudolph, "'Vanitas': Die Bedeutung mittelalterlicher und humanistischer Bildinhalte in der

niederländischen Malerei des 17. Jahrhunderts,” *Festschrift Wilhelm Pinder* (Leipzig, 1938), 405–12; Blankert, *Vermeer*, 44.

47. De Jongh, “Realisme en Schijnrealisme,” 144f.

48. E. de Jongh, “Pearls of Virtue and Pearls of Vice,” *Simiolus*, VIII, 1975–76, 69–97.

49. Dirck van Bleyswijck, *Beschryvinge der Stadt Delft*, 2 vols. (Delft, 1667–[1674?]), II, 859f.

50. This painting may not have been commissioned by the guild since it is documented as in the possession of Vermeer’s widow in 1677. See Blankert, *Vermeer*, document 51.

51. Baroness van Leyden Sale, Paris, Sept. 10, 1809, no. 62. The painting described in the sale was *The Concert*.

52. Christian Josi, “Discours sur l’état ancien et moderne des arts dans les Pays-Bas,” in Ploos van Amstel et al., *Collection D’imitations de Dessins d’après les principaux Maîtres Hollandais et Flamands* (London, 1821), i–xxxiv.

53. S. J. Stinstra Sale, Amsterdam, May 22, 1822, no. 112. For the full transcription of this sale and other sales of Vermeer’s paintings see the catalogue section of Blankert, *Vermeer*.

54. W. Thoré-Bürger, “Van der Meer de Delft,” *Gazette des Beaux-Arts*, XXI, 1866, 297–330, 458–70, 543–75.

55. “This persistent mania led me on many journeys and to many expenditures. To view a painting by van der Meer, I traveled far and wide; to acquire a photograph of a van der Meer, I behaved like a fool.” *Ibid.*, 299.

56. The literature on Van Meegeren’s forgeries is extensive. See in particular: P. B. Coremans, *Van Meegeren’s Faked Vermeers and De Hoochs*, trans. by A. Hardy and C. M. Hutt (Amsterdam, 1949); *Vermeer de Delft: Une Affaire Scandaleuse de Vrais et de Faux Tableaux* (Brussels, 1958); Lord Kilbracken, *Van Meegeren* (Bristol, 1967).

57. Swillens, *Vermeer*, 64, rejects the painting despite the signature.

58. First mentioned by Bode, *Rembrandt und seine Zeitgenossen*, 50.

59. J. G. van Gelder, *De Schilderkunst van Jan Vermeer*, with a commentary by J. A. Emmens (Utrecht, 1958), 14, identifies the comparable costume of the painter in *The Allegory of Painting* in this manner.

60. E. de Jongh, *Tot Lering en Vermaak*, exhibition catalogue, Rijksmuseum, Amsterdam, 1976, 144–47.

61. See Madlyn Millner Kahr, “Vermeer’s Girl Asleep, A Moral Emblem,” *Metropolitan Museum Journal*, VI, 1972, 115–32.

62. John Walsh, Jr., “Vermeer,” and Hubert von Sonnenburg, “Technical Comments,” *The Metropolitan Museum of Art Bulletin*, XXXI, no. 4, 1973.

63. Information discovered by Peter Meyers and Marian Ainsworth through examination of the painting with neutron auto-radiography.

64. Blankert, *Vermeer*, 34, illustrates a drawing by Bramer after a painting by Adam Pick, a little-known Delft artist, that comes close to Vermeer’s original conception.

65. Swillens, *Vermeer*, 93ff.; Blankert, *Vermeer*, 39f.

66. A. J. J. M. van Peer, “Rondom Jan Vermeer van Delft,” *Oud-Holland*, LXXIV, 1959, 243f., and Montias, “Vermeer and his Milieu,” 58f., also share these doubts.

67. For an excellent discussion of the relationship between De Hooch and Vermeer, see: Peter C. Sutton, *Pieter de Hooch* (Oxford, 1980), 19–27.

68. See: Schwarz, “Vermeer and the Camera Obscura,” 174; Wheelock, *Perspective, Optics, and Delft Artists*, 290.

69. J. A. Welu, “Vermeer: His Cartographic Sources,” *The Art Bulletin*, LVII, 1975, 529–47.

70. Blankert, *Vermeer*, 157f., cat. 7.

71. Swillens, *Vermeer*, 69ff.

72. E. Neurdenberg, “Johannes Vermeer, eenige opmerkingen naar aanleiding van de nieuwste studies over den Delftschen schilder,” *Oud-Holland*, LIX, 1942, 65.

73. This interpretation is presented by Rüdiger Klessmann, in the exhibition catalogue *Die Sprach der Bilder*, Herzog Anton Ulrich-Museum, Brunswick, 1978, 165ff.

74. These paintings are in the Stedelijk Museum “Het Prinsenhof,” Delft. For the history of city views in Dutch art see the exhibition catalogue *The Dutch Cityscape in the 17th century and its sources* (Amsterdam/Toronto: Historisch Museum, and Art Gallery of Ontario, 1977).

75. Swillens, *Vermeer*, 90ff.

76. Blankert, *Vermeer*, 77, note 54; 171, cat. B2, does not accept the attribution to Vermeer.

77. This information was discovered through examinations with infra-red reflectography undertaken at the National Gallery, London.

78. Blankert, *Vermeer*, 44.

79. Herbert Rudolph, “ ‘Vanitas,’ ” 409.

80. For discussions of Saenredam’s drawings see: J. Q. van Regteren Altena’s introduction to the exhibition catalogue *Pieter Jansz. Saenredam* (Utrecht: Centraal Museum, 1961), 17–28; Walter A. Liedtke, “Saenredam’s Space,” *Oud-Holland*, LXXXVI, 1971, 116–41.

81. Blankert, *Vermeer*, 171, cat. B1, does not accept this painting with certainty.

82. *Ibid.*, 159f., cat. 12.

83. Gowing, *Vermeer*, 123–24.

84. P. J. J. van Thiel, “Marriage Symbolism in a Musical Party by Jan Miense Molenaer,” *Simiolus*, II, 1967–68, 91; De Jongh, *Tot Lering en Vermaak*, 183ff.

85. See Blankert, *Vermeer*, 162f., cat. 16 and cat. 17.

86. See H. J. Raupp, “Music im Atelier,” *Oud-Holland*, XCII, 1978, 106–29. For further symbolic relationships between music and the art of painting see: De Jongh, *Tot Lering en Vermaak*, 73ff.

87. Extensive literature exists on this painting. The most important discussion is by van Gelder, *De Schilderkunst van Jan Vermeer*. See also Blankert, *Vermeer*, 46–49; Welu, “Vermeer: His Cartographic Sources,” 536–41.

88. Cesare Ripa, *Iconologia, of Uytbeeldingen des Verstands*, trans. by D. P. Pers (Amsterdam, 1644), 273.

89. J. A. Welu, "Vermeer and Cartography," dissertation, Boston University, 1977, 75ff., has added important new information about this wall map, published by Claus Jansz. Visscher. Welu was the first to identify all of the city views flanking the map of the United Provinces: Significantly, Clio stands before the view of the Hof in The Hague (in the lower left-hand corner); the Hof was the seat of government in the Netherlands. Welu emphasizes that Vermeer may have placed Clio near the decorative cartouches on the map because its texts are in praise of the Netherlands, its people, and its cities.

90. For a theoretical interpretation of this curtain and of the painting itself see H. Miedema, "Johannes Vermeer's 'Schilderkunst,' " *Proef* (Amsterdam, 1972).

91. Bleyswijck, *Beschryvinge*, 646ff.

92. Blankert, *Vermeer*, document 51.

93. *Ibid.*, 73f., 172, cat. B.3, rejects the painting. For arguments defending its authenticity see Wheelock, *Maltechnik; idem*, review of the original Dutch edition of Blankert's book, *Johannes Vermeer van Delft 1632–1675* (Utrecht/Antwerp, 1975), in *The Art Bulletin*, LIX, 1977, 439–41.

94. Similar colored highlights occur on the keys of the lute lying on the table in *The Concert*.

95. Seymour, "Dark Chamber and Light-filled Room."

96. Blankert's rejection of this work is largely based on the position of the finials.

97. Blankert, *Vermeer*, 170, cat. 30.

98. *The Frick Collection, an Illustrated Catalogue: I, Paintings* (New York, 1968), 296, suggests that the painting is unfinished. The effects Vermeer created in this work are, however, entirely consistent with his painting techniques from 1667–68. The only difference is one of scale. These figures are sufficiently large that the diffuse quality of his technique is more apparent than normal.

99. Blankert, *Vermeer*, 165f., cat. 23, 24.

100. See note 4.

101. Welu, "Vermeer: His Cartographic Sources," 543ff., discusses cartographic elements in these paintings.

102. Boitet, *Beschryving*, 765.

103. E. de Jongh, *Zinne- en Minnebeelden in de Schilderkunst van de Zeventiende Eeuw* (Amsterdam, 1967), 67.

104. I would like to thank D. Dinderer and C. Rupprath who independently brought to my attention the connection between the Finding of Moses and Divine Providence in the 1758–60 Hertel edition of Ripa, *Iconologia*. See: Cesare Ripa, *Baroque and Rococo Pictorial Imagery*, ed. by Edward A. Maser (New York, 1971), 162. Although this connection has not yet been found in a seventeenth-century reference, the association probably is an old one.

105. A different opinion is expressed by De Jongh, *Tot Lering en Vermaak*, 15ff., who finds the Moses scene to have Vanitas implications.

106. Welu, "Vermeer: His Cartographic Sources," 533.

107. The painting was first connected with Cesare Ripa's *Iconologia* by A. J. Barnouw, "Vermeer's zoogenaamd Novum Testamentum," *Oud-Holland*, XXXII, 1914, 50–54. This information has been supplemented by De Jongh, "Pearls of Virtue and Pearls of Vice."

108. De Jongh, "Pearls of Virtue and Pearls of Vice."

109. Blankert, *Vermeer*, document 37.

110. *Ibid.*, 73f.; 172, cat. B4, believes that the *Girl with a Flute* was painted in France in the eighteenth or nineteenth century. For the argument that the painting is by someone in the circle of Vermeer see Wheelock, *Maltechnik; idem*, review of Blankert's *Johannes Vermeer van Delft*.

111. H. Kühn, "A Study of the Pigments and the Grounds used by Jan Vermeer," *Reports and Studies in the History of Art*, National Gallery of Art, Washington, D.C., 1968, 194.

112. Dendrochronological examinations of this panel were undertaken by Dr. J. Bauch in 1977.

SELECTED BIBLIOGRAPHY

BLANKERT, ALBERT. With contributions by Rob Ruurs and Willem L. van de Watering. *Vermeer of Delft*. Oxford: Phaidon Press, 1978. Revised from Dutch edition: *Johannes Vermeer van Delft 1632–1675* (Utrecht/Antwerp, 1975).

BLEYSWIJCK, DIRCK VAN. *Beschryvinge der Stadt Delft*. 2 vols. Delft: Arnold Bon, 1667–[1674?].

BODE, WILHELM. *Rembrandt und seine Zeitgenossen*. Leipzig: E. A. Seemann, 1906. Translated by M. L. Clarke as *Great Masters of Dutch and Flemish Painting*. London/New York: 1909.

BOITET, REINIER. *Beschryving der Stadt Delft*. Delft: Reinier Boitet, 1729.

BÜRGER, W. THORÉ-. "Van der Meer de Delft," *Gazette des Beaux-Arts*, XXI, 1866, 297–330, 458–70, 543–75. Articles reprinted in A. Blum, *Vermeer et Thoré-Bürger*, Geneva, 1945.

COREMANS, P. B. *Van Meegeren's Faked Vermeers and De Hoochs*. Translated by A. Hardy and C. M. Hunt. Amsterdam: J. M. Meulenhoff, 1949.

FROMENTIN, EUGÈNE. *Les Maîtres d'Autrefois Belgique-Hollande*. Paris: 1876. Translated by Mary C. Robbins as *The Old Masters of Belgium and Holland*. New York: Dover, 1963.

GELDER, J. G. VAN. *De Schilderkunst van Jan Vermeer*. With a commentary by J. A. Emmens. Utrecht: Kunsthistorisch Instituut, 1958.

GOLDSCHEIDER, LUDWIG. *Johannes Vermeer, the Paintings*. London: Phaidon Press, 1967.

GOWING, LAWRENCE, *Vermeer*. 2d ed. London: Faber & Faber, 1970.

HOOGSTRATEN, SAMUEL VAN. *Inleyding tot de Hoogs Schoole der Schilderkonst: anders de Zichtbaere Werelt*. Rotterdam: François Van Hoogstraten, 1678. Facsimile ed., Soest, The Netherlands: Davaco, 1969.

JONGH, E. DE. "Realisme en Schijnrealisme in de Hollandse Schilderkonst van de zeventiende Eeuw," in *Rembrandt en Zijn Tijd*, exhibition catalogue, 143–94. Brussels: Paleis voor Schone Kunsten, 1971.

———. "Pearls of Virtue and Pearls of Vice," *Simiolus*, VIII, 1975–76, 69–97.

———. *Tot Lering en Vermaak*, exhibition catalogue. Amsterdam: Rijksmuseum, 1976.

KAHR, MADLYN MILLNER. "Vermeer's Girl Asleep, A Moral Emblem," *Metropolitan Museum Journal*, VI, 1972, 115–32.

KÜHN, H. "A Study of the Pigments and the Grounds Used by Jan Vermeer," *Reports and Studies in the History of Art*, II, 155–202. Washington: National Gallery of Art, 1968.

LIEDTKE, WALTER. "The 'View in Delft' by Carel Fabritius," *Burlington Magazine*, CXVIII, 1976, 61–73.

MAYOR, A. HYATT. "The Photographic Eye," *The Metropolitan Museum of Art Bulletin*, V, New York, 1946, 15–26.

MONTIAS, J. M. "New Documents on Vermeer and his Family," *Oud-Holland*, XCI, 1977, 267–87.

———. "Vermeer and his Milieu: Conclusion of an Archival Study," *Oud-Holland*, XCIV, 1980, 44–62.

PEER, A. J. J. M. VAN. "Rondom Jan Vermeer van Delft," *Oud-Holland*, LXXXIV, 1959, 240–45.

RIPA, CESARE. *Iconologia, of Uytbeeldingen des Verstands*.

Translated by D. P. Pers. Amsterdam: D. P. Pers, 1644. Facsimile edition, Soest, The Netherlands: Davaco, 1971.

SCHWARZ, HEINRICH. "Vermeer and the Camera Obscura," *Pantheon*, XXIV, 1966, 170–80.

SEYMOUR, CHARLES, JR. "Dark Chamber and Light-filled Room: Vermeer and the Camera Obscura," *The Art Bulletin*, XLVI, 1964, 323–31.

Die Sprach der Bilder, exhibition catalogue. Brunswick: Herzog Anton Ulrich-Museum, 1978.

SWILLENS, P. T. A. *Johannes Vermeer, Painter of Delft 1632–1675*. Translated by C. M. Breuning-Williamson. Utrecht/Brussels: Spectrum Publishers, 1950.

VRIES, A. B. DE. *Jan Vermeer van Delft*. Amsterdam: J. M. Meulenhoff, 1939. 2nd rev. ed., London/New York:

B. T. Batsford Ltd., 1948.

WALSH, JOHN, JR., "Vermeer," and Sonnenburg, Hubert von, "Technical Comments," *The Metropolitan Museum of Art Bulletin*, XXXI, no. 4, 1973.

WELU, J. A. "Vermeer: His Cartographic Sources," *The Art Bulletin*, LVII, 1975, 529–47.

WHEELOCK, ARTHUR K., JR. "Constantijn Huygens and Early Attitudes towards the Camera Obscura," *History of Photography*, I, 1977, 93–103.

———. *Perspective, Optics, and Delft Artists Around 1650*. New York: Garland Press, 1977.

———. "Zur Technik Zweier Bilder die Vermeer Zuge-schrieben Sind," *Maltechnik-Restauro*, LXXXIV, 4, 1978, 242–57.

INDEX

PHOTO CREDITS

Note: Numbers refer to figures, and an asterisk () denotes a colorplate*

The author and publisher wish to thank the libraries and museums for permitting the reproduction of works in their collections. Photographs have been supplied by the owners or custodians of the works of art except for the following, whose courtesy is gratefully acknowledged:

Jörg P. Anders, Berlin: 7, *14, 21, *24, 45, 74; Henry Beville, Annapolis: 76; A. Dingjan, The Hague: 10, 55; Frequin-Photos, Voorburg: 56; Giraudon, Paris: 62; Green Studio Ltd., Dublin: 50, 51; Louis Held, Weimar: 80; B. P. Keiser, Brunswick: *15; The Library of Congress, Washington, D.C.: 1, 49, 54, 66; Erwin Meyer, Vienna: frontispiece, *33; The National Gallery, London: 48, 52, 79; The New York Public Library, New York: 38, 78; Gerhard Reinhold, Leipzig-Mölkau: *4, *5, *7, *8; Rijksbureau voor Kunsthistorische Documentatie, The Hague: 13, 53; Rijksmuseum, Amsterdam: 64, 65; Tom Scott, Edinburgh: *1, *2; Service de Documentation Photographique de la Réunion des Musées Nationaux, Paris: 47, 59; Jac. P. Stolp, Utrecht: 41; Ed van Wijk, Delft: 40; John Webb, London: *46.